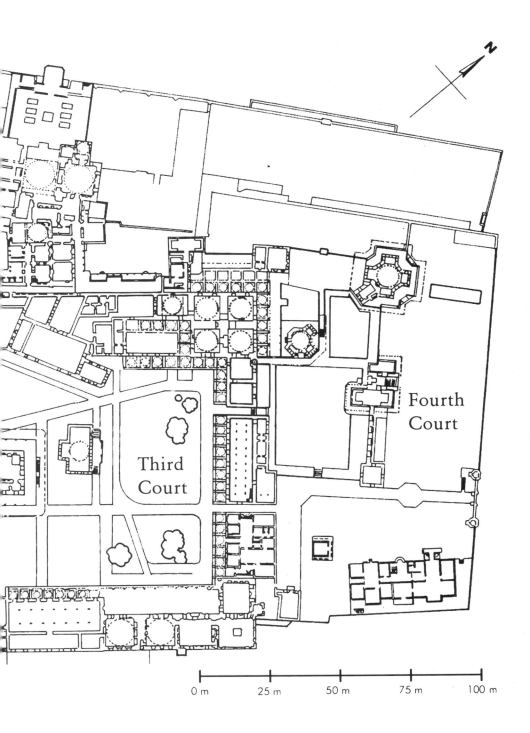

Fourth
Court

Third
Court

0 m 25 m 50 m 75 m 100 m

TOPKAPI PALACE

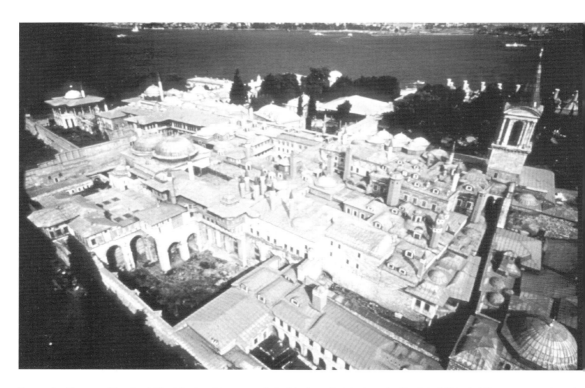

From the Tower of Justice (*R*) with the chimneys of the kitchens behind to the Baghdad Kiosk (*L*), encompassing the Harem and its hospital (*down centre*)

Godfrey Goodwin

Topkapi Palace

An Illustrated Guide
to Its Life & Personalities

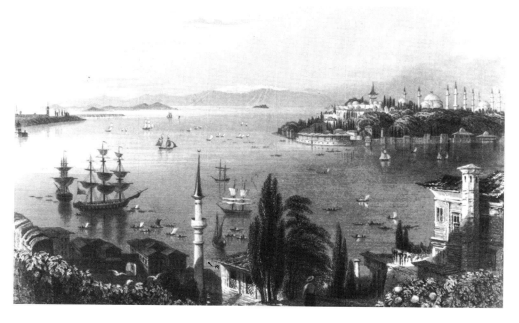

A view of the *saray* from Pera (now Beyoğlu) across the mouth of the Golden Horn

Saqi Books

To Gillian

British Library Cataloguing-in-Publication Data
A catalogue record for this book is available from the
British Library

ISBN 0 86356 067 9 (hb)

© Godfrey Goodwin, 1999
This edition first published 1999

The right of Godfrey Goodwin to be identified as the author of this work has been asserted
by him in accordance with the Copyright, Designs and Patents Act of 1988

Saqi Books
26 Westbourne Grove
London W2 5RH

Contents

Genealogy of the House of Osman

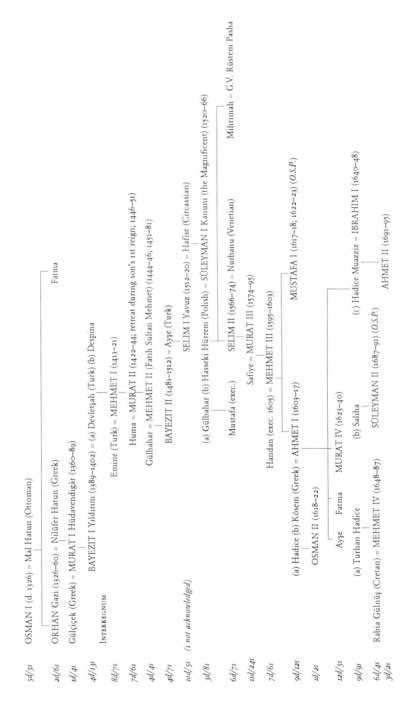

6d/4s Rabia Gülnüş (Cretan) = MEHMET IV (1648–87) SÜLEYMAN II (1687–91) (O.S.P.)

11d/10s MUSTAFA II (1695–1703) = (a) Saliha (b) Şehsuvar (Russian)

29d/22s MAHMUT I (1730–54) (O.S.P.) OSMAN III (1754–57) (O.S.P.)

8d/2s (a) Mihrişah (b) Rabia Şermi = AHMET III (1703–30)

14d/12s Mihrişah (Georgian) = MUSTAFA III (1757–74) ABDÜLHAMIT I (1774–89) = (a) Ayşe (b) Nakşidil

1d/1s SELIM III (1789–1807) (O.S.P.) MUSTAFA IV (1807–08)

17d/19s (a) Bezmialem (Georgian) (b) Pertevniyal = MAHMUT II (1808–39)

22d/18s ABDÜLMECIT I (1839–61) = (a) Şevkefza (Circassian) (b) Tirimüjgan (Circassian) (c) Gülcemal (d) Gülüstü (Circassian)

7d/6s MURAT V (1876) Hayranidil = ABDÜLAZIZ (1861–76)

3d/3s

10d/8s ABDÜLHAMIT II (1876–1909) MEHMET V Reşat (1909–18)

1d/3s MEHMET VI Vahideddin (1918–22) (abdicated)

3d/1s

1d/1s ABDÜLMECIT II (1922–24) (caliph only; deposed)

d/s = no. of daughters/sons born to a sultan (shown in left-hand margin)
exec. = executed
G.V. = Grand Vezir
O.S.P. = died without issue

Acknowledgements

I owe a deep debt to the directorate of the museum of Topkapı palace since 1957 when I first met Dr Mualla Eyüpoğlu Anhegger, who was then responsible for its restoration. I have since had constant help from successive directors, not least Dr Filiz Çağman. Professor Gülru Aktaş has solved such problems as teachers always encounter. My students have always lent me their eyes and it would need a chapter if I were to list them all, but I must mention Erol Atilla Yazıcı who was among those of distinction and who has assisted me in so many ways, including a sense of humour, after his graduation. The kindness of Professor John Carswell when he had so many problems to face is matched by that of Graeme Gardiner in the preparation of photographs. A distinguished conservator, he has certainly conserved me. I must also thank my Turkish publisher, Fatih Çimok, and my old and inexhaustible friend Mary Berkmen.

I am also indebted to the faith of my publisher, André Gaspard, and to Jana Gough, my editor. Without her labours, her ever deeper perception and critical care, let alone coping with a dishevelled manuscript, this book would never have appeared.

A Note to the Reader

The spelling adopted is based on modern Turkish, but only five letters may pose an initial problem for the non-Turkish-speaking reader: *c* is pronounced *j* as in *jam* (thus Cem Sultan is pronounced Jem Sultan); *ç* is pronounced *ch* as in *child*; *ğ* is not pronounced but merely lengthens the preceding vowel; *ı* is akin to the *u* in *radium*; and *ş* is akin to the *sh* in *shark*.

Each room or building mentioned in the text is numbered on the plan at the beginning of each chapter. Not many published sources of information have been overlooked although they may have been used harshly because of lack of space. None has been more deeply studied than the recent masterpiece by Professor Gülru Necipoğlu (see the bibliography on page 213).

The names of some buildings have changed over the centuries and the Turkish words *oda* and *köşkü* have more than one meaning in English according to context. The most obvious is the major residence of Mehmet II – Fatih, or 'the Conqueror'. It was built as the Has Odası, effectively the Privy Chamber as Professor Necipoğlu points out. When Selim I brought the relics of the Prophet back with him from Cairo, they were stored in this residence; but since the Republic, when these apartments were turned into a museum for the display of these relics, it has been known as Hırka-ı Saadet Dairesi, or the Pavilion of the Holy Mantle.

No guide book can cover temporary exhibitions and I have avoided listing particular objects in the Topkapı collections with the exception of a few kaftans. Fortunately, everything from Sung ceramics to clocks is carefully labelled. Because they are frail, many items which one might expect to be on permanent display need to be rested because the rules governing conservation include the avoidance of over-exposure to strong light and variations in climate.

A view of freedom at the entrance to the confines of the Third Court

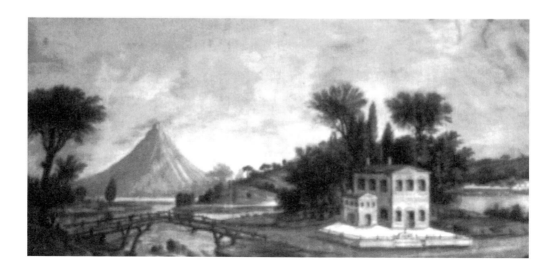

Foreword

How good a world it was we never knew until lost
without a trace.
(Cem Sultan)

This guide to the great palace of Topkapı is about the buildings, but these can only be meaningful if something is known about the people who lived inside its walls. Some smiled – though never in front of the sultan since it was not allowed – and some suffered; but the majority suffered little worse than boredom. The book is also about power. The present-day visitors who enter the *saray*, or palace, and even those who stay safely at home, are imagined strolling from one area to the next, meeting people and discussing the symbolic meaning of each corner of an immense empire, rather than on an organized tour. The palace was once known as the New Palace until it grew long in the tooth and became known instead as the Palace of the Gun Gate: Topkapısaray.

Bedraggled, rescued from ruin, mauled by fire and by time, Topkapı is an encampment translated into stone and mortar. Throughout, one must remember the power that custom held over the elite Ottomans who graduated from the Palace School – also known as the Enderun Kolej (the College Within) or the Pages' School – to rule the empire. They have all departed but the palace is still here. It is time to enter the gate.

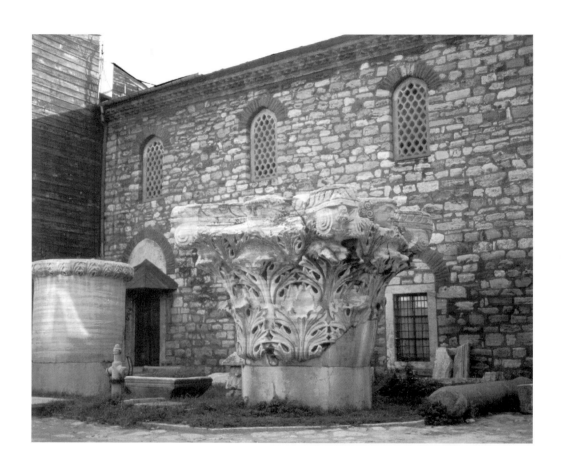

Fragment of a
triumphal capital of
the early Byzantine
period

The Gate of Majesty

(Bab-ül-Hümayün)

Be not proud, my sultan; greater than you is God.
(Turkish saying)

When Mehmet II put an end to the tatters of Byzantine power on 29 May 1453, he conquered a city which had been the eastern capital of the Roman empire. Constantinople had never recovered from the sack that scattered its treasures all over Europe in 1204, when it was taken by treachery by the knights of the infamous Fourth Crusade, led by the blind Doge of Venice, Enrico Dandolo, a nonagenarian. The city that Mehmet – known as Fatih ('the Conqueror') – took after a bitter siege consisted of scattered neighbourhoods among ruins and litter of past greatness. The symbol of this greatness was the church of Haghia Sophia, or Holy Wisdom (Aya Sofya). Its dome was the largest in the world after that of the Pantheon in Rome and Mehmet took it for his chief mosque before night set in on the day of victory.

He needed a headquarters and on the far side of the city was the relatively intact monastery of the Pantocrator, or the All-Seeing Saviour (Zeyrek Cami'i). It was an extensive group of churches, lodgings, cells and hospitals. But Mehmet immediately ordered the building of a palace in large grounds on top of the Third Hill between the later mosques of Bayezit II and Süleyman the Magnificent and the Grand Bazaar. (It is now the site of the core of Istanbul University.) Work began immediately and, once the foundations had been dug, building was swift because of the quantity of half-ruined

monuments, including the Forum of Theodosius, which became quarries; even their lead roofing was reused.

The sultan continued to live at his palace in the old capital of Edirne when he was not away on campaign, subduing neighbouring states both in the Balkans and in Anatolia. Ultimately, he hoped to conquer Italy and take Rome for his capital. Indeed, he claimed to be the emperor of Rome (Rum in Turkish) in place of the fallen Byzantine rulers. However, he returned ever more frequently to Istanbul, as we shall call Constantinople from now on, and stayed in the palace on the Third Hill. This was completed in 1458, insofar as a palace is ever completed, and already housed his harem. (After they conquered Thrace in the fourteenth century, the Ottomans adopted the Byzantine custom of keeping women secluded from all except their immediate families.) Now Mehmet required a majestic centre of government and power. It was not to become the principal residence of the sultan, however, until the middle of the sixteenth century.

There was an obvious site. The long-abandoned acropolis stood above a triangle of woods and open land that ended at what is now known as Seraglio Point (Sarayburnu), the meeting-place of the Sea of Marmara, the Golden Horn and the Straits of the Bosphorus. This high ground on the doorstep of Haghia Sophia, once sovereign church of the Orthodox faith and to which it belonged, would be adequate to sustain a grand palace, with all its services, that looked out on the whole city. It was full of old materials (spoglia) from ruins, including huge capitals from the city's earliest days. These probably carried statues of such Byzantine emperors as Constantine and Justinian, who built Haghia Sophia, mounted on horseback at the top of grand columns. Some of these capitals can today be found in the Second Court and the Kitchen Court.

Here, then, in 1463 Mehmet decreed the building of the two original courts: one was for the government and the highest judiciary, the Divan, while the other was for the sultan's private lodgings and also the Palace School which was to be transferred from the old capital, Edirne. Mehmet must have foreseen the growth of kiosks (köşkü in Turkish), or pavilions

(because this is what they really were, not places to buy tickets or cigarettes), like large tents in stone, which were the ideal form of Ottoman domestic architecture. Craftsmen were assembled from all over Ottoman Europe. Possibly, Italian builders who had just completed the walls and towers of Yedikule, the fortress and treasury on the far side of the city, also served.

People living in the area were compensated and sent to live elsewhere and the square kilometre of lower ground with its copses was to become idyllic hunting territory. Wilder animals like boar were kept apart and only released before a hunt. To prevent them escaping, the existing Byzantine walls and towers beside the water were repaired while new stretches of walls with towers some 140 metres apart were built on the land side, passing within a few metres of the wall of Haghia Sophia on their way to the Gate of Majesty (Bab-ül-Hümayün) and then down to the Sea of Marmara and the great stables. So it was almost by accident that the present First Court was established and it was for this reason that the great gate was built like a fortress because it was the main entrance to the *saray*. It was the Gate of Majesty or of Justice, symbolic of the old tradition that a sultan dispensed justice from above his gate.

The Gate of Majesty is formidable although the entry is only just wide enough to admit a tourist coach. It was the only gate open all day. Indeed, in theory smaller gates could only be opened by command of the sultan. The building itself is large and imposing because it is not simply a gate but also a barracks for the royal guard of fifty who carried bows and arrows. On the sultan's left side marched the *solaks* (which means left-handed) in their plumed helmets. They were relieved at night by janissary recruits.

The janissaries were Christian boys levied from the villages of the Balkans to be converted to Islam and trained to be the elite corps of the Ottoman army. Those youths who were outstanding were admitted to the Palace School and could achieve the highest posts in the empire. The towers of the land walls served as the barracks for ordinary recruits of the Outer Service who never saw the Second Court at all.

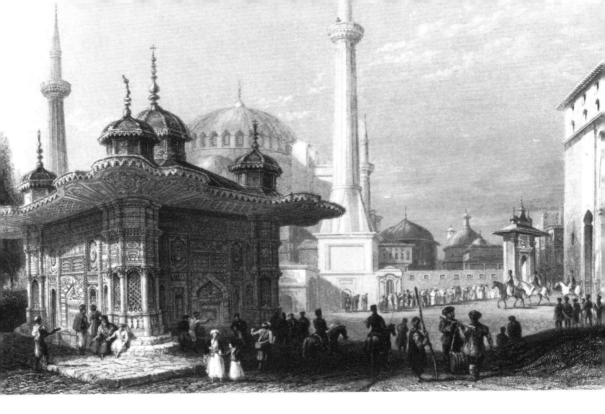

The fountain of
Ahmet III (*L*) (*see
page 184*) and the
Gate of Majesty (*R*)
with Haghia Sophia
behind

The gate's marble facings date from the reign of Abdülaziz
(1861–76), as do the niches. A man of formidable strength, he
also collected romantic seascapes endlessly turned out by the
Russian Ayvasovski and was himself an artist whose
masterpiece was a life-size painting of a stallion. Deposed on
30 May 1876 because of his opposition to reforms, Abdülaziz
was sent to Topkapısaray (which the sultans had abandoned
for the palace of Dolmabahçe in 1853), but only for one night.
The next day he was taken to the Çırağan palace on the
Bosphorus, now a luxury hotel. There he committed suicide
by cutting his wrists in disputed circumstances. He can
therefore claim to have been the last sultan to sleep at
Topkapısaray.

Inside the gate are staircases in the immensely thick walls,
leading up to constricted and dark rooms on either side.
Observant visitors will soon feel that something is out of
proportion: they are right because there was once a palatial if
unornate superstructure with a row of windows under a
pitched roof. Behind these was a central salon and rooms for
the harem. From these, courtiers and the harem women could

watch the colourful processions and the bustle of life beneath. It was Abdülaziz who demolished these rooms.

The first two courts of the *saray* were in use by November or December of 1486 although work continued for another ten years. As a result, the political axis of the city was radically altered. Anyone approaching the gate, where fifty guards were always on duty, would have been awed by the heads of traitors stuck on hooks on its walls. The Chamberlain was also officially the High Executioner but he delegated this task to a professional headsman who, appropriately enough, was called 'the Merciless'. It was also his duty to prepare the prisoner, comfort him and with his right hand make sure that his head faced Mecca. He would raise his sword in both hands and sever the head from the neck at one stroke. Then he read out the opening verses of the Koran (the *fatiha*) to those assembled. The actual block or stone was outside the Middle Gate (Orta Kapı), or Gate of Salutation (Bab-ül-Salaam), which had originally been intended as the Gate of Majesty, and the head was then taken by the hair to the actual Gate of Majesty on the street.

Anyone approaching the *saray* knew well the significance of the heads and their warning. There were also public executions before the gate itself. The heads of people of inferior status — thieves, pimps or idle, vile boys without the anyway worthless protection of a guild — would roll under the hooves of passing horsemen. Even if men of rank were beheaded within the *saray*, their heads were still hung up at the gate, where they were joined by those of bandits or crooked landlords in the provinces. They were parboiled and sent in bags to be washed before being stuck up along with the rest. It was a common practice all over the world at that date, not least at London Bridge. The use of refined torture was rare, however, and the guild that made the instruments consisted of one man who was the head and tail of it. The

seventeenth-century Turkish historian and traveller, Evliya
Çelebi, whom we shall meet again, was horrified by the
cruelty that he witnessed in Iran, for example, and there was
in Turkey no rack like the one that stretched Christopher
Marlowe in sixteenth-century Britain.

All who had business at the *saray*, and the sultan coming
from or returning to the Old Palace, used the Gate of Majesty.
Although austere, it was originally partly faced with tiles.
Mehmet II immediately moved some of the women from the
Old to the New Palace and Süleyman the Magnificent did the
same to obviate his riding home and back. There was also the
question of where to locate the Koran School for Princes. But
the sultans still rode to mosques on Fridays and by passing
through the city maintained the democratic custom of
permitting anyone to petition the sovereign's stirrup. For
convenience, a written document had to be submitted, since
the sultan could not constantly rein in his horse or he would

The Gate of Majesty
from the First Court

never have reached his destination. The Ottomans were practical. The Grand Vezir, for example, was permitted to ride a little in front of the sultan so that the monarch did not have to turn his head when he wanted to speak to his minister.

There was another reason for Mehmet II to reduce his public appearances except when he was on campaign. The Conqueror was deeply imbued with Byzantine concepts of royalty. Not only did his bodyguard of *peyks*, or foot guardsmen, inherit the formal Byzantine uniform – a helmet massed with ostrich feathers, for example, along with Byzantine weapons – but they also had their spleens removed, just as was the rule under the Basileus, for reasons that the present author has been unable to discover. It was majesty that set the ruler apart. The untouchable sovereign lived in deliberate seclusion in order to foster awe and humility among the great and the humble alike. There was also the sanctity of the invisible and divine power of the sultan, the 'Shadow of God on Earth' – but, unlike the Byzantine emperor, he was not regarded as a temporary saint for the duration of his reign. The New Palace, or Topkapısaray as it is now known, was built to be a sublime symbol.

What Mehmet the Conqueror believed, so did his descendants. Süleyman the Magnificent, or Kanuni ('the Lawgiver') as he was known to his subjects, was notorious for his arrogance. But do not be afraid. It is time to go in.

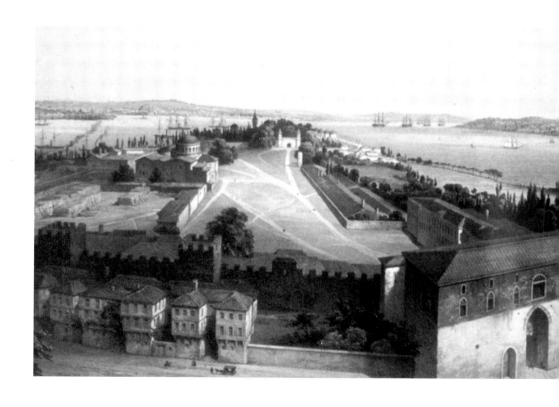

The First Court from
the Gate of Majesty
to the Middle Gate
with the Bosphorus
(*top L*)

The First Court

The ladder can only be climbed rung by rung.
(Turkish saying)

As mentioned previously, Mehmet II's original plan simply consisted of one court for government and another as his residence and the Palace School for recruits or pages (*içoğlans*). His apartments (Has Odası) are now the Hırka-ı Saadet Dairesi, or Museum of the Sacred Relics, in the Third Court. These relics were brought back from Cairo in the early sixteenth century by the conquering Selim I. His kiosk, built over his treasure vaults, is now the Treasury Museum.

It is probable that the Middle Gate was always guarded by two towers because it was originally intended to be the Gate of Majesty. It is for this reason that the cobbled path leading from the actual Gate of Majesty to the Middle Gate is out of alignment. It was cobbled in black and white, woven into patterns, in the manner of the paths which unite the Third with the Fourth Court. These divisions between the areas are necessary in any palace since the running of a place where thousands worked, from pages of the school to the kitchen scullions, meant that all needed quarters according to their rank. There were also gatekeepers, guards, storemen, grooms and so on.

Mehmet built the first two domed kitchens, which needed larders, granaries and waterworks. The waterworks were all-important because by the sixteenth century there were 5,000 men of the Inner (Enderun) Service and as many as 15,000 belonging to the Outer (Birin) Service, made up of military

units from the cavalry, or *sipahis*, huntsmen and gardeners to oarsmen of the sultan's barges. Indeed, it was a sizeable town with all its complex services. By the time of Süleyman the Magnificent in the mid-sixteenth century, this supply had become inadequate and Sinan, the greatest of Ottoman engineers and architects, built no fewer than four waterwheels, including one in the First Court. He also discovered and cleared two large Byzantine wells, one 9 and the other 18 metres deep, towards Seraglio Point.

The court of any despot is like a pedestrian corps de ballet. Under the Ottomans, each area had its own code of behaviour, from how to dismount a horse to the more significant crossing of hands over the kaftan, or robe, as a sign that the courtier was unarmed in the presence of his sultan. This rule applied even to the Grand Vezir, who was in any case carrying his seal of office. However mighty a monarch might be, there was always the fear of assassination.

Let us return to the Gate of Majesty. On our right, coming in through the gate, used to be the hospital of the pages (İçoğlan Hastahanesı) of which only the foundations remain; but it was far too important a part of palace life for the modern visitor not to pause a moment. Miniatures show the warden sitting at the door and also keeping an eye on the wood yard opposite, of which nothing remains either. The firewood was stacked in the open but superior timber was matured under cover. It was brought by boat from the forests of the Gulf of Izmit which seemed to be inexhaustible. The timber transports were crewed by janissary recruits who had failed to obtain a place at the palace or any subsidiary school, because it was a toughening job. One of the excitements of life in the First Court was watching the trains of ox carts, carrying not only timber but also many other goods from Asia which were unloaded at the harbour below. On some days, these carts blocked the gateway. There could be as many as 500 shiploads

of timber stored on the left side of Haghia Irene (Aya Iren), used as the armoury until the early twentieth century. In the sixteenth century, Sinan built a warehouse for building materials and there were also workshops and sheds, including those where matting (which was replaced annually) was woven for the *saray*.

Carpets were only used to cover floors in rooms used by grandees and this was true of mosques too. Plain straw may not be luxurious but it is lighter and shines and is therefore more cheerful than darker, woven fabrics. (The mosque of Süleyman, the Süleymaniye, for example, is a different place when stripped of its red carpets because it is full of light reflected from its floor.) The *saray* stores overflowed and churches and sheds that had been the haunts of beggars around the Hippodrome (At Meydanı) harboured the menagerie, stables, a powder magazine, archives, tailors, calligraphers, tent-makers and a special elephant house.

Behind the wood yard was the palace market garden. The produce was on sale to all and its revenues kept the treasury in gold coins, the confetti of sultans, which they could distribute or throw to people when riding to a mosque or to servants who pleased them. One and all scrambled for this golden rain. It was the happy duty of two of the sultan's thirty-nine senior pages to replenish his pockets every night and they had the right to keep any coins that the monarch had not distributed that day. Nonetheless, the kitchens spent considerable sums on purchasing vegetables – quite apart from the luxuries demanded by the sultan such as caviar, which was still plentiful in the rivers of the Black Sea in the sixteenth century. There were also exotic fruits, fresh, dried or crystallized in the honey of the gods. This came from Egypt, Wallachia or the Aegean islands, where beehives might be taken 'on vacation' when the mainland clover dried in summer else the queen might starve.

The First Court would already be crowded before any guest arrived or the vezirs and other notables made their ceremonial entrances, riding in accompanied by their musicians, attendants and grooms, and perhaps even a mountain lion or two. Once past the gatekeepers and guards, however, this

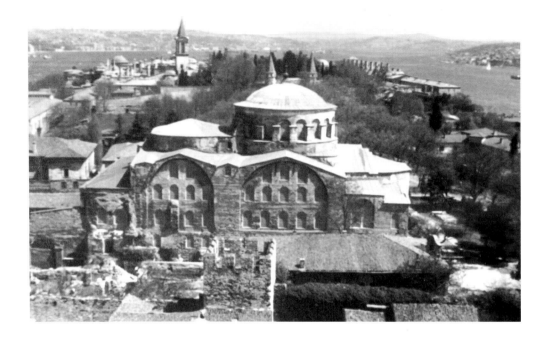

The church of
Haghia Irene, which
became the armoury

court was less oppressive than any to come and one man might speak to another. The large space within the newly built walls was put to instant use. When Pierre Gyllius, the unique among janissaries (he was sent by King François I of France to collect Greek manuscripts but was forgotten and had to join the corps in order to eat), measured it carefully he found that its area was 700 x 200 paces. (This is an exaggeration or his legs were remarkably short.) It had all the advantages of a free space where buildings and services could expand in a way that would have been impossible in the formal courts, with their buildings arranged symbolically according to their importance.

To return to the hospital, we find that, as late as the nineteenth century, it was clearly large and still standing. The master was not a doctor but an administrator from the company of the black eunuchs; he sat on a bench protected from the wind and where he could watch all coming and going. He was immediately accessible to nursing staff and woodmen and was doubtless kept busy. The hospital was of great importance to the pages of the Palace School, who suffered from

an implacable discipline when lodged in their dormitories in the Third Court. If they could feign illness, or at least exaggerate some minor ailment, they would be put in a curtained litter somewhat like a sedan chair and carried at a run to the wards reserved for them in this refuge beside the Gate of Majesty. It was too near in the opinion of some, since supervision inside the hospital, although undertaken by eunuchs who had been well trained, was not so much lax as corruptible. The pages received wages and could slip coins to a eunuch so that he would go out shopping for forbidden fruits which included wine.

There seem to have been occasions, however, when the virile patient escaped altogether to enjoy the illicit pleasures of the town. The risk to patient and eunuch was too great for this to happen often but one can well understand that a desperate youth of 20 or more might take his chances when he could. There were almost no chances at all back in the Third Court. If a page died in the night, he was covered by a kilim and carried to the imam of the hospital. He would be buried next day in the vast cemetery at Kasımpaşa or at the mosque of Kara Ahmet Pasha, by the main gate into the city. There is an anonymous sketch plan, done from memory, of the hospital which is of little help, but one may accept that it had two storeys even before Fossati partly rebuilt it in the nineteenth century. Apart from the wards for the pages, there were others for each janissary company stationed at the *saray* and there were small rooms for officers. There were also servants for every kind of illness so as to separate men suffering from contagious diseases from those who were the casualties of battle, rioting or a quarrel with fellow students. There were also *hamams* (Turkish baths) and laundries and other services.

Crossing over to the opposite side of the avenue, we can study the exterior of Haghia Irene, the sister church of Haghia Sophia. Sometimes open for concerts and exhibitions, special permission may be obtained to visit it. This is an important architectural experience because it was rebuilt after a major earthquake in 740 and, although it has lost its original columns, the nave is still uniquely grand with the apse under a fine half-dome over semicircular banks of seats for the clergy,

thus creating a powerful climax. The large mosaic cross and inscription also survive. Its courtyard was reformed in Otto-man times, as were the frail wooden galleries to the west. The church is impressive outside but the earth has risen 3 metres or more and the visitor must peer down at the skirting at the former level in order to appreciate how much more grand its proportions once were. As soon as the *saray* was walled, Haghia Irene was used as the palace armoury (though its Greek name means Holy Peace) and displays of shields and arms were mounted on the walls as if they were radiant sun discs.

When, in 1826, Mahmut II was advised that the time had come to get rid of the mutinous and decadent janissary corps for ever, students in their thousands rallied to the sultan's decree and stripped the armoury of weapons; latecomers were disgruntled to find that there was nothing left for them. The students marched to the Hippodrome and into the Sultan Ahmet Mosque, where the Grand Vezir had planted the standard of the Prophet on the mimber. Like the sultan, the pashas had reached the city by skiff from their weekend homes along the Bosphorus. A mere two cannon were enough to dispose of the dregs of a great corps which had once been feared across Europe. Until recently, there was a large display of mainly nineteenth-century guns and mortars outside the former armoury as tokens of great victories in the past. These curiosities from forgotten wars are now stowed away.

There were once workshops beside Haghia Irene for car-penters and other craftsmen who were constantly at work on the maintenance and embellishment of the *saray*. Hereabouts also were the offices of the Chief Architect who, as Master of the City, enforced strict building regulations, from the re-pair of pavements to the height of buildings. Streets were swept on festive occasions but most of the rubbish was the larder of scavenging dogs which fought with each other over their territories but tended to leave citizens alone. They knew where their food came from.

The next extant building on the left is the Mint, which lies well back from the avenue. It was moved inside the *saray* walls soon after they were built, for safety, and it expanded year by year into the eighteenth century. The new building

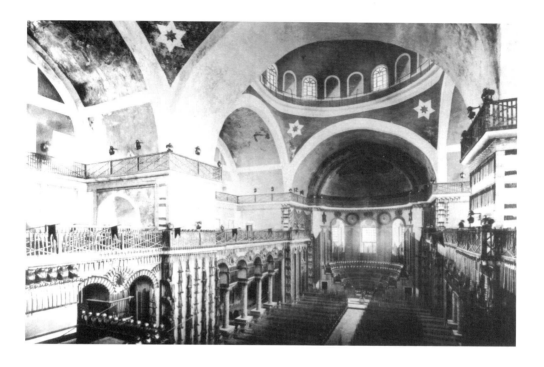

The armoury, *c.* 1909

was founded in 1727 and restored on a grand scale. It should
be visited when there is an exhibition because of the aston-
ishing array of furnace rooms where coins were struck, gold
and silverware fired and gold thread spun. Hidden behind a
high wall, one alert nineteenth-century traveller glimpsed the
weighing of coins with which to pay an army that was fight-
ing in Persia. The steep lane between the Mint and the walls
of the Second Court leads down to the Tile Kiosk, or Çinili
Köşkü, a favourite resort of Mehmet II.

On the other, far right side of the avenue, past the vanished
hospital, the visitor passes the walls of barracks built to house
gardeners and other men of the Outer Service such as grooms
and orderlies. Rebuilt, they now serve as workrooms for the
museum. There were also two bakeries, one of which produced
a great quantity of coarse but edible bread while the other
baked the famous loaves of royal quality for the sultan and
his family. No recipe for this white 'cake' (rather than 'loaf')
has, to the author's knowledge, survived and perhaps there

never was one since apprentices of exceptional skill would soon learn the techniques by heart.

Beyond, under the trees lining the avenue, are the tourist service rooms and the ticket-offices. These must be ignored together with the ranks of coaches that have now invaded the lower park while the major part, but not quite all, of the present trees were planted after Topkapı was vacated for Dolmabahçe on the Bosphorus in the mid-nineteenth century. Previously, there had to be ample space for mounts and grooms, whose numbers could reach as many as 500 at any one time. It was an endearing feature of Ottoman government that benches – here for grooms but elsewhere for other attendants and even guards – were provided for them to rest on. Towards the Mint (Dar-ül-Zarb-i Enderûni), these benches were set under a tiled colonnade. A pasha would dismount for his horse to be led into the shade as the new arrivals grew in number and filled the entire forecourt with their mounts and entourage, none of whom could enter the Second Court.

As if this throng were not enough, there were humble petitioners who came on foot and, in later years, a few audacious intruders came to enjoy the spectacle. In the days before television, people went to the news: it did not come to them. But the great mass of the population of Istanbul no more entered the *saray* than people would gatecrash the White House today – that is, except in times of hardship and discontent, which might lead to an uprising such as that of 1730 because there were popular leaders who, however, had little idea what to do with power when they achieved it.

We have already admired the heads of some of the lowest class of all guilds, which was made up of professional thieves, prostituted youths and also the desperately poor, besides the steady flow of wretched peasants who had lost their land. These defied the law and slipped into the city secretly because their land could no longer support their families or had been appropriated by landlord or usurer. In the eighteenth century, the latter was often a bullying janissary.

In Byzantine and Ottoman times, and still today, a constant aspect of city life was that ex-villagers kept together and that the new city neighbourhoods were named after their

towns of origin, such as Aksaray. The lowest stratum of the lowest class was composed of religious fanatics, who were not necessarily poor. They were hostile to any form of change. If they were despised by scholars or their rulers, they were not by the *ulema* (members of the judicial class), who were often just as hostile to changes which threatened their own privileges: sometimes they included the mufti of Istanbul and the Chief Justices (*kadıaskers*) of Europe and Asia. Fortunately, there were scholars and open minds among the judicial elite. Such a man was Ebüssu'ûd, the great sixteenth-century mufti (*şeyhülislam*) for whose reforms Süleyman the Magnificent won the credit. Like many a great officer of state, the mufti was a passionate gardener. Many judges were corruptible, open to hush money just like any other class; and even when Peruvian silver spread like a disease in the sixteenth century and the Ottoman currency was debased, they continued to enrich themselves.

As for governments, if things went wrong it was underlings who were likely to suffer. When Koçu Bey – an early seventeenth-century defender of civilized values, inspired by the many counsels of Mustafa Ali – published his *Risala* [Influential Advice for Sovereigns] for his master, Murat IV, it stirred the pot but did not save it from boiling over. He urged that anyone in government, from the most illustrious to the most humble, should be dismissed for corruption or incompetence: but not on insufficient evidence. He also recommended that only the worthy should obtain a post and it is significant that he himself did not achieve preferment but was nearly hanged. Instead, he was exiled to Cyprus. A most important element in Ottoman society, as in other Islamic lands, was that sufferers did not complain: to do so would have suggested that God could be wrong or even did not exist. Uninfluential unfortunates faced the consequences of their misdeeds, like the three tax officers arrested for jiggery-pokery. Two of them were flogged and all three dismissed. The eighteenth-century mufti Feyzullah Efendi, however, escaped the law only to be torn to pieces by the mob.

There were older influences in Ottoman society, some from a heroic past in Central Asia. Trees were seen as animate and

it was an offence against God to fell one that stood on its own. Rags were hung on the branches of exceptional trees to draw heavenly attention when one prayed. It is recorded that Abd al-Rahman I, who has claim to have founded Islamic Spain, saw a palm tree born of a seed that had escaped Africa for Andalusia. Overwhelmed by homesickness, he wrote a notable poem to it.

The mystical among the dervish orders absorbed some of these concepts and meditation was held to be a necessity, with rooms built for it at dervish convents, or *tekkes*, but also at the *saray* and at the great mosque of Selim II, the Selimiye, at Edirne. There were dervish or mystical sects with different beliefs from which to choose, and superstition was common to all of society. Dervish orders believed that the first duty of the soul was to be rid of property – otherwise there could be no true independence. This is the essence of Sufi mysticism, still a potent force today. What a Sufi does need is a staff, a water pot, a loincloth, a toothbrush, a needle and nail scissors but not, the reader will perceive, a razor. Even the leaders and the educated consulted soothsayers and almanacs or the fall of a leaf. An invisible power from the past was in constant attendance at the *saray* by day and by night. In this, the Christian minority did not seem to be different.

Such were the people and such their roots. Wise sultans took all these elements into account. It follows, then, that as we prepare to pass through the Middle Gate we should be aware of the struggle for life and happiness that motivated the existence of everyone, both inside and outside the *saray*. We pass the dust-buried octagon in the ground that is the ghost of the Kiosk of Petitions (for justice); it was curiously known as the Kiosk of the Paper-Maker (Kağit Emini). The petitions were handed in early in the morning of a meeting of the Divan, or Grand Council of State. The plaintiff received judgment in the form of a royal decree, or *firman*, in the afternoon. We shall now leave this bustling village of brick and red-tiled roofs for the space and silence of the Second Court.

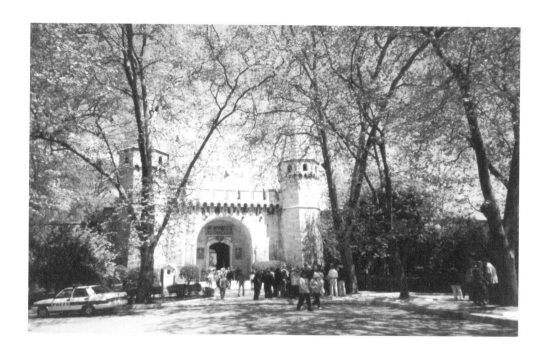

The Middle Gate,
with prison towers
on each side

The Second Court

1. Orta Kapı (Middle Gate) or Bab-ül-Salaam (Gate of Salutation)
1A. Model of *saray*
2. View to Has Ahır Meydanı (Stable Court)
3. Ahır Odası (Stables and Harness Store)
4. Beşir Agha Cami'i and *Hamam* (Mosque and *Hamam* of Beşir Agha)
5. *Araba* (carriages)
6. Mutfaklara Erzak Kapısı (Gate of Kitchen Supplies)
7. Tablakarlar Koğuşu (Foodstore)
8. Aşçılar Mescidi (Cooks' Chapel)
9. Mutfaklar (Kitchens)
10. Şekerciler Helvahane (Sweetmeat Kitchen)
11. Şekerciler Mescidi (Chapel of the Sweetmeat Cooks)
12. Kitchens built by Mehmet II
13. Aşçılar Dairesi (Kitchen Staff Offices and Dormitories above)
14. Bab-ül-Sa'adet (Gate of Felicity) or Akağalar Kapısı (Gate of the White Eunuchs)
15. Site of original Divan Odası (Divan Hall); and (15A) of former window of pages' families
16. Diş Hazine (Outer Treasury)
17. Kubbe Altı, Divan Odası (High Dome, Divan Hall)
17A. Secretariat
18. Adalet Kulesi (Tower of Justice) .
19. Araba Kapısı (Carriage Gate)
20. Zülüflü Baltacılar Koğuşu (Barracks of the Halberdiers with Tresses)
21. *Avlu* (court)
22. Baltacıilar Cami'i (Mosque of the Halberdiers)
23. Meyit Yokusu (The Sloping Way)
24. Şal Kapısı (Gate of the Shawl)
25. Kara Ağalar Cami'i (Mosque of the Black Eunuchs)
26. Meskhane Hamamı (Musicians' *Hamam*)
27. Meskhane (Musicians' Hall)
28. Şadırvanlı Taşlığı (Court of the Fountain, with the sultan's mounting block)
29. Kara Ağalar Taşlığı (Court of the Black Eunuchs)
30. Kara Ağalar Dairesi (Barrack of the Black Eunuchs)
31. Şehzadeler Mektebi (Koran School for Princes)
32. Kızlarağası Dairesi (Apartment of Chief Black Eunuch)
33. Harem Girisi;and (33A) Nöbet Yeri (Harem Door)

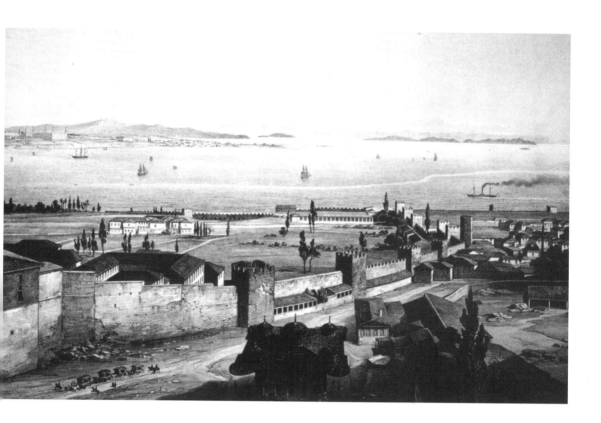

Top: A view in 1847 of the pages' hospital
across the training ground to a barracks
L) and stables with the Sea of Marmara

Right: The Master of the Horse

The uncovering of the seventeenth-century dome of the Twin Pavilion

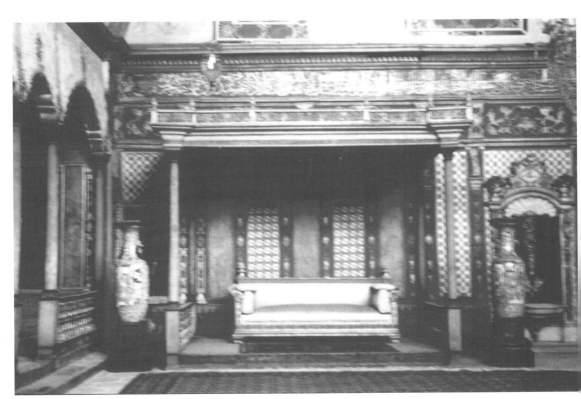

The Throne Room

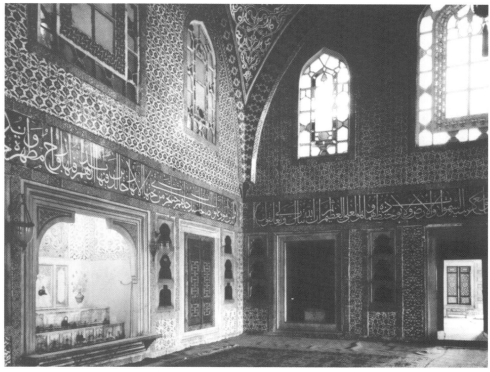

The chamber of Murat III

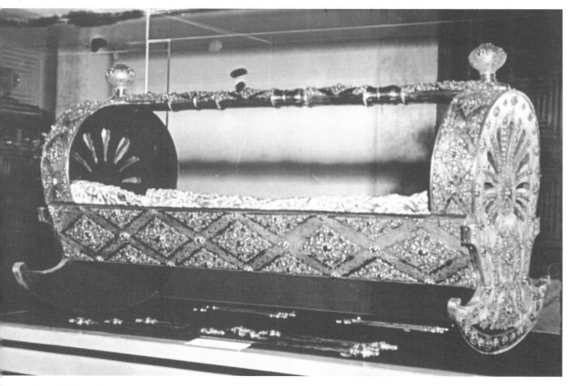

The cradle of Ahmet I

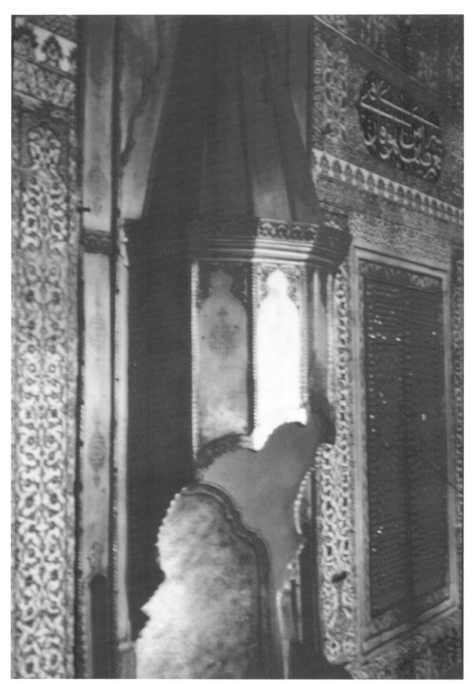

The fireplace of the Twin Pavilion

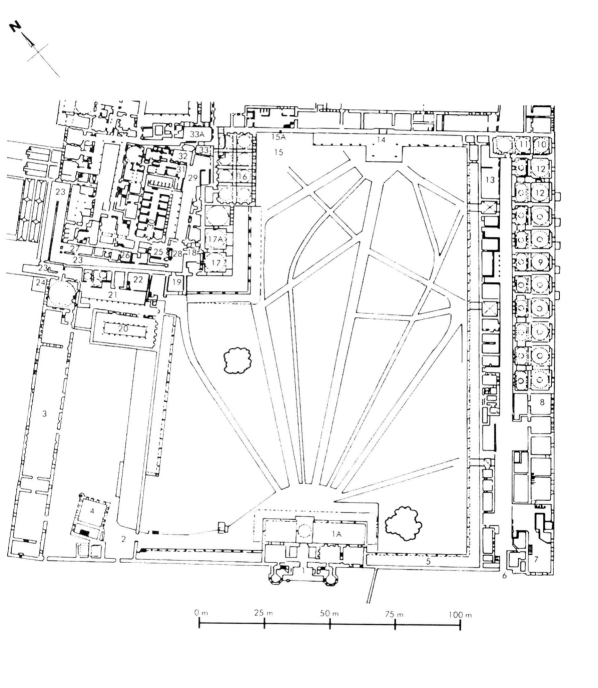

N

33A

32

33

31

29

30

23

15A

15

14

11 10

12

12

13

16

17A

9

17

27

23

26

25 28 18

24

23

22

19

21

8

20

3

4

2

1A

5

7

6

1

0 m 25 m 50 m 75 m 100 m

Portico into the
Second Court with
the Middle Gate
behind

The Second Court

The fifteenth-century Gate of Salutation (Bab-ül-Salaam), built
by Mehmet II and better known as the Middle Gate (Orta
Kapı), no longer has its brilliant gilded doors nor the por-
tico of 1524. It is flanked by two handsome towers which
were refurbished by Murat III (1574–95) in the later sixteenth
century. It was in these towers that proud officials were im-
prisoned prior to their death. Inscriptions on either side of
the gatehouse door list repairs carried out by other sultans
but it is clear that the work of Murat III was the most impor-
tant visually.

A better pedagogue than he was a sultan, and devoted to
the Palace School, Murat was a man of cultivated tastes. He
was deeply interested in flowers like his forebear Mehmet II,
who had 12 gardens and nearly 1,000 gardeners. Yet there were
no bunches of flowers: the single most perfect bloom was
placed in a tall-necked vase. The tulip at first was paramount
among the 12 court flowers such as narcissus and rose.

In 1580, however, a shadow fell over Murat: at the age of
34, he suffered an attack of epilepsy from which he recovered
in his mother's garden at her palace at Edirne. His govern-
ment was to come near to economic ruin and he finally lost
heart and died of melancholy. Significantly, he was the son
of Selim II, all too sensitive a man and for whom the prince
of Ottoman architects, Sinan, built the mosque in Edirne

which is his masterpiece and has never been excelled. Selim was also a passionate gardener and introduced fixed prices for flowers. Both monarchs had Anatolia scoured for as many as 40,000 bulbs at a time.

Selim II (1566–74) married Nurbanu, the daughter of a Venetian nobleman, who corresponded with the Doge. She added a breadth of cultural vision that illuminated the lives of both her husband and her son. When she died in December 1580, Murat helped carry his mother out of the palace gate wearing purple mourning. No sultan had ever done this before, still less followed the funeral procession to pray at the Fatih Mosque. Then Nurbanu was carried back to Haghia Sophia to be buried in the sumptuous tomb that Sinan had built for Selim II.

When the *saray* was still a royal residence in the early nineteenth century, a visitor would be admitted by the Captain of the Gate and lesser keepers, where today are modest sentries and museum warders. The two stone divans where these officials once sat, and where glittering armour was displayed, are now obstructed by old ticket-offices. On the left is an empty chamber through which a visitor will leave at the end of the visit. It gives some idea of the size of the closed halls on the right of the present entry which were once used as guardrooms and sometimes as waiting-rooms for an ambassador and his entourage. Sadly, they have lost the tile panels which Gyllius recorded in the mid-sixteenth century. It was by one of these halls, on the left or right, that an unfortunate official ascended the stairs to his cell in what were prison towers. It would usually be fatal to descend them.

Today, once through the checkpoint, the visitor steps out under large wooden eaves measuring some 4.5 x 40 metres. These are carried on four columns on the left but six on the right, indicating that the guardrooms were extended at some later date. This large wooden canopy probably dates from the late eighteenth century but the Arcadian, if amateur, scenes painted there are later work – as are those on the eaves of other gates in the *saray*. In the eighteenth and nineteenth centuries, there were itinerant artists whose work is to be found all over Anatolia. In Karaman there are portraits of

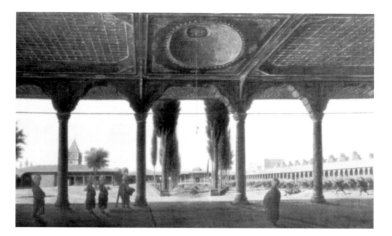

A view of the whole court in the eighteenth century

Bosphorus paddle steamers and nostalgic views of Istanbul, stylized and idealized, to soothe the melancholy of those weary of provincial life. The Byzantine clergy had been equally bored a millennium before.

Inside the Second Court at last, all of it lies before the visitor little altered in design since the sixteenth century when William Harborne, the first English ambassador to the sultan, described it admiringly as being twice the size of the courtyard of St Paul's Cathedral. One or two of the original trees survive; they can be recognized by the stone skirting built around them as protection from the gazelles that wandered freely and tamely in what was a miniature wood. There were peacocks as well and even ostriches, symbolic of Mecca, where they abounded until annihilated by the Saudi sultan in the 1920s. (The eggs were brought back to prove that one had indeed completed the pilgrimage.) Nowadays there are carefully planned shrubberies and even flowers, which in the days of the sultans would have been cropped by a gazelle. The *saray* at Edirne and the Old Palace in Istanbul had only trees and creepers such as honeysuckle for the same reason.

In essence, the court itself is a great assembly hall without a roof, but with the addition of two other major buildings. But let us start the visit by turning sharp left, past the modern bookshop, to reach the gateway that breaks the flow of the arcades at the far corner. From there, we can look round

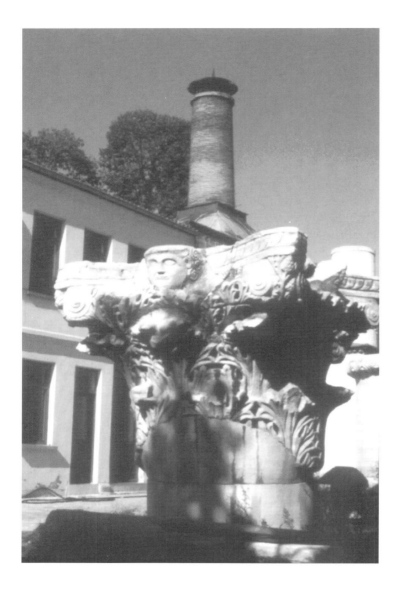

Elaborate early
Byzantine capital in
the Kitchen Court

the corner, past the mosque of Beşir Agha, and down to the
royal stables and the coach house, both of which are now
closed. So is the office of the Master of the Horse (*mirahor*), a
most exalted official of the Outer Service. The horses kept in
the stables (never more than forty in number) were the per-
sonal mounts of the sultan and one or two of his favourite
pages. From time to time, carriage horses may have been kept

here too. The superb saddles and trappings were stored in the lofts above.

The main stables of the Outer Service were situated down the hill from the Gate of Majesty where the land and sea walls meet. Like the hospital, they are now gone, but the large gate opens onto the street and is still known as the Stable Gate. Not a nag is to be seen, only the tourist coaches in their park. Once, there were so many horses that they had to be sent to pastures outside the city, including the Sweet Waters of Europe at the top of the Golden Horn, and not just to the Hippodrome, near which the national stud was maintained until the second half of the twentieth century.

Returning to our viewpoint from the Second Court, we can also see the rebuilt mosque of Beşir Agha, which was erected above the level of the stable yard for obvious reasons. It has a minaret so modest that it is tucked into a corner as if under its arm. There is no balcony but only a turret under a conical roof from which to make the call to prayer. Behind the mosque are the remains of a *hamam* for those janissary recruits who served as grooms and stable boys. The back walls of the Barracks of the Halberdiers with Tresses can also be seen and hints of the roofs of the Harem beyond.

The visitor should now return to the Middle Gate and inspect an amusing if not totally accurate model of the restituted *saray*. Proceeding to the right, or south-east, we find a glazed-in section of the arcade which houses a few of the mainly nineteenth-century carriages some of which were gifts while others were purchased in Europe. They include a sedan, a coupé belonging to Mehmet V Reşat (1909–18) and phaetons and the state landau of Ahmet II (1691–95) which he liked to drive himself.

From here we make our way round to the nearest entrance to the Kitchen Court. Outside stand two of the three very large capitals which were early Byzantine work. By reaching up and feeling the top of one of them it is possible to find indentations suggesting that it carried the figure of a mounted emperor. Dug up in the 1960s during repairs to the *saray*, it is a reminder that the artisans of Mehmet II took their materials from the ruins of the acropolis all around them. It has

proved impossible to identify the columns reused through-
out the *saray*, but it should be remembered that the Ottoman
quarries produced no columns of any size until the eight-
eenth century. In Europe spoglia was also used, including
marble from Africa for the Leaning Tower of Pisa.

Inside the Kitchen Court, which is hardly wider than a
broad open passage some 150 metres long, we encounter a
third capital, even more elaborately carved than the other
two and which seems to be the earliest in date; it has a gro-
tesque head on each side. From the present barrier it is possi-
ble to see the outer entry, used for the delivery of great
quantities of food and livestock besides admitting workers
to the all-important waterworks. Next to the entry was one of
several food stores and there were more in the basements of
the kitchens.

When oil in pans frying kebabs caught fire in 1574, a high
wind carried sparks from the then lower chimneys across the
Second Court to set the Harem alight. The architect Sinan
was immediately called in to heighten the flues and add coni-
cal caps which were removed in the 1940s. The quantity of
lead required meant expeditions into the Balkans to the mines
at Banya Luka. Murat III improved and enlarged the Harem
apartments and transformed his own as well. He built more
of the *saray* than any sultan after Mehmet II.

The first eight of the ten kitchens were built for Mehmet's
son, Bayezit II, after the great earthquake of 10 September
1509 while only the farthest pair date from his father's reign.
At the very far end of the Kitchen Court was a little prayer
room leading out of the sweetmeat kitchen. These now house
a display of glassware some of which was (and still is) manu-
factured across the Bosphorus at Paşabahçe. One can only
suppose that the master cooks of frail delicacies could not
stray long – unlike more humdrum cooks who had to keep
watch over huge boiling cauldrons, even if they did need half
a tree to stir them. The two kitchens built by Mehmet II con-
tain examples of these cauldrons along with other cooking
instruments for stewing and basting. Master cooks still be-
lieve that the bigger the pot, the better the pilaf. But nothing
can make grotesquely large cabbages into delicate dishes, not
even charity kitchens.

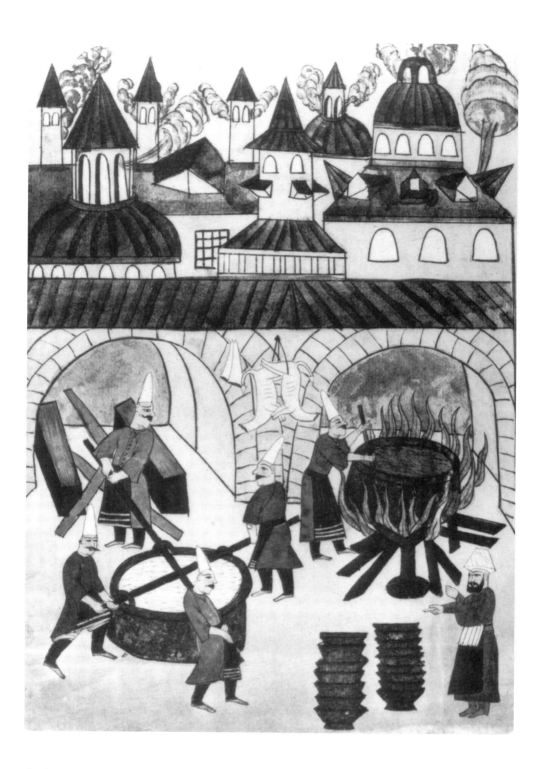

Cooks cooking

Opposite the kitchens were the quarters of the brigade of cooks and scullions along with other subordinate personnel such as porters and watchmen. They slept in dormitories running the length of the upper floors as if they were soldiers (as indeed they were, since the 200 under-cooks and scullions were officially cadets and subject to military discipline). The rooms beneath are now used for a display of Ottoman silverware and European glass and silverware of considerable interest. The number of these junior cooks and skivvies was not great when one considers that they might prepare as many as 6,000 meals a day – everyone had to be fed, from the sultan to the executioner, from the vezirs to the garbage collectors. Mehmet II had a mere 150 cadets, but in the seventeenth century Mehmet IV, a spendthrift with an empty treasury, had nearly 400 on the payroll.

There are also a great number of former offices that are striking because they are so small. They were largely rebuilt after 1926, which accounts for their lacklustre appearance when compared with nineteenth-century photographs. It was from the kitchens that janissary officers took their titles of rank (colonels, for example, were called *çorbacıs*, or cooks) and on state occasions the commanders of the corps rattled and gleamed with silver pots and pans. Long before Napoleon, commanders of armies knew that they marched on their stomachs.

When in disgrace, the cynical old Mehmet Köprülü – for years a mere administrator in the kitchens – emerged as if a waking leviathan to be the first of the intellectual Grand Vezirs. He and an increasing number of politically important friends would meet under his inspiration and actually discuss the economic and political issues of the day. He founded a dynasty which was to eclipse sultans until the end of the seventeenth century. It was an astonishing world, a Hades of flames and smouldering embers crowned with pots of all sizes. For a time these kitchens were divided into those for the sultan and for his mother, the Valide Sultan (queen mother), then those for the senior officers of state and so on down the social scale to minions who tasted no *helva* made with Egyptian honey, nor baby lambs in springtime, nor ducks

nor partridges either. Curiously, fish was unpopular except when caught by hungry pages from the rocky shore in secret.

In the kitchens of the sultan and the Valide all the foods had to be tasted first, while the use of celadon ware is partly due to the superstition that it changed colour if, so to speak, it tasted poison. There were sultans who ate off gold and silver but the Valides used brilliantly polished tinned copper, and also porcelain. Throughout the kitchens, pots and dishes were kept gleaming. While it was not unusual for the confectioners to have included the Chief Syrup-Maker, it is surprising that the palace soap was also made in that particular kitchen.

Meals were served at 10 am and 3 pm. Breakfast consisted of bread, fruit and jam. In the afternoon boiled mutton, stewed vegetables and pilaf were served with sherbets or *pekmez*, the juice of unfermented grapes. Some people followed a strict diet: for example, the black eunuchs' only meat was veal. Quantities were immense. In 1723, 30,000 bullocks, 60,000 sheep and 200,000 fowl were cooked. In the mid-seventeenth century, 80,000 bushels of rice, 60,000 pounds [27,216 kilograms] of honey and 2,000 pounds [907 kilograms] of salt were consumed each year. Various regions sent their specialities but, like their pages, sultans would only eat fish that they saw caught from one of their kiosks. There was a vast barnyard behind the mosque of Sultan Ahmet while the best fowl and pigeons came from Bursa. Eggplant was imported from Egypt, turkeys from Gallipoli and caviar from the Black Sea, where, as we have seen, there were still plenty of sturgeon in the mouths of its rivers. Add chickpeas, starch, vermicelli, olive oil, pepper and 900 pounds [408 kilograms] of ambergris and it is not surprising that there was a platoon at work carrying garbage from the kitchen middens down to the sea to feed the fish. But there was no real wastage since the ever-hungry janissaries would eat up the remains of any meal.

The sultan's own water was brought daily from a sweet spring above Eyüp beyond the Golden Horn and this 'silver water' was guarded night and day by janissaries. (In miniatures, pure water was depicted with silver leaf, which has oxidized over the years and is now black.) Nearby, royal sheep

were driven to a farm from where, after the palace supply had been selected, the rest were sent to market. The sultan ate three or four times a day. Ahmet I (1603–17) is known to have preferred pigeon, goose, lamb, chicken and the rare wild fowl. Other sultans were less conventional. Their dried beef (*pastırma*) came from pregnant cows and their honey from Candia, not Romania or Egypt (considered of lesser quality). Butter came wrapped in ox or buffalo hides, hairy side inwards; when rancid, it was sold off to unhappy grocers. The *saray* orchards supplied good figs, grapes, peaches and melons while Egypt sent dates and plums. Since only coarse cheeses were made in Turkey, Gorgonzola from Milan was specially imported for the sultan, while gifts of Parmesan arrived from the Doge of Venice.

Today, the imperial kitchens make appropriate pavilions for the astonishing collection of ceramics which has survived because of the careful listing of individual pieces over the centuries. The Chinese collection is one of the most important in the world and includes such a quantity of celadon, for example, that one is almost glad that the vast majority of

The Kitchen Court with capital in the distance

the pieces are kept in the vaults. Of particular relevance are the blue and white dishes decorated with vines and grapes, flowers and cloud scrolls; they delighted Bayezit II and even more Süleyman the Magnificent and influenced the royal studio when the designers prepared pounces for the potters of Iznik. If a rim or a lip were chipped the wound was hidden by a ruff of gold, making an enhancement out of a bandage.

When open to visitors, beyond the Chinese and Japanese sections are examples from almost all the important European kilns such as Meissen, Limoges and Sèvres, the last of which supplied a 75-piece breakfast service for a dozen people in 1885. The coffee cups from Vincennes are seventeenth-century. Almost all were gifts, including a particularly obtrusive array of huge nineteenth-century vases, mostly from St Petersburg, so big that one wonders whether one should shake them by the hand or make an obsequious bow. It is hard to believe that such giants could be thrown even in parts and sections. They cease to be urns or vases and become symbols of an extraordinary period when design emerged on the far side of vulgarity. The human race is growing taller and one day may not find these creations disproportionate. Indeed, in Dolmabahçe, the first palace of a new era, they already stand quite at ease.

On leaving the Kitchen Court, the visitor should make for the Gate of Felicity (Bab-ül-Sa'adet), where a plaque records its restoration in 1524. A roped-off stone records the place under its eaves where the gold throne was brought from the Inner Treasury (İç Hazine) by halberdiers on a sultan's accession and on feast days when the court paid homage. The Grand Vezir and the officers of the Divan stood either side of it while queues knelt to kiss the royal stole but the sultan would graciously half rise to receive leading members of the *ulema*. Made up of sections, the throne is easily portable and is now an outstanding exhibit in the Treasury Museum in the Third Court.

The visitor should next move on to the far corner beneath the high and impressive Harem wall. Here, the first Divan Hall of Mehmet II stood against the wall of the Third Court. It was too small but survived as a waiting-room into the

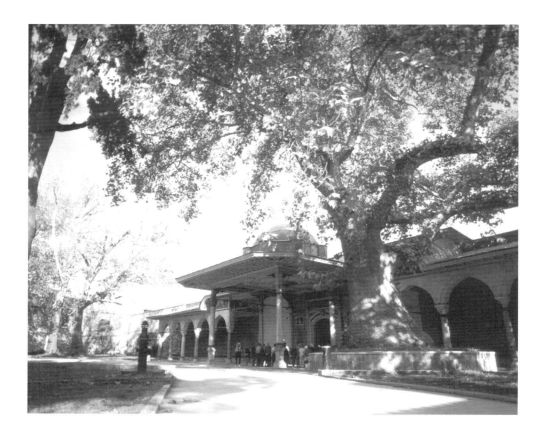

twentieth century. It was there that pages in the Little
Dormitory could come to a (now vanished) grilled window
like convicts to speak to their families.

Next to it stands the still extant eight-domed Outer Treas-
ury (Diş Hazine), built as strong as a fortress to secure the
revenues of the imperial dominions. Its doors are of iron
and iron grilles mask the windows. It was rebuilt by Süleyman
the Magnificent in its present form in the 1520s. The treas-
ures arrived in sacks day by day, but sometimes so few were
left that an alarmed government might have to resort to the
sultan's private treasury guarded under his pavilion in the
Third Court. There were times when gold and silver plate
had to be melted down. Worst of all was the death of a sultan
because his successor had to placate the janissaries with ac-
cession purses, a bad custom for which Mehmet II must be
held responsible.

Across the Gate of
Felicity to the Outer
Treasury

The perennial problem was the janissaries' pay and their allowance for new clothes (bought from their special shops), their food and their firearms. Such was their affection for their harquebuses that they engraved and carved their personal decoration on the wooden stocks. Weapons were all kept in a central store for obvious reasons of security. The Outer Treasury is now the Arms Museum, where such guns are displayed along with bows and arrows. Their curious inverted shape is caused by the removal of the bowstring and it would be conventional were it possible to keep them in tension. The bow was not a single strip of yew like those of England; it was made up of slender threads of gut and wood, bound together with a formidable glue. Their value was rivalled only by that of a cadet's bowfinger, which could all too easily be damaged or even lost. For this reason, and also in order to protect the bow itself, a youth would need more than a year of practice before he fired his first arrow.

The best swords and scimitars were made of tempered steel from Damascus and so were of great value. The chain-mail was light and easy to carry as were the painted, woven, wicker shields which were surprisingly strong. Grand helmets were chiselled with quotations from the Koran and also gilded. In the Museum of Turkish and Islamic Art in the former *saray* of Ibraham Pasha on the Hippodrome are finely woven vests with many quotations besides magic grids and squares: all of which were talismans against fate.

Leaving this lofty hall which has lost its eaves, with its atmosphere of power, we proceed on round the court to the instantly recognizable Divan Hall, or Hall of Deliberation and Justice. Riding high above it is the Tower of Justice, which, leaves permitting, overlooks the whole *saray* and can be seen from all over the city and Galata too. The original tower of Mehmet II was low with deep vaults which were the original Outer Treasury. There was a plain imperial staircase but no pomp. By the sixteenth century the stairs reached a belvedere with four windows that still surveyed the whole *saray*, but more particularly the Second Court because it was the centre of government and therefore of intrigue. From this tower, a sultan could oversee the extinction of fallen pashas who were

executed in this court and not beside the Executioner's Fountain in the First Court (used for all those of lesser importance). If he opened the window, he could listen to pleas for mercy and, in theory at least, reprieve the fortunate penitent but there appears to be no clear record of such mercy. Like

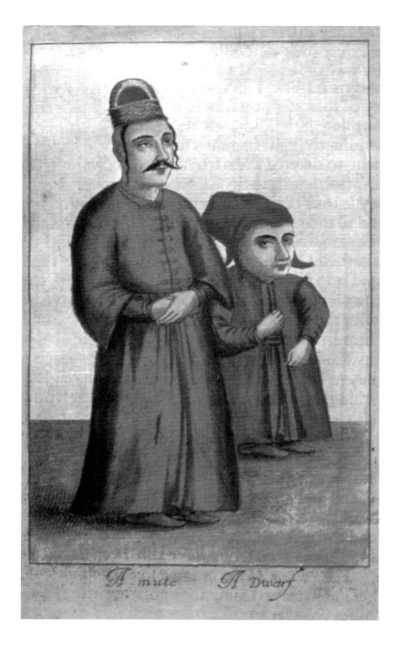

A mute A Dwarf

Deaf mute and dwarf

The royal window
onto the Divan Hall

everyone else, the sultan could watch the deaf mutes among
the jesters and the dwarfs idling in the crowd. To these sinis-
ter servants we shall return. On campaign, the royal enclo-
sure included a wooden tower from which the sultan could
look down on his camp and also be seen to do so by the
soldiers. It was from this that the stone tower of Topkapısaray
descended.

Work on the tower was carried out for Mahmut II in 1820
but a photograph of 1850 shows that the form was unchanged.
Another photo of 1852, however, shows the old upper storey
rebuilt with a crown of classical columns without a viewpoint.
The proportions do not clash with the Ottoman tradition.
Who built this whisper of Christopher Wren? It could have
been one of the Fossati brothers, who had just finished their
repairs to Haghia Sophia in 1849, but that is merely a rash
guess.

The Divan Hall was rebuilt in the 1520s and is the achieve-
ment of the great Ibrahim Pasha, the first Grand as opposed
to merely Chief Vezir. It has been thoroughly restored. Stand-
ing under the gilded eaves, the visitor contemplates the sym-
bol of open government because the bench on which the

Looking through the
Gate of Felicity

council of state sat is there for all to see. The inner hall on
the right housed the secretariat where the scribes recorded all
decrees and imprinted the sultan's *tughra*, or signature, on
each copy. Beyond this office was the archival library.

There is no mistaking the Divan Hall even if it has lost its
central wooden inside dome from which the four senior vezirs
took their title of Vezir of the Cupola. A golden lattice sphere
(now replaced by a golden ball), symbol of the world and the
universe, formerly hung from the centre of this dome. The
Divan sat in front of what was a polished wall of Egyptian
marble (now covered with tiles) which may have been brought
back from Cairo in 1525 when Ibrahim Pasha ceased to be
viceroy. The window over the centre of the bench is the most

potent of all symbols. Unobserved from behind a lattice, the sultan could look down on the proceedings when he wished, attended by two of his most senior pages who carried his bow and arrows. Beneath the window there was once a door through which only the Grand Vezir could pass. A window is an open eye and no one could block the view.

A miniature records that one day Selim II stood up, took his weapon and let fly an arrow at the latticework globe. Some have attributed this to his tipsy state but it was actually a signal that the sultan agreed, or disagreed, with the decision taken. With some sultans, it was a gesture that could mean life or death for a vezir. When the janissaries came near to mutiny over the execution of Süleyman the Magnificent's son Mustafa in October 1553, the sultan was forced to dismiss his Grand Vezir, Rüstem Pasha. He did so against his will because Rüstem was his son-in-law and also because his monetary acumen could not be matched. Kara Ahmet Pasha was recalled from the command of the army in Persia to become Grand Vezir but he had little talent for high office and, within two years, the monarch had found an excuse to dismiss him. It must be remembered that the term vezir meant 'bearer of the burden' and, curiously, also the queen in chess.

In September 1555 Kara Ahmet Pasha left the session of the Divan to report to the sultan in the Chamber of Petitions (Arz Odası) beyond the Gate of Felicity where he was promptly strangled by deaf mutes: the greatest office was papier mâché and few vezirs died in their beds. The silken bowstring was an honour reserved for royalty because royal blood might not be shed. The deaf mutes, spared last cries and unable to report what had happened, had death as their only duty as if clowning under the mask of life at court. Immediate execution was the custom. A little later, a vezir could be sent into exile but, most often, officers were sent to catch up with him and kill him on the road. His neck was already stiff from looking over his shoulder. It was Mephistopheles who, when asked why he was not in hell (to which he had been condemned for ever), pointed out that hell is here and all about us. Sparkling clean as it was kept, the smell of death lingered about the *saray*.

Selim II was the laureate of the many poets of the dynasty.
Known as Sarhoş ('the Sot'), among other humiliating nick-
names, he was not sober when he slipped and later died from
a fall in the hot room of the superb *hamam* which he rebuilt
for the pages in the Third Court. Iznik panels of the finest
period, 1572, are his monument and still have to find a fit-
ting home.

By now the visitor will be conscious of the oppressive
ceremonial of life at court, controlled by a monotonous round
of duties, and the sultans' seclusion when they were in resi-
dence at the *saray*. Sultans escaped to the garden palace at
Edirne which they could reach in seven days, hunting all the
way. There they suffered less from the clamour of the dis-
gruntled janissaries' cooking pots. In the early days of the
dynasty, princes went on campaigns and slept in tented camps,
a life they had always enjoyed. That lasted until the Ottoman
army was matched and then overtaken by the growing effi-
ciency of the armies of the European powers. Their training
put a stop to Ottoman victories, so there were no new terri-
tories from which to take awards for the senior officers. The
troubled years of Ottoman rule in Hungary make this clear.
The climax was Kara Mustafa Pasha's failure to take Vienna
when it was within his grasp in 1683. The nationalist winds of
the Balkans were soon to whisper.

The Divan usually sat on four days in each week, from
Saturday to Tuesday. Membership chiefly consisted of the
Grand Vezir, who wore the gold ring of the sultan and car-
ried the seal of his office in a green purse. There were gener-
ally four Vezirs of the Cupola, although at one time they
became as many as seven. Next in rank after the Grand Vezir
were the two Military Judges (*kadıaskers*): they were supreme
in their authority in the law under the mufti, and sat on his
right. The mufti was the head of the whole judicial system; he
would be consulted but was never permitted to attend meet-
ings where he might be a threat to the status of the monarch.
The execution or the deposition of a sultan had to be ap-
proved, or more or less approved, by the mufti. Sometimes
the great man cowered behind ambiguity. Thus the Chief
Justices of Anatolia and Europe enjoyed supreme authority

over all major legal decisions. Indeed, the Grand Vezir had no authority over the *ulema* whose approval he had to seek for any legal action. Nor did he have authority over the royal household, at least in theory, although officers of the household waited on him. Other members of the Divan who sat on his left were the Minister responsible for External Affairs, the Chief Secretary and, of great importance, the Treasurer. The Captain-General of the janissaries, because he might be called on to attend, waited in the arcade along with other senior officers. When, in the seventeenth century, it looked as if the dynasty might die out, the well-liked Giray Khan of the Crimea, who had been nominated heir in that event, attended the Divan regularly for a time.

Meetings were always over before 3 pm, when a banquet was served which was an extraordinary occasion. The Divan and any invited grandees ate a rapid succession of dishes on round trays covered in embossed leather cloths and resting on folding legs reaching to knee height. Seated in the hall itself, ambassadors might attend and even be given full-size but still round tables. If they hoped to hear gossip, they were disappointed partly because the vezirs may have been ill

The curious custom of the sousing of the Bailo, or Venetian resident, in the presence of the Grand Vezir

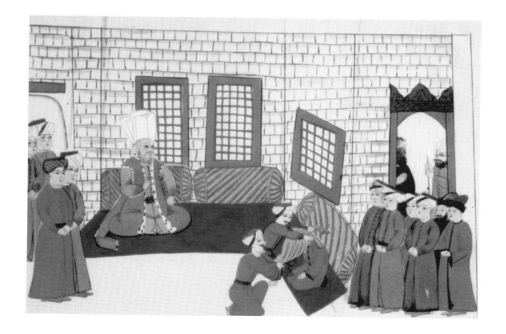

informed themselves and partly due to discretion. Meats and their sauces included partridge, which is still abundant in parts of Anatolia, and there were various vegetable dishes. Pilaf was the groom and any sweetmeat made of honey was the bride. The service was swift because the dishes were passed from hand to hand from the kitchen to the Divan Hall, where the feast was decorously served by footmen. It was presented in communal dishes and on ordinary working days was eaten with a wooden spoon.

Criminal cases did not reach the Divan, where every aspect of civil law was disputed. The petitioners, advocates and, if necessary, witnesses were fed in groups outside without ceremony; their dishes appear to have consisted of vegetable stew and some sort of pilaf.

The picnic may have been plain, but it should be remembered that hundreds, including wily intruders, had to be fed. Figures reaching thousands are improbable if only because of the lack of space. There is no reference to kebabs and one may suppose that the janissaries, who had their own butchers, ate meat in their barracks and canteens. Hospitality brings a sense of bondage in Islam, and the sultan's generosity would never lack lustre. Originally, the meals were served in handsome bowls but the temptation to steal a souvenir defeated the care of the officers in charge of the store and the food then had to be served in the crudest pots available: so cheap that it hardly mattered if they were lost. Guests at the giant picnic went to one or other of the fountains in the court to obtain water in the shade of the trees and drink from a gold cup chained to the basin. What happened to the gazelles during this invasion is not clear, however tame they might have been. It was all but a party except that there could be no conversation because a rule of silence after leaving the First Court was strictly enforced by chamberlains with supple white wands. Like many courts in Europe, the Ottomans developed a palace language as a defence against eaves-dropping outsiders but the deaf and dumb language was the one most important to acquire. Such rules did not apply to the notables since no chamberlain had the authority to rebuke them.

It is difficult to conjure up a vision of these picnics during

which dignity had to be preserved against all odds, including the weather, which in Istanbul come spring or autumn is unpredictable. Winds can bring the climate of the Mediterranean from the west, of the desert lightly cooled from the south, the indomitable rains of the Black Sea from the east or the bitter cold of the Carpathian mountains and Russia from the north. It can be a nipping and an eager air indeed; like iced pepper. In the houses, there were braziers or little charcoal burners on window-sills to keep out poisonous fumes, but in the Second Court of the *saray* there could be nothing. When the rain came, the portico on the kitchen side of the court was empty but hundreds of people could not cram into what was indeed the parlour of Ottoman public life.

Centuries of hardihood in Istanbul have passed and for some still endure. People struggled to survive plagues and mere fevers. To outlive childhood was an achievement. Many children of sultans did not but Ahmet I, fat and strong though he was, was the only sultan to die of typhus, at the age of 27. Most sultans died of apoplexy or gout or melancholia. The whole world faced hardship in the sixteenth century and people had to be stoic come whirlwind or high seas. However, it is hard to believe that even the toughest did not seek and receive shelter during one of those downpours that leave Istanbul afloat. Since umbrellas were forbidden to one and all because they could easily conceal weapons, some people at least must have sheltered under the eaves of the Middle Gate.

Ordinary citizens would be dressed quietly since signs of wealth were hidden from tax-collectors and a house, while splendidly furbished inside, would present a shabby exterior. Clean as the population was in the days when *hamams* abounded, compared with the bath houses of western Europe, a crowd was nevertheless a crowd. In the Grand Vezir Ibrahim Pasha's own Divan on the Hippodrome (now the Museum of Turkish and Islamic Art), eaves opened so that nothing was hidden from the public gathered in the courtyard beneath, the heart of which was sown with a vast bed of double violets which made those of Parma seem modest. Their intense scent mattered for the same reason that Cardinal

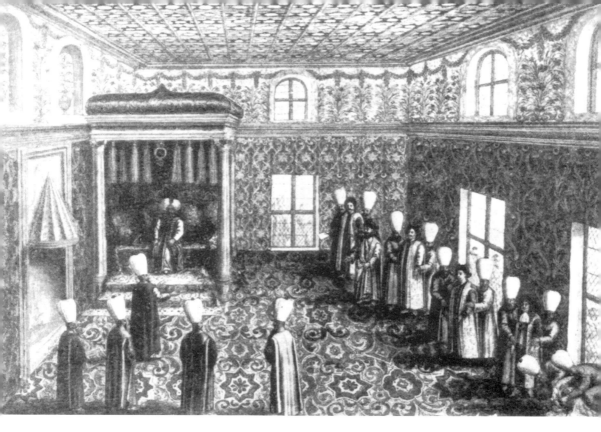

Wolsey, son of a butcher though he was, protected his nose with the open heart of an orange against the stink of the petitioners at the court of King Henry VIII.

Ambassador received in the Chamber of Petitions

Whether the Divan was in session or not, the album of Süleyman the Magnificent shows that, like the deer, peacocks were free to wander in this, the centre of palace life, but the greatest peacocks were the court. A number of grandees wore embroidered Bursa kaftans of red, blue and gold that remind one of the great heralds of Europe. These kaftans were embroidered with identical patterns, giving them the appearance of uniforms or else of gifts from the sultan as a reward for distinguished service. But there were many more kaftans with other colours and other designs as if from an array of fashion houses. For the three great justices, there were also the trains of silken Angora wool, watered and light blue, which would have made cardinals jealous. Even everyday robes gave a courtier dignity – provided that he did not smile. (To be dignified, a face had always to be grave.) Someone sitting near the Gate of Felicity, for example, might appear deep in thought

whereas wisdom was merely boredom and the mind was far away at home or hunting. Or it might have been soothed by drugs of which many vezirs consumed great quantities.

Hashish of the finest quality and subtly spiced may have been the curse of good government but it was essential for the peace of mind of many officers, who lived every day on the edge of the precipice of fortune. From time to time, drug dealers were rounded up and sent to the archery ground above the Golden Horn. The janissaries would then fetch school-boys to watch these traders being mauled by trained bears which appear to have shaken twisted white sachets out of them to fall like snow on the grass. Someone later would have had to gather the harvest and the drug trade continued. The last humiliation was the loss of a dealer's turban and the exposure of his shaven head. At least the boys would have been too frightened to laugh.

Rain or fine, the notables sat around the Second Court on benches hidden under red carpets waiting to render services which were seldom required, while others spent a large amount of time between one petty duty and another. Vezirs, great officers like the Master of the Horse and even messengers were indeed busy; only some of the thirty-nine senior pages attached to the sultan's personal service were equally occupied. But on state occasions like the rare reception of an ambassador from an important power, the court was alert and the scene splendid because fine rugs were hung in the porticoes. Against this brilliant background, whether the capitals were regilded or not, the columns were polished with rose-water and vinegar and then a cloth soaked in lemon to make them gleam. Magnified by a grandeur that would have pleased Mehmet II, the courtiers in their state kaftans and dazzling white turbans clearly impressed the most urbane of envoys. Mere republicans might have found the display akin to the Grand Bazaar. The ambassador had to wait in the guardroom of the Middle Gate while his open gifts were paraded for all to see, thus ensuring their splendour. After this, he was permitted to proceed with the cream of his entourage to the Chamber of Petitions in the Third Court. There his arms were grasped in case he meditated assassination but also to force him onto his knees

in order to kiss the stole of a silent sultan serenely masked by the 'scowl of majesty'. The ambassador then backed out of the monarch's presence as would happen at any court. He and his senior entourage were well dined since 1,000 crowns were allowed (of which the steward might keep a quarter).

The courtiers on their benches were not simply ornamental. They watched each other as allegiance switched from one rising potentate to another since the quick-witted among them divined probably, and no more than probably, where the future lay. It was the equivalent of the early-bird wisdom found today in the corridors of finance and industry. Out of earshot of the *saray*, gossip flourished although it was mostly tittle-tattle. This fed the ignorant if exciting reports of foreign residents, for whom the *saray* gates would never open. It was the Mad Hatter's version of the truth. One fact was paramount: power did not mean privacy.

The five daily prayer times divided the day punctually according to the rising and setting of the sun. There was, in addition, the Mehter band (the royal band). At set times they massed as many as forty instruments, from flutes and trumpets to the corpulent grand drums. Not allowed to desecrate the silence of the Second Court, they were massed on the battlements of an octagonal tower midway between the Kiosk of Processions and the Iron Gate beyond the Tile Kiosk. The Grand Vezir had the right to a smaller group of musicians and, like fleas, lesser pashas had still smaller; just as the sovereign had standards of nine yak tails while the most junior commanders had only one. The fortunate might progress to three or five, signifying that they were commanders-in-chief in the field.

Next to the modest Carriage Gate (Araba Kapısı), which is the entry to the Court of the Black Eunuchs and so to the Harem, is the entrance to the Barracks of the Halberdiers

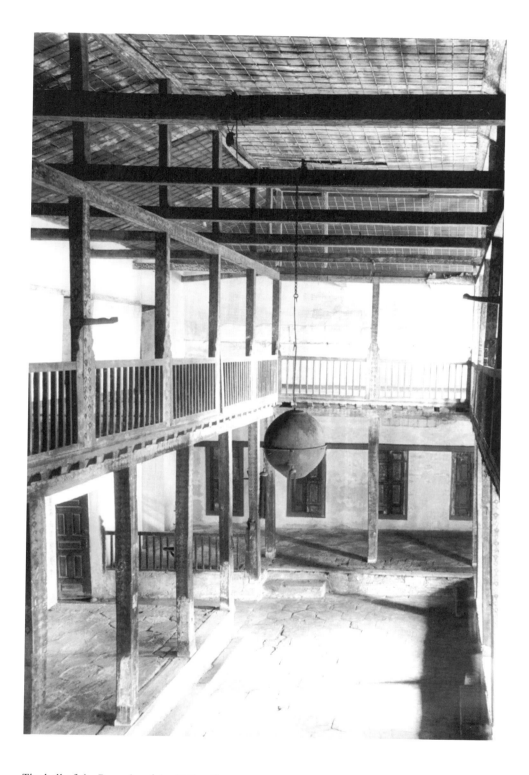

The hall of the Barracks of the Halberdiers

with Tresses (Zülüflü Baltacılar Koğuşu), with its fine inscriptive panel above an imposing door. Like the Outer Treasury, it is one of the original foundations of Mehmet II, who liked to keep groups together in order to build a team spirit. Murat III rebuilt the barrack hall towards the end of the sixteenth century. He employed Davut Agha, the most gifted of Sinan's students. Prudently, one of the wealthiest women in the harem financed the work because many costly projects at a time of inflation and recession presaged an even worse economic decline. But the hall, in fact, had to be enlarged rather than beautified.

Beyond the gate, a small courtyard is dominated by this new hall. The cupboards inside were for halberds and have survived along the entry wall, as have the broad galleries on three sides. They had to be wide because the soldiers slept on platforms surrounded by low rails. The groups were small but the platforms needed to be some 3.5 x 5.5 metres. (Those at the Ibrahim Pasha *Saray* when it was used as a cavalry barracks, however, were square.) With Edirne-style carving and painted green and gilt, they were indeed dashing. In the sixteenth century, however, barrack platforms were likely to have been soberly bedecked. There was sufficient space in the galleries and the floor below to sleep 100 men each without trouble. The centre of the ground floor was warmed by a brazier round which addicts smoke their *naghiles*, those splendid pipes with amber mouthpieces and long tubes through which the smoke is drawn through cooling water while the tobacco glows on a red-hot coal. The building of a smoking-room behind the hall presumably meant that the barracks air was clean. There is a modest prayer room across the cobbles with washrooms, a kitchen and a miniature *hamam*. When working on the restoration of the *saray* in the 1950s, the architect Mualla Eyupoğlu Anhegger had trouble with rising damp from blocked drains all over the *saray*. That in the barracks was filled with broken pieces of Iznik pottery, which suggests heavy-handed washing up but is evidence of the janissary corp's love for Iznik ware. Even castles captured above the Danube were panelled with it.

The duties of the halberdiers included carrying heavy goods

like coal and logs into the Harem and for this purpose there is a masked passage like the embryo of a maze leading into that of the Shawl Gate. This leads up an incline into the Court of the Black Eunuchs (Kara Ağalar Taşlığı). The halberdiers hid their eyes behind tresses which they were forced to grow each side of their faces and at the appointed hour they had to run to avoid any loitering with intent, although the girls were safely locked and shuttered in their rooms and dormitories. The halberdiers were also responsible for cleaning some of the sultan's rooms and the Divan Hall itself and it was they who polished the columns. They had other special duties. Twelve literate men attended the sultan on journeys, with thirty comrades as standard-bearers and guards while others carried the baggage of the harem ladies when the sultan went on an excursion. Not only were they coffee-makers but, surprisingly, at one period the literate among them taught young black eunuchs to read and write.

It is time for us to enter the Harem since no mutes are grimacing near the Carriage Gate. We shall visit the Third Court later.

The Harem

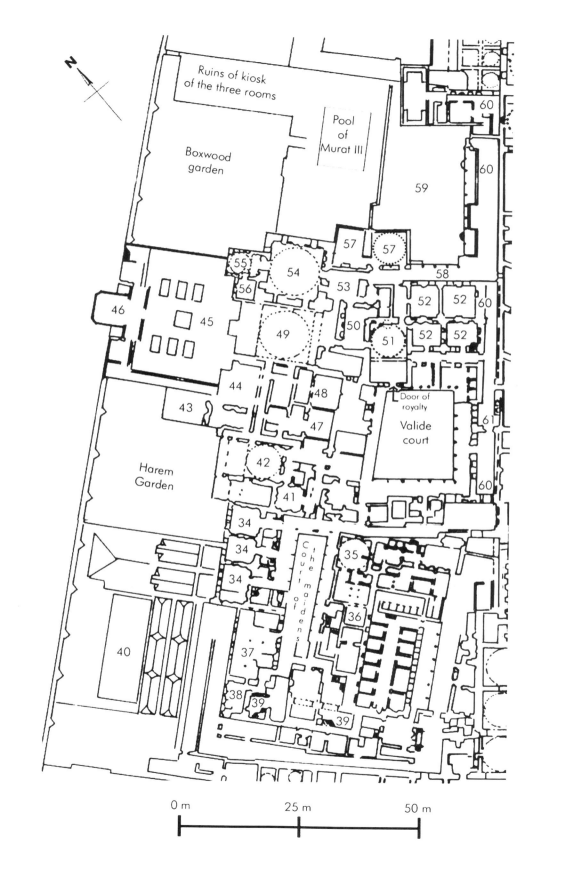

N

Ruins of kiosk
of the three rooms

Pool
of
Murat III

Boxwood
garden

59

60

60

57

57

55

54

58

56

53

52

52

60

46

45

50

52

52

49

51

44

48

43

47

Door of
royalty

Valide
court

61

42

41

60

Harem
Garden

34

34

35

40

34

Court of the maidens

36

37

38

39

39

0 m 25 m 50 m

The Chief Black Eunuch

In the apartments of Mihrişah Valide, late eighteenth century

The Ottoman kiosk personified, with water, strictly drilled garden and the wilderness beyond

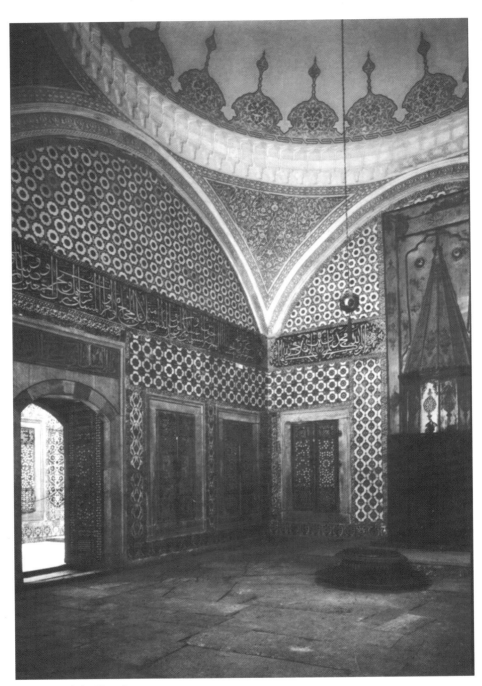

The Hall of the Hearth

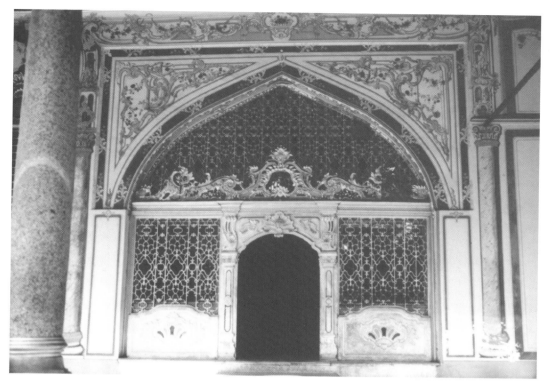

The entry to the Divan Hall

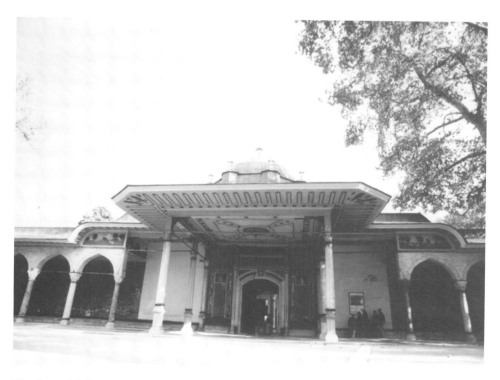

The Gate of Felicity. Note the idealized landscapes in contrast to the confines of the *saray*

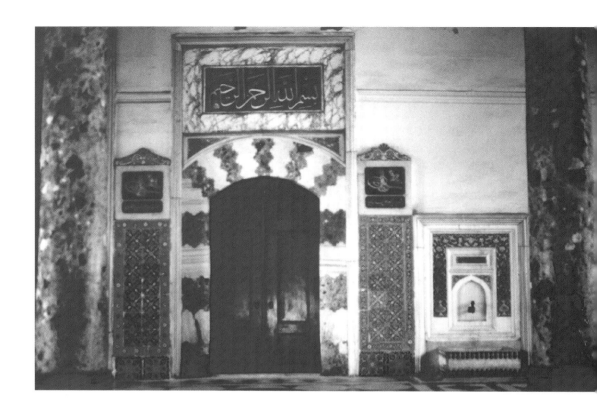

Top: The door of the Chamber of Petitions
Note the *cuerda seca* panels of tiles on each
side

Left: The perfect fountain of Süleyman the
Magnificent

The Harem

*Do not confine your love life to youths or women
so that either becomes inimical.*
(Kay Ka'us ibn Iskender, *A Mirror for Princes*)

Nowadays, the public gains access to the Harem through the
Carriage Gate (Araba Kapısı) of 1588, which leads into a mod-
est hall. When, in the late sixteenth century, the Chief Black
Eunuch rose to power over the White, it was here that he
held a weekly levee in his capacity as director of religious
foundations and charities. Many Europeans found lucrative
employment in the Ottoman empire. One from Lowestoft
endured gelding in order to further his career. As Hasan Agha,
he had strong relations with English Turkey merchants, show-
ing that the black eunuchs' ascendancy was not total.

The cobbled path indicates that the sultan would arrive
on horseback because this is not the actual entrance to the
Harem itself. It was only used by the residents when they
entered their narrow, closed carriages in order to drive out
on state occasions or when going to one of the many pleas-
ure palaces and pavilions along the Bosphorus or the Golden
Horn; or even as far as Edirne, a favourite residence for sul-
tans, some eight days' ride away. From this gate, the girls left
to take part in the procession of a new Valide from the Old
Palace to Topkapısaray with attendants scattering gold and
silver to the crowds. They also went to wedding feasts and
ceremonial festivities with mock battles, music and acrobats
by day and fireworks by night. On the great religious festival
of the Night of Power, they went to the Hippodrome to watch
the fun from their coaches while black eunuchs brought light
food, fruit, ice-cream and coffee.

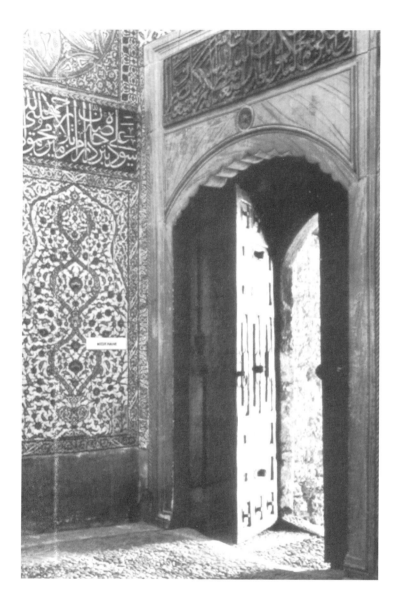

The Meskhane Gate
– open

It was difficult even for a woman to visit the Harem: she
would have had to pass through the Court of the Black Eu-
nuchs before reaching the inner gate. It was even more diffi-
cult for a girl to leave. One Chief Black Eunuch – who ranked
third in the hierarchy of power by the end of the sixteenth
century – was so strict that, when there was a fire, he refused

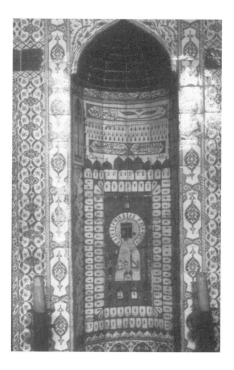

Mecca in the mihrab
of the Eunuchs'
Mosque, or *Mescit*

to open the doors to allow the women and their maids to
escape until an order was obtained from the sultan himself:
and only just in time. The slave woman who was accused of
causing the fire was hanged, in a sack in order to avoid ob-
scenities.

Minor fires were frequent but the major fire of 1574,
perhaps caused by sparks from the kitchen chimneys, gave
Murat III the excuse to enlarge the Harem and his own
apartment with a splendour that was never to be matched.
Bricks were dyed, gilded and silvered while domes and finials
were seemingly dressed in gold. Sinan and his student Davut
Agha summoned skilled craftsmen from everywhere,
including those working on the great mosque at Edirne. The
Grand Admiral of the Fleet (*kapudan paşa*), Kılıç Ali Pasha,
of a noble Sicilian family, took command of the galley slaves
who shouldered the heaviest burdens in the winter months
when the ships were laid up. Most of the work was completed
between the spring of 1578 and the autumn of 1579. The sultan

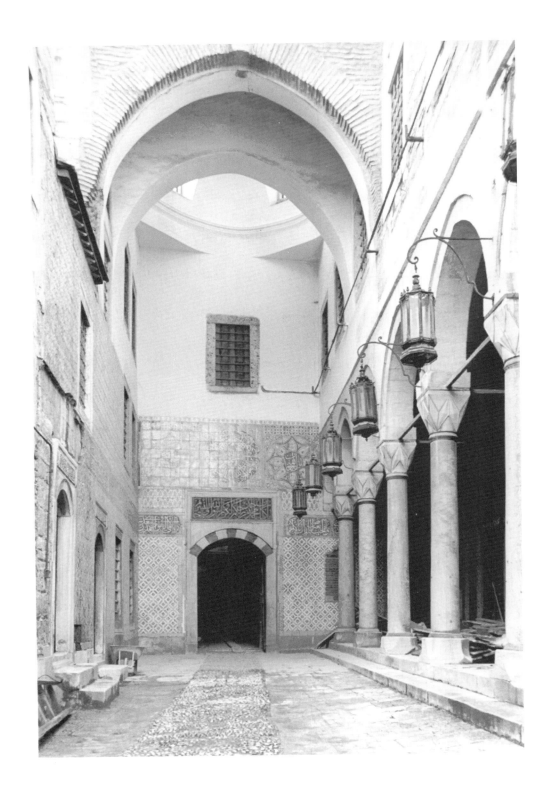

The Court of the Black Eunuchs

retreated to the Old Palace, a summer residence across the
Sea of Marmara, and also at times to the palace of his mother
at Yenikapı along the city shore towards the land walls.

Murat had considerable help from his mother's monthly
inspections of the work in progress. She was the remarkable
Nurbanu, born Cecilia Vernier-Baffo, the illegitimate daugh-
ter of Nicolo Vernier, who was governor of Paros and the
Cyclades from 1520 to 1530. She was captured in about 1540,
along with 1,000 other girls and 1,500 youths worth 500,000
gold coins in ransom. Even at 12 years of age, Cecilia was a
Titianesque beauty. She was also gifted intellectually as well
as having a strong character. The Grand Admiral, Barbaros
Pasha, gave her to Selim II while he was still adolescent; she
became his favourite, a position cemented when she gave birth
to the future Murat III, who inherited much of her Renais-
sance culture. After the fire of 1574, the inhabitants of the
roofless Harem were removed to the Old Palace but it seems
probable that Nurbanu was influential in the Harem's rapid
reconstruction. Murat left an imprint both on the Harem
and on the *selamlık*, the area where men were admitted.

The second great fire in 1665 was almost as disastrous as
the first and it is likely that the uninspiring Mehmet IV (1648–
87) (who lived as much as possible at Edirne) let his mother,
the Valide Sultan Turhan Hadıce, supervise the repair work
and decoration. She was a powerful woman in her own right.
The workmanship was good and the time taken remarkably
short. Mehmet had inherited the Ottoman passion for gar-
dening and enjoyed the freedom of the country. It was under
him that classification of tulips was brought to perfection.

The hallway leads into a large tiled vestibule. On the far
right is the sultan's door to the Tower of Justice, in which
was the room from which he looked down on the Divan in
session. On the left is the usually closed Gate of the Musicians
(Meskhane Kapısı) from which slopes a long alley which led
to the Gate of the Shawl (Şal Kapısı), past the *hamam* that
may have served the black eunuchs, the music school and
smaller rooms that had various uses at various periods.
Beyond the passage to the Barracks of the Halberdiers with
Tresses, the somewhat sinister gate to the Harem was reached

at last. If a harem girl died at night, she was covered with a shawl and carried through this gate below the stables into the park and next day to the place of burial. By contrast, the gate was also used by the sultan, more particularly when he rode back from Eyüp from his accession ceremonial when the Mevlevi dervishes girded him with the sword of Osman, founder of the dynasty. This is the reason for the large dismounting block next to the fine fountain; hence the name, Court of the Fountain (Şadırvanlı Sofa). Tiles are lavishly used but they are later seventeenth-century work which does not compare with Iznik ware of the previous century in either colour or design. The designs are nevertheless well drawn and an inscription over the door records the repairs attributed to the ignoble Mehmet IV – these were partly due to the fire of 1665 but also because Mehmet's appetites enlarged the harem. The circular tiles contain the ninety-nine names of God.

On the left of the Court of the Fountain is the Eunuchs' Mosque or, correctly speaking, *Mescit* because it was not used for the noon prayer on Fridays. It was in or near this spot on the night of 2 September 1651 that the Valide of Valides, Kösem Mahpeyker, was strangled with her own plaits by a janissary commander and the Chief Black Eunuch, signalling a revolution that petered out with her dying breath. Kösem had invented the office of Great Valide so as to prevent the mother of the new sultan exiling her to the Old Palace. Now, Turhan Hadıce had her revenge and Kösem went to her death aged 68, fighting as she had done all life long; she had earned the titles of 'Greek Daredevil' or 'the Goat that Leads the Flock'. She did not care if her sons were fit to rule and with Ibrahim, yet another lover of flowers, she made sure that he did not cling to power (which he was incapable of doing anyway) but that power clung to him. It is strange that a woman as sharp-witted as she did not care whether Ibrahim was deranged or not so long as she kept power. She showed no more loyalty to the house of Osman than had Murat IV, very much her son.

The shadowy interior of the mosque, since no lamps are lit, is bedecked with a fine seventeenth-century panel depicting the Ka'aba stone and the Great Mosque of Mecca, its

minarets, gates and line on line of lamps hanging beside the courtyard. There is no mimber, since it is not a Friday mosque, but the teacher's chair – inlaid in the finest tradition – stands on a dais while on the wall behind it is another panel. This shows Medina and the tomb of the Prophet but the colours have run amok in the firing and an array of cheerful, giant palm trees are in even greater disorder.

Entering the long Court of the Black Eunuchs itself, the visitor will note some closed doors on the right: behind them are modest, empty rooms which may have been used by white eunuchs concerned with administration and the education of the princes. When these rooms were repaired in the 1950s, human bones were found under the floor of one of them. For a time, they were a source of imaginative speculation which grew until it died in its own ordure. Today it is thought by some that the rooms may have been for dwarfs but they are the wrong shape and of disproportionate height. One only has to think of the apartments for dwarfs at the palace in Mantua where one trespasses with bowed head.

Opposite (on the left) is the large Barracks of the Black Eunuchs, usually forty but sometimes as many as seventy in number. It is three storeys high, with rooms each side of a narrow court. The walls of the handsome arcade are tiled and have large grilled windows. On them, engraved on marble, are lists of the sacred foundations administered by the eunuchs. Once rid of the surveillance of the white eunuchs in the late sixteenth century, due to the politically astute chief Habeşi ('Ethiopian') Mehmet Agha, the black eunuchs took over the administration of the Holy Places of Mecca and Medina. The slim gold inscriptions down the tiled walls record their authority.

There are some four to six rooms on either side at ground and first-floor levels. One or two are larger than the rest, which suggests they served special functions. At third-floor level, skylights substitute for windows which would have opened onto a splendid view. One may deduce that most of the thirty-one rooms were shared between two men unless the total number reached seventy. Inside, the rooms are tiled and the central space is long and narrow and dominated by a lofty,

hooded fire which could keep the whole place warm in winter. Here hangs one of the drums which were beaten to arouse the eunuchs each morning with sticks that the sadistically inclined prefer to believe were those used to punish miscreants.

It is true that young recruits were beaten and there were officers to keep watch over cleanliness and prayers. But eunuchs rarely retired – perhaps some knew too much – and the majority were middle-aged and dignified, while some were so old that their faces had shrivelled with time. If any of them offended, they were admonished and, if lucky, were sent into comfortable exile in Egypt where eunuch revenues and resources were considerable. For a new boy, perhaps the only one that year, promotion was slow and would depend on how many ancients died off each year. But when adults, they did qualify as superior to apprentices serving at the humblest level. These African boys passed through Egypt where they were castrated, entire, in Coptic monasteries at about 10 years old and were then sent to market in Istanbul and elsewhere. If chosen for the *saray*, they were given traditional eunuch names such as Hyacinth, Rose or Gillyflower. White eunuchs, on the other hand, were castrated in their homeland, mainly the Caucasus, Hungary and the Balkans. They were spared total eclipse or, to use seventeenth-century parlance, retained their yards.

Apart from those older eunuchs who devolved the most menial tasks onto the recruits, there were boys for whom other older eunuchs developed an affection that led to cuddling, curdled by frustration. It must be remembered, however, that emasculated men retain their emotions and there were bitter rivalries over the affections of the beautiful women whom they fervently served. Moreover, living together until death tended to magnify irritations from tiresome habits to minds twisted by humiliation. When freed after the First World War, palace and private eunuchs formed a colony on the heights of Çamlıca above Üsküdar with its Arabian Nights view of Istanbul. They were old and, because their faces were like crumpled paper, the cruel likened them to cats. Some had been in charge of children and retained affectionate relationships with

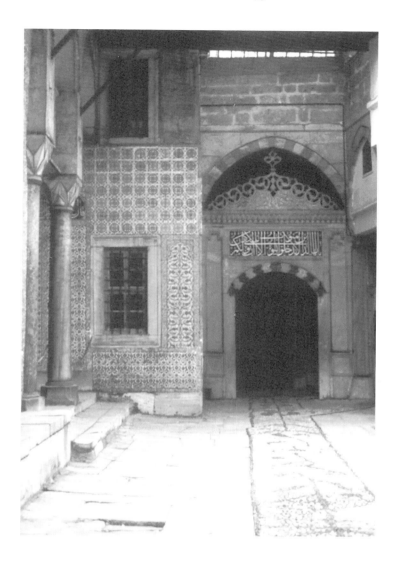

The Harem gate with
the apartment of the
Chief Black Eunuch
(L)

them. The new recruits in the barracks were presumably given
beds on the top floor with its attic windows but they shared
the most luxurious washroom with large basins and equally
large lavatories.

We are now approaching the actual gate to the Harem but
first we pass stairs on the left leading up to the ornate rooms
of the Koran School for Princes. This was built in the eight-
eenth century for sons of sultans to attend as soon as they
reached the age of 7. Previously, the boys had been tutored

until they joined the Palace School. Now that they were no longer sent out to govern provinces, after the future Selim II abolished this privilege because of the civil war between himself and his brothers in the reign of their father, Süleyman, they no longer needed a quasi-military education.

The two rooms of this preparatory school are richly tiled and have gilded baroque railings and other furniture, and plaster chimneypieces with lively decoration. Teaching was mainly in the hands of royal religious tutors, or *hocas*, who often became lasting friends of their charges after they had become sultan and could even hope to become the mufti.

From the lowest step in the hierarchy, we now come to the most senior post of Guardian of the Keys to the Harem. On his appointment, the new officer kissed the Master of the Harem or Chief Eunuch (the *kızlar ağa*), and then went to the mosque to distribute largesse. One such senior Keeper of the Gate was always in attendance on the sultan when he was in the palace so as to convey his orders to the Chief Black Eunuch. Each of the princes and princesses in one or other of the apartments in the 'Cage', or *Kafes*, was also attended by a tutor, or *lala*, who was also their warden. (Cage is a loose term. When princes ceased to be executed upon their eldest brother's accession they had to become prisoners, although eventually allowed increasing freedom, unless they were dangerous like the ex-sultans Mustafa and Ibrahim.) Before the relaxation of the rules in the eighteenth century, the princesses played together when they were under 10. For the boys it was 6 to 11 although they were not often circumcised before the age of 14. The eunuchs also had to supply guards for the harem at night and favourites served the Chief Eunuch as his valet, cook or coffee-maker.

It should be remembered that the true purpose of a harem was to ensure that a mother bore the sultan a son who was heir to the throne and that wives of future great officers of state were suitably educated. That a girl pleased a sultan was secondary to the duty she bore state and dynasty, especially at times when a dearth of brothers put its continuance in danger. Ideally, the sultan like any man needed fulfilment and a rescue from tedious ceremonial duties and the problems

of government, including the soothing of the enmities of ambitious men. The interests of the throne were seen as identical to those of the empire. That said, many sultans enjoyed intimate relationships with women with whom they were in love, as happened with Murat III and Safiye. Nothing could have been further removed from the Mongol attitude to heredity, which meant that children might be pledged in marriage before they were born. Ironically, one might say that Mongol wives were the equals of men because neither had any choice of spouse.

At Topkapısaray, chance dominated succession. The probationary girls were very young and while being schooled in reading, writing, music and manners, they were also instructed in sexual skills whether by older women or by precocious intimates. The flow of perfumes, the definition of eyes with kohl, the seductive carriage and the demure smile that was an invitation were all the result of training. Intelligent and beautiful girls were frequently the gift of a grandee seeking to please the sultan but some were purchased. Usually they went first to the Old Palace to be divided into two groups by the Valide. The majority remained there but good reports might lead to a girl being examined again as a possible candidate to join the girls of the harem. In 1499, during the reign of Bayezit II, there were eighty girls in the Old Palace and only ten in the New. But the numbers in the Old Palace were far greater in the seventeenth century although it is hard to believe that more than seventy or so could be squeezed into the Harem quarters at Topkapısaray. Both sections were schooled in preparation for their marriage to pages on their graduation.

It was again the sultan's mother who selected a girl when he wished for a new companion in bed and who, in the morning, informed her of her duties that night. There was also a gift from her son. The Court of the Maidens (Çariyeler Taşlığı) vibrated with excitement. Special clothes, until then an undreamed-of luxury, were sent to a private chamber while the girl was washed, pomaded and fêted all day by her harem friends who were as excited as she. It was the best loved of these who conducted the girl to the *hamam*. Evening came and she was left alone for the sultan to arrive and embrace

her. The mattresses were covered with velvet sheets of cambric from Damascus sewn in the Turkish manner to sheets of silk and cloth of gold. In winter these were covered by furs of lynx or sable.

It is important to remember that in Islam the act of love-making is of heavenly importance because it is creative and the nearest that a mortal can come to imitating the creativity of God. It is not something to be ashamed of but the contrary. In the *hamam*, the anointing or depilation of a member of either sex needs care and time. Sufi thought is devoted to the oneness of love but Sunni or Shiite Islam is equally aware of the sublime in intercourse.

We have now reached the main door to the Harem (Cümle Kapısı), which was well guarded by eunuchs and was also under the watchful eye of the Chief Eunuch or his deputy from a window immediately above this entrance. His well-proportioned but modest chamber had a nook for his coffee-maker and stairs up to his bedchamber. On the right of the Harem door is an appropriate seventeenth-century ceramic panel showing a garden of cypresses, hyacinths and tulips. Nobody entered the Harem without the permission of the *agha* or his deputy even if the visitor were a princess who was married and so living outside the *saray*. However, in the mid-seventeenth century the remarkable and tragic Kaya Sultan, who was married to Grand Vezir Melek ('Saintly') Ahmet Pasha, could not be gainsaid. She forced her way in to see the Valide, the senior vezir and the sultan himself. Most people were not daughters of a Murat IV and admittance took longer.

The most frequent visitors were the *kiras*, or agents, who were mainly Sephardic Jewesses with economic skills, refugees from Spain. Harem women also patronized them because of their knowledge of medicine. However, if no man might leave the *saray* unless he had somewhere to go, the women went to the Old Palace hospital and, later, their own

hospital in the Harem. A doctor's life was difficult since he could not look at a woman patient. Her groans and cries might well be ham acting. Pulses, however, could be taken at the wrist if it were covered in muslin. Surgery was another matter and it is unlikely that any harem woman suffered under the knife but only at the hands of midwives, who were deeply respected and carried a staff of office. Kaya Sultan had two, both with their hands up into her, killing her as well as the baby. Black women went to the Old Palace infirmary if sick and were lucky to live. Only black women who were considered old and ugly were chosen for the *saray* (deformities were welcomed): those who were young and beautiful would have usurped the position of European or Circassian concubines and all kinds of jealousies would have arisen. Those black women destined for the *saray* were transported through Cairo and Alexandria to Istanbul.

The *kiras* were in the service of the Valide and also of the whole harem. It was they who taught embroidery and dancing but, even more important for the women and girls, they went into town and purchased the necessities of harem life from combs and simple salves to perfumes, adornments and other luxuries. Since the harem women and girls were adequately paid, they could indulge in henna and powders and still save against the day when they might achieve a husband and so escape a lonely middle age at the Old Palace, or House of Tears. The great *kiras* wrote letters for the Valides, including some that begged presents from the Doge of Venice, Queen Elizabeth I of England and other monarchs in the west. Moreover, some Valides invested large sums of money in merchandise and greatly increased their fortune, while the go-between herself might do even better.

Success could lead to tragedy, however, as when a *kira* and one of her sons were torn to bits in circumstances engineered by the basest mob. Others were more discreet until their usefulness declined. By the eighteenth century, for example, eunuchs could go out and shop for women of any rank, returning with all manner of trinkets and perhaps with *papuç*, those dainty light slippers which were so important to Ottoman life.

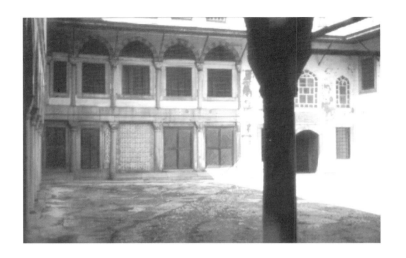

One side of the
Court of the Valide

Elizabeth I sent a gift of a wonderful cat that won a pres-
tige to rival the Valide's although nobody recorded why. The
Doge was admonished for sending big, long-haired lapdogs
which were not small and white as requested. When Nurbanu
was suffering from cancer, she requested a dozen Venetian
cushions – one wonders why Turkish cushions were not good
enough – but, sadly, she was to die four weeks later before
they arrived. On a previous occasion, she had asked permis-
sion for the son of her *kira* to run a lottery in Venice.

A great amount of space in these begging letters was given
up to claims for the power of the sultan, who was as lofty as
the sun. He also sat on the throne of the Abode of Felicity by
the decree of God and the 124,000 prophets of God. Corrup-
tion was universal and when ambassadors were given gifts to
send to their monarch, harem women dared to steal some of
them and, one might say, held them to ransom – a ransom
that the unfortunate diplomat was forced to pay.

Next we enter the true hall of the Harem. Depressed by
the aged floridity of the nineteenth-century mirror frames
and other furniture, we turn left into a plain corridor on the
south-west side of the Court of the Valide (Valide Taşlığı).
Through a window, the visitor may glimpse this court with
open colonnades, which is now sadly sober, but the secret of
the whole *saray*, and the Harem in particular, lies in its re-
stricted space. There was never enough room and in the north-

west corner opposite is a colony of homely looking rooms which hint at the problem, for it was once a handsome court with colonnades on all four sides. This luxury had to be foregone and the intervals between the columns filled in except on one side.

On the far right hand were the apartments of the senior lady, the mother of the first-born son; she was likely to become the next Valide Sultan. Her two or three rooms occupied first-floor level and there were slightly less spacious apartments for the three lesser mothers as well. Everywhere there is evidence of the damage caused by relicts moved out from the Old Palace in the nineteenth century. Quite apart from the hideousness of their decoration, valuable evidence is put in doubt. But one expects the senior wife to need more space than her juniors lodged in the same mansion since she would receive many more sycophants. The rooms behind her own apartment were allotted to younger sons, who had achieved a little freedom by the end of the seventeenth century although they were kept under constant surveillance quite apart from their spying servants. In the eighteenth century, Abdülhamit I (1774–89) was to encourage visits from the future sultan, Selim III (1789–1807). They discussed the possibility of reforming a state in disarray and an army famous only for its defeats. Defeat brought on a melancholia and despair which were to kill Abdülhamit while Selim's reforms led to his assassination.

At a higher level is the grim attic room which was believed to be the Cage of the mentally sick Mustafa I (1617–18, 1622–23) and, less likely, of the equally unstable Ibrahim I (1640–48). He lived under the threat of death until he succeeded Murat IV (1623–40) at the age of 26. So frightened that he had to see his brother's corpse to believe even his mother's report, and deprived of women unless hideous, Ibrahim's debauchery made up for the lost years of his youth – but did not quell his terrible headaches. Malicious gossip, not without awe, claimed that he could ride twenty-four girls in twenty-four hours. Perhaps.

Ibrahim's passion for sable and other fur had him impose a tax so that all imports were reserved for the palace:

The Court of the Maidens

merchants were ruined and over-trapping in the forests of Russia and Siberia was disastrous. The sultan also drank quantities of amber in order to calm his nerves – necessitating yet another tax. As if it were the 1960s, he wore flowers in his hair and behind his ears. Even an Ottoman court was shocked. His fall was inevitable and he was sent back to the Cage. But there were rumours that he had ministers – and his mother – scheming for his restoration, and within ten days, barricaded as it was, the door was broken down. Allegedly, Ibrahim went down on his knees begging for mercy until the mutes drew the silken cord tight and he was gone.

There is no window to the outside and the door opens onto a landing reached by a wooden stair. But the apartments of younger brothers are humane and on their far side look down onto the open Court of the Favourite Girls (Ikballer Taşlığı; eighteenth century) and the *Kafes* (seventeenth century), which the visitor will reach before leaving the complex. The overcrowding was due to the arrival of the harem in an area which once housed a mere handful of girls and servants. The hillside towards the park falls precipitously and new buildings had to be carried on formidable piers and monumental vaults. A whole world exists among these vaults since this was yet another space which could not be wasted. Part may have formed dormitories for the slave women and one bay with stone walls is said to have been the prison for such miscreants as the woman who allegedly stole Ahmet I's cradle.

A few paces lead to the much earlier Court of the Maidens, which is relatively long and narrow. It was built for Murat III, who was to have great need of women. Many of these girls came as virgin gifts from great dignitaries such as the Grand Admiral Barbaros, master of much of the Mediterranean in the sixteenth century. A pasha might find a splendid girl when on a visit to the slave market, which was strictly controlled by legal and treasury officials, and he would then purchase her as a judicious gift for the sultan. These novices might not spend longer than a year in the Harem since they were strictly educated like the pages and left the *saray* if they lacked ability. If sent away, they might with luck marry a

page who had also failed and been sent to the Outer Service as an officer in the cavalry or similar post. It was also possible for a girl to leave simply in order to marry a particular suitor. As we have seen, on their arrival at the Old Palace, the girls were all examined by the Valide Sultan, the most difficult examination of all. Normally, they graduated at the age of 25.

On the left side of the court are the kitchens, washrooms and *hamams*, and at the end of the first floor are two large dormitories organized in the same manner as those of the pages. Smaller rooms might also have been used but it is still difficult to see how a larger number of girls could have found space for themselves and the precious trunks in which they kept their possessions. They slept in beds set head to toe round the walls like a procession of dreams: or nightmares. One old woman watched over every 10 girls, who lived like nuns in the flower of their youth. She could do nothing about jealousies and malice from which a girl's only permitted escape was to marry a man of modest rank whom she had never seen before: or he her. As for the travellers' tales of 2,000 houris, one may safely divide by 20 and deprive sensationalists of their fertile imaginings of strap-hanging orgies.

Senior officers of the harem were the Mistress of the Robes, the Mistress of Ceremonies, the Valide's Taster and, most important of all, the Treasurer, who enjoyed great power because her mistress had her own state revenues and a plethora of other resources. These officials were housed in lodgings on the right side of the court, each of which had fine views of the city. Some scholars believe that these apartments were assigned to the four wives (although they were not actually married) of the sultan. These elegant lodgings were graded by size, but each of them had a hall off which were private washing facilities – a very real privilege – and a staircase up to the balcony which overlooked the adequate and certainly richly furnished domed salon.

Between these lodgings and the dormitories, a broad staircase leads down to the Harem hospital, which may date from two periods. Certainly, it was in use during the seventeenth century. Originally, sick women and pregnant mothers were

sent to the Old Palace, which probably became inconvenient, but there were certainly busy wet nurses in the Harem. The hospital is remarkably large, with service rooms which include kitchens, a *hamam* and a room for the laying out of the dead – so there had to be access to the path that leads to the Gate of the Shawl. The wards are divided, as in the pages' hospital, according to malady and also rank. It is a fine hospital but it certainly sequestrated much of the Harem garden. The staircase is known as that of the Forty Treads but there are, at least nowadays, over seventy.

This magic number occurs again and again and *kirk* (meaning 'forty') also means infinity in Turkish. It occurs, of course, as a symbol in most cultures – one has only to recall the forty days and nights in the wilderness, the expression 'forty winks', Alaettin (Aladdin) and the Forty Thieves and so on. The symbolic number was powerful indeed. Murat II (1421–44, 1446–51), the Sufi father of Mehmet II the Conqueror, was given a special copy of *The Mirror for Princes*, composed by Kay Ka'us ibn Iskender. In this the limits of life are set at 40, when a man's powers decline and the monarch should abdicate. Murat did exactly that and retired to a Sufi monastery, but Mehmet was too young to rule and Murat was recalled to put the state in order and lead the troops to victory. He was sultan for the remaining four and a half years of his life.

At the end of the court and above its roof is the kiosk of Ahmet I: it is of symbolic importance because this sultan finally abandoned the solemnity of the Royal Pavilion, or Pavilion of the Holy Mantle (in the Third Court), for the convenience, pleasure and privacy of making the Harem his home. Ahmet came to the throne at the age of 13 and was only 27 when he died. It is his mother, Hamdan Valide, of whom one would like to know more. It may have been she who stopped the custom of the execution of brothers, and one might suppose that she was a dominating personality. On his accession, Ahmet was impatient for her to be rescued from the Old Palace, but as he grew older she may have been too severe a restraining influence on an adolescent whose private life indeed called for restraint. Or there may have been political intrigue. For whatever reason, she was executed,

less than two years later, on 26 November 1605, when at 15½ Ahmet was already an adolescent. Interestingly, as if he preferred strong-willed women, he married the most formidable of Valides, who was four years his senior. We have already seen the corner where Kösem Mahpeyker was strangled. Ahmet's second wife was the mother of the tragic Osman II (1618–22) but, perhaps fortunately, she died before his murder. Kösem was also for some years the regent of Murat IV and it could be argued that this pugnacious tyrant did more harm to the Ottoman empire than even Mustafa I.

Ahmet I was said to have three passions: women, hunting and God, in that order. He took delight in yielding flesh and the country was scoured for a woman fat enough to please him. The Armenian who was eventually carried to the *saray* was said to weigh well over 88 kilograms. She could not do much else than submit to Ahmet and was doubtless rewarded until the Valide had her strangled as a monster. Happily, she had borne no children.

Ahmet's devotion to God led to the building of the huge Sultan Ahmet Mosque, which dominates the Hippodrome. It caused great ill-feeling because of its cost at a time when the economy was in tatters and the sultan's subjects in great distress. Even the *ulema* turned against him and beat him, so to speak, with each of his six minarets which they declared sacrilegious because that was the number of minarets at Mecca. Either they knew that they were lying or else none of them had made the pilgrimage to the holy city, which at that time had seven. Hostility did not deter the sultan, who came himself to help dig the foundations and speed the work. Wisely, because he only just lived long enough to see it completed. He died of typhus, one of the recurrent plagues of Istanbul, on 22 November 1617. Although the cramped conditions of the *saray* were unhealthy, he was the only sultan to die of this or any other plague.

We should now return to the young girls, recruited for their beauty and wits. Like the pages, they were paid quarterly and collected valuables in their chests to use as dowries if they went to the Old Palace. There is evidence that some of the rasher girls used a *kira* in order to indulge in speculation

and lost their savings when, often enough, they were sucked into the drains of fraud in the seventeenth and eighteenth centuries. They had servants, who may account for the exaggerated number of young beauties. Sometimes their numbers were very low since a sultan like Süleyman needed none at all for his bed but only for their talents as musicians and singers. (All his life he was devoted to his wife Hasseki Hürrem, known as Roxelane in the West.) They came under the deputy Treasurer. Every job in the *saray* had its officer in charge, from barbers to *hamam* attendants, stokers of *hamam* furnaces, laundrymen and laundrywomen. The harem also had governesses for the children and so on.

The girls supplied their own amusements, as well as the sultan's, and some became proficient instrumentalists, dancers and singers. All appear to have been fine needlewomen. That they were trained in pleasuring the sultan, an honour that they were unlikely to achieve, is more than probable but their abilities and agilities were an addition to their dowry if they married a former page or even a total outsider. In 1599 Queen Elizabeth I sent Thomas Dallam with the gift of an organ. This he set up in the colonnade of the Fourth Court and so had the chance to peer through a grille and watch the girls at play in the Boxwood Garden.

Dallam describes the harem girls as wearing little caps of gold cloth with plaits down their backs which ended in tassels of pearls. They had jewels on their breasts and in their ears. Along with red or blue coats, translucent breeches of fine English cotton reached Cordovan buskins with a gold ring round each ankle. Their velvet *pantoufles* were some 2 centimetres high. And then Dallam's prying ended suddenly because it meant death for his guard were he discovered.

On the death of a sultan, those girls who could not find a husband had to go into exile at the Old Palace under the old Valide to make way for the heir's harem although some may have been retained by the new Valide if they were virgins. She might have known them well when she was the senior mother. If not, and even if their dowries brought no sparrows to the crumbs, the food was good. At one time the harem at the Old Palace had 205 cooks, most of whom were pensioners, and 57

sweet-makers. And there were 251 halberdier cadets to do the heavy work. The grounds were large until Süleyman took half of them for his complex. The gossip was as spiced as curry.

For a great Valide like Safiye, the love match of Murat III, life must have been intolerably boring. Even her half-finished mosque had to be abandoned. She and Murat had lived happily as if man and wife until she was 37, by which time only one of her sons had survived: Mehmet III (1595–1603). Nurbanu Valide made it clear to her son that promiscuity was his duty so as to ensure the succession. He could only obey and his mother presented him with a panorama of beauties by whom he sired nineteen more sons. Mehmet survived, however, and all his half-brothers met their destiny in death, which roused the population's disgust and eventually brought an end to the system. Safiye may well have enjoyed her newly quiet life and a rest from her virile husband, whose sexual life became an obsession. The nineteen boys were led to the Circumcision Kiosk (in the Fourth Court) for the necessary decapitation of their foreskins for the good of their souls, kissed their half-brother's hand and immediately entered the anteroom to be strangled with the silken cord still warm from another boy's neck. At what age, one wonders, did young princes know their tragic destiny? In their late teens, certainly – but as young as 10, the age of one of these victims?

Safiye is said to have been a present to Murat III when he was 13 and learning the rudiments of rule as the nominal governor of Sarahan and also, as it turned out, of love. She was born in 1550 and so was only 16 when she gave birth to Mehmet III and became the leading lady. She had extravagant tastes and her correspondence with Elizabeth I of England resulted in a flow of gorgeous gifts, including garments of gold cloth, jewels to fill a Christmas tree and a coach which was the wonder of the court. The paper on which she wrote her first letter to England was of pure ambergris with ink of the finest musk: the quality later declined. One source claimed that she was haughty and quick-tempered with all the bad traits of an Albanian but that she was witty. Later, the Venetian envoy declared her to be prudent, wise and patient. One may note that when Ahmet I succeeded upon the death of Mehmet

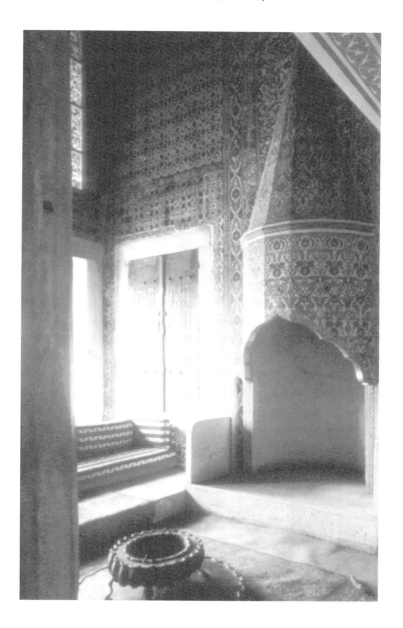

The withdrawing-
room of the senior
ladies

III, he could not dispatch his grandmother to the Old Palace
quickly enough.

For the daughters of the sultan, life was different and
mostly worse since mutual love was not a consideration in
their marriages. Because they usually wed powerful vezirs who
were much older than themselves, they often married more

than twice. Such marriages were intended to entwine poten-
tially dangerous men with the royal house but the intention
does not seem to have been reciprocal since bridegrooms were
often executed: indeed, in a few cases, this was as soon as the
following year. These stories amuse but only if one forgets
that the heroines were human beings. With some exceptions,
the sons of such marriages could not seek preferment and
were not even members of the royal family.

There were happy marriages, however. In 1717 Fatma Sul-
tan had been the widow of a Grand Vezir when she married
Damat (royal son-in-law) Nevşehirli Ibrahim Pasha. (She had
first married as a child and her husband can hardly have
known her since she was only 13 when he died. The cruelty in
this was that her husband had been forced to divorce a wife
he might have loved, and by whom he had had a family, be-
cause a princess had to be the only wife.) Ibrahim Pasha came
from a modest clerkly background in the provinces and grew
to be the boon companion of Ahmet III, having enriched his
education in the capital. Fatma was widowed by the mob when
Ibrahim was 64 and she was 26. But this remarkable man,
who had opened the state's intellectual portcullis to many
western influences, had so completely won her heart that she
fought bitterly for his ideals and was kept under house arrest
until she died three years later aged only 29.

Her sister, Saliha, was first married at 15 to be widowed
three years later. At 23 she married Sarhoş ('Drunkard') Ali
Pasha, who died when she was 29½. She then married the
foremost administrator from the new class of trained civil
servants, the Grand Vezir Ragip Pasha, aged 59, who was cer-
tainly a change from the alcoholic Ali. He died in 1763 and
the next year Saliha married for the fourth time. After six
years she was widowed again, leaving her to the peace of
widowhood until she herself died aged 63.

The stories of these two princesses are fairly typical, as
was that of Ahmet I's terrible daughter, another Fatma, whose
mother was Kösem Mahpeyker. Fatma married the Grand
Vezir Melek Ahmet Pasha in 1660 as her fourth husband
after he had lost the devoted Kaya Sultan. She brought 300
servants with her. Fatma was born in 1605 and first married

at 19; she divorced the man seven years later – perhaps for a more attractive groom – and got through six husbands in all. A few other princesses also married as many as six men, but most of these were decapitated sooner or later and some they hardly saw.

A royal marriage was a magnificent affair, with the wedding gifts having a procession of their own through the city, bedecked and escorted by grandees and military officers. Not only were the girls in the Harem allowed a day out to accompany the bride on her wedding day, but a number of the women slaves were given their freedom early. Manumission also followed on the circumcision of princes or the recovery of the sultan from a serious illness.

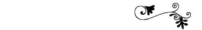

We now pass the withdrawing-room of the senior ladies. This is a perfect example of an intimate Ottoman room. On three sides of a small window bay is a sofa raised on a platform, while the rest of the room confronts a very large hooded fireplace. The woodwork is not inlaid, as is so much in the royal apartments, and the glass, as everywhere, is a replacement in vivid colours. The tilework is contemporary with all the rest, due to the rebuilding of the Harem by Mehmet IV, except for the fireplace where the hood is painted in a modestly successful imitation of ceramics as an economy measure.

The next room is the heart of the matter. The salon of the Valide Sultan, it is a fine but by no means enormous room which was restored after the 1665 fire by the Valide Turhan Hadıce, who had conspired successfully to be rid of the overbearing Kösem, whose corpse, so to speak, we have already met outside the Eunuchs' *Mescit*. It is hard to believe that Mehmet IV would have wanted to waste time away from his hunting when his strong-willed mother had ideas of her own. The fireplace and the tilework are as good as any of the period in the Harem and this is equally true of the marble

fountain of the oratory and bedchamber which can only be glimpsed through the door. This is a pity because the design of the tile panels reaches a new height and there are a number of delicate details such as the bottle glass deep in the plaster of the skylight which softly admits the morning into the chamber.

Here we must turn to Mehmet IV once more. Sultan at 6 years old, he watched the Grand Vezir Tarhuncu ('Tarragon-Seller') Ahmet executed before his eyes when he was 11. The great reformer was overthrown by rivals who hated the new

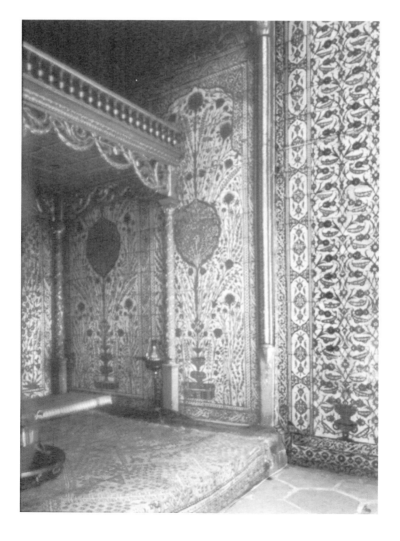

The oratory and bedchamber of the Valide

taxation and the purging of malefactors from the court. The boy grew uneasy and fixed his fears on his brothers as potential rivals to the sultanate. By now the formidable Köprülü Mehmet Pasha was Grand Vezir and neither he nor other ministers had any respect for the adolescent so that when Mehmet demanded that the princes should be executed he was dismissed with contumely. He procured a knife and, surprisingly, was able to make his way through the Harem to his mother's bedchamber where, worried by her son's moods, Turhan Hadıce had hidden the boys. The Valide surprised the would-be assassin and argued him out of three murders.

The youngest brother, Selim, died when he was 25 but Ahmet II and Süleyman II (1687–91) lived to make Mehmet's abdication possible when in 1687 the army had had enough of his extravagance. He died of gout and melancholy – or was poisoned. Süleyman II died of dropsy in the third year of an inglorious reign, to be followed by the pointless alcoholic Ahmet II: except that he was an adept coachman, like the Duke of Edinburgh. He lived for three and a half years and added apoplexy to dropsy and depression. But on occasion one serves one's country better if one is useless. Both sultans made Edirne their home. Ahmet had achieved four children after being freed from the Cage but none of them survived him; Süleyman had no children at all. It would seem clear, and hardly surprising, that years in the Cage reduced fertility.

From her salon, the Valide reigned over her domain. Here she received her son each morning, and then the Chief Eunuch, before anyone else so that the administration of the harem was coordinated. After this, she received women of her entourage who might have petitions to present or favours to ask. There were also those whom she herself had summoned to be awarded punishment for neglect or misconduct – or rewards – according to the girls' desserts. Or else she might indulge in selecting potential bedfellows for her son. These women or girls came into her presence dressed in their finest robes, with eyes averted and hands crossed, and it would never have occurred to any of them to sit in her presence.

The room measures some 11 x 7.5 metres, which is the

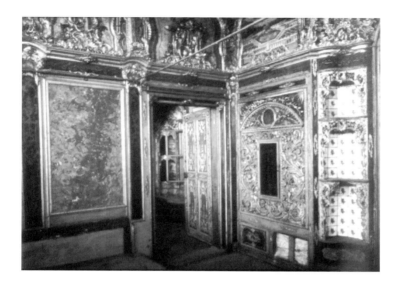

The apartments of
Mihrişah, Valide
Sultan, in the late
eighteenth-century
taste

diameter of the dome. The decoration depicts, light-heartedly,
vines and grapes with the crudeness of nineteenth-century
Italianate splendour. It is something of an affront to the tiles
and to the fine inlay of mother-of-pearl, ebony, tortoiseshell
and bone, of the doors and shutters. Of the glass, little can be
said. Above this salon are the apartments of Mihrişah Sultan,
which are not open to the public. These were added in the
late eighteenth century by the mother of Selim III. The deco-
ration is of good craftsmanship although it blossoms and
blooms with heavy baroque and rococo plasterwork reflected
in fine mirrors over a fire that has almost lost its hood. There
are also jejune frescos of kiosks with their formal paved gar-
dens, while behind a wall is the free landscape (like the Euro-
pean concept of the wilderness) which would have provided
relief for inward-looking eyes. The plain glass was cut to fit
the undulating caprices of the frames. They also carried thin
rococo bands of leaves, casting elegant shadows on the glass
above which they were set. They outshone the clumsy col-
oured panes that dominate so many rooms in the *saray*. When
the Valide Sultan moved upstairs, the old salon can have been
little more than a waiting-room.

On leaving this chamber, the visitor passes the closed doors
of the rooms of Selim III and Abdülhamit I. The fashion set

by Ahmet I had led to sultans adding chambers in the Harem for their own use. These have been assaulted by the worst paintwork of the late nineteenth and even twentieth centuries: as if to emphasize that the great palace was now the House of Tears or, less melodramatically, of chess or bezique. One room had not been enough for Osman III (1754–57) in the middle of the eighteenth century. In his short reign, he extended the vaulting over the Harem garden by means of piers, trampling it to death like giants in seven-league boots in order to hoist a terrace and a large pavilion as well. The high-spirited girls, however, were allowed to frolic in the park and in the no longer extant small kiosks scattered about the Tile Kiosk. The amount of wood and glass used, with a French elegance, in the construction of Osman's pavilion gives a false impression of frailty. When the garden of a now somewhat arid terrace was laid out and tended, Osman III's pavilion epitomized the ideal eighteenth-century Ottoman kiosk reflected in the wall paintings in the Valide Mihrişah's apartments.

Osman III closed the cafés and regulated the dress of non-Moslems, though he proved unable to discipline the janissaries. This resulted in terrible fires in the city in 1755 and 1756 because the janissary firemen spent their time pillaging when they should have been fighting the flames. Osman dithered through six Grand Vezirs in two and a half years but then, happily, towards the end of his reign, appointed Ragip Pasha who proved the best minister for many years. Osman also closed the streets to women because he liked to walk about the humbler quarters in the evenings and talk to the men, who presumably were busy fetching the water from the fountains. Sadly, he was ugly and deformed with his head on his shoulders, one of which was higher than the other; he died of apoplexy at the age of 58.

Osman's pavilion is reached by a long corridor from the Harem lit by windows all the way to the central chamber, flanked by anterooms, and which rides outwards on a giant surfboard for a console. All was white and gold with panels of *trompe l'oeil* plasterwork. The apartments are now closed but *trompe l'oeil* of the same quality can be found in the gallery

of the mosque of the New Valide Sultan (Yeni Valide Cami'i) at Üsküdar.

Returning to the Harem, there is a slender corridor just beyond the Valide Sultan's salon which is lofty and pleasingly lit by hexagonal skylights, like those of the Valide's bedroom, and with pretty eighteenth-century flower paintings on the doors. By it one reaches the twin *hamams* of the Valide and then the sultan on the right. These were completed in 1585 but completely reappointed in the eighteenth century – perhaps several times because their styles slowly change. This may have been when the Iznik tiling was replaced with marble. Each *hamam* is of three sections of moderate size. The sultan's disrobing room also contains his water closet whereas that of the Valide does not. The carpeted disrobing platforms, with their costly cushions of Persian brocade, are gone. Through the cool room is the capacious, domed hot room.

The sultan's *hamam* has a deep marble bath in the centre of the far wall and a grilled area on the left which was personal to the monarch. All the appointments, including the grilles and taps, are lavishly and heavily ornamented. Silver *hamam* bowls and other utensils must be imagined, as must the highly trained masseurs and other attendants who, according to sex, washed the sultan or his mother.

A *hamam* is inevitably a social centre even today – let alone in Ottoman times, when it had such sexual significance – because there is need for companionship while heat relaxes the tongue as well as the muscles. In public *hamams*, women would bring food as well as their children in order to spend the day, unfettered by the ears of men. One may suppose that the Valide in all her grandeur wished for the company of a few of her great ladies and perhaps a child or two, just as the sultan might select the most intimate of his companions to be his guests, as well as one or two of his sons. What was forbidden was that he should be attended by women and break a social taboo as rigid as a religious law. The Valide – or the sultan, in some cases – was less concerned about lesbians or the homosexuals who were a part of Murat IV's youthful indulgences. The sultan would be waited on by some of his pages, including those who were attending him as masseurs, but all thirty-nine could hardly have crowded in. At the end

A corner of the sultan's *hamam*

of the corridor, and dividing the Harem from the *selamlık*, is
a door that no male other than the sultan might use. Conse-
quently, there is a small lobby outside the sultan's lavatory
with another door into the sultan's hall or, in effect, his throne
room. By this door, the pages could enter or leave the *hamam*
without breaking the taboos of the Harem.

It is by this route that the visitor now reaches the Hall of
the Throne (Hünkar Sofası). It was used for formal meetings,
by men as well as by the girls, but never together. On the far
left side is an arcaded platform; a music gallery above it,
reached by stairs in the wall, was added by Osman III in the
eighteenth century. Here the girls danced and sang before
their sultan. When male voices were required, pages are said
to have been admitted blindfolded but the only recorded
witnesses are the imaginations of libidinous travellers. Tips
to hirelings produced all that the travellers wanted to hear
although these minions could never have visited the Third
Court, let alone the Fourth. It was not that the sultans were
virtuous. Ibrahim, for example, had such carnal yearnings in
the Cage that they surely account for his rampant years of
excess when he was freed. But there was a place for everything
and sex was not for throne rooms.

The hall has a fine dome, 9.75 metres in diameter, which
is attributed to Sinan because the room was built for Murat
III in 1588. Apart from the intrusion of a room in one corner
and a chimney shaft, it is a very grand space indeed. It is
possible that it was the work of Sinan's finest student, Davut
Agha, who was certainly responsible for much of the work in
the *saray* – the more so because in the year the work was
finished, his old master had lived 100 Muslim and 96 Chris-
tian years.

The decoration is another matter. Although not of the
quality of sixteenth-century Iznik work, a frieze of inscrip-
tive tiles rides along three sides of the room and is not en-
tirely out of place. Nor are the three fountains. Below them
is a host of pretty Delft tiles in blue and white which may
themselves be copies from Italy. The floral paintings on the
eighteenth-century doors echo those of the *hamam* corridor
in the Harem. Such furniture as there is belongs to several

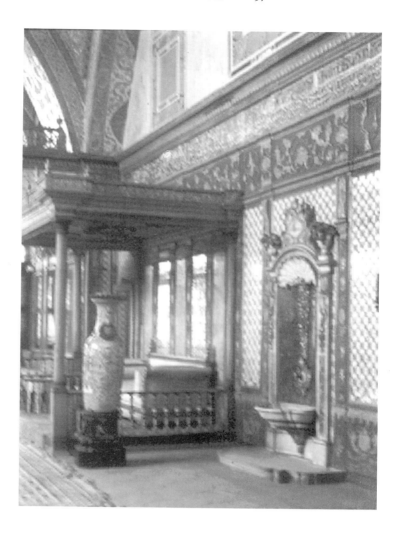

The throne, now a
sofa

periods. All of the gallery is the work of Osman III, who
excelled in being up to date.

Until the 1950s, the dome and its four great arches were
covered in that deplorable red paint with which the visitor to
Istanbul has become familiar. It was work that Mehmet V
Reşat ('the Virtuous') even continued from 1909 to 1918 when
the empire was in desperate need of money. The directors of
the museum have wonderfully restored the original paintwork
of red and blue and a delicate gold to designs that are as
pleasurable as they are mystic. The dome itself had to be rebuilt

rather than repaired and the wooden lining replaced because of wet rot. But the negative handling, like a host of hints, is a workmanlike compromise.

There have to be mirrors and various unfortunate gifts in 1898 like the rococo fountain of Wilhelm II and his vulgar chair or throne, which is revealing of his mentality but has nothing to do with anything Ottoman. Its legs are gilt-winged lions and its back a crushed eagle. It is only one example of a set. There are also the usual Chinese exportware vases, man-high and distant and illegitimate cousins a hundred times removed of the great vases which ennobled the halls of the Alhambra. The Chinese themselves must have been glad to be rid of them but at least they stand with the dignity of a courtier – and are equally hollow. When the floor was lifted during the restoration work in the 1950s, rings, seals, coins and papers were discovered. They had been brought there for safe keeping by the royal mice.

We know the use that Murat IV made of this grand hall and it is likely that he was following on the heels of tradition. One evening saw a reunion of mullahs and other holy men. Others were given to poets, philosophers and the military, and only one was spent with music and dancing boys. For a time, Murat favoured Evliya Çelebi, who has left an exact account that there is no reason to disbelieve. He was so pert a young man that the terrifying Murat called him a braggart, but he succeeded in making his sultan laugh. He was ordered to sing and there was a curious ambiguity in their relationship which was risky for Evliya. He chose to play one of Murat's own laments for a friend of his wild youth and a tear was seen in the royal eye when the sultan reproached Evliya. However, his modest cap was replaced with one of sable as a sign of his sovereign's favour.

Leaving the Hall of the Throne by the public door, and not by the private door beside the throne which leads to the cabinet or dining-room of Ahmet III, the visitor enters the Hall of the Hearth (Ocaklı Sofası). In this area of the *saray* the fittings, above all the inlaid doors and shutters, are the finest examples of Ottoman craftsmanship. The tilework in the Hall of the Hearth, including the inscription, dates from

the period of Mehmet IV and it is worth noting the floral
background to the elegant and lively script, giving it a sense
of agitation which contrasts with the confident mood of the
sixteenth century. The copper-gilt hood of the fireplace and
its frame reach to the dome and in its polished splendour it
is a faint echo of Seljuk triumphal entrances.

This is a good room in which to pause and consider the
size of the stone flags of the floor now that they are not masked
by carpets or matting. It is a statement about strength and
durability which is echoed by the more polished surface of
the Hall of the Fountain (Çeşmeli Sofası). Opposite the fire-
place is the door of the Hall of the Throne: this was the en-
trance from the Court of the Valide and was also the door by
which the ladies of the harem proceeded to the Hall of the
Throne on ceremonial occasions. On the south side is an-
other door which opens onto a corridor leading directly to
the Golden Road (Altın Yol) by which one leaves the Harem.
Off this corridor are the apartments of the senior mothers of
children of the sultan. These cannot be visited. The passages
and some of the rooms are lit by skylights and the whole area
is full of individual staircases for each apartment and their
service rooms. Another door, to the right of the fireplace,
leads to even more interlacing stairways. I was once taken up
one of these to the attic room that purported to be the Cage
in which Ibrahim and Mustafa I were to spend long years.
Today, a large and well-appointed chamber is judged to have
been Mustafa's, along with others of princes lodged above
their mothers' apartments. When Mustafa was freed, he had
not eaten or drunk for three days and was too weak to ride.
He had to be carried to the Chamber of Petitions in the Third
Court to receive an outward show of loyalty from the vezirs
and other senior officers of the state and law.

Returning to the Hall of the Fountain, the visitor is con-
fused by the number of patterns which convolute over the
tile panels. Like the skirting tiles, they imitate sixteenth-cen-
tury designs; but most cover every possible space, which is
the hallmark of seventeenth-century taste in the *saray*. The
fountain is of the same period and with its red and gold
paintwork is a cheerful sight. It is strikingly grand since the

large stone frame is for the sake of only one tap and basin. The plain but handsomely carved stone niches in this hall were, presumably, for jugs; and an alcove is surmounted by a Bursa arch (an arch with two consoles carrying a beam between them) which is equally fine. In the little recess are displayed two attractive inlaid trunks (of interesting woods), which belonged to the members of the harem and in which they stored their possessions.

It is from this hall that we enter the anteroom to the chamber of Murat III. It was cropped in the seventeenth century in order to build the new apartments of the heir to the throne. The damage to this room is considerable, including the introduction of blind windows, even painted windows, and there is eighteenth-century paintwork on one of the doors. Again, the tilework (which is not the original) lacks lustre; but on the three unaltered walls, it is of one piece, unlike the haphazard arrangement, if such it may be called, of the panels in the Hall of the Fountain. Beyond the finely proportioned

The tile garden in the anteroom to the chamber of Murat III

door into Murat's chamber, on the wall that was rebuilt, there is all that remains of a ceramic arcade. It has imitation marble columns with multicoloured capitals from which spring joggled (interlacing) arches. In rooms that were often without a view and even windowless, these tile vistas of the garden of paradise were welcome. The arcade is incomplete and halfway across the wall ends in a confusion, indicating that this sixteenth-century masterpiece was moved from somewhere else or even simply replaced badly after rebuilding had finished. Enough remains of the sumptuous fruit trees in bloom to enrich one's imagination and see the interior of the royal rooms as they once were, pleasure domes to rival those of Kublai Khan.

Next we enter the chamber of Murat III, passing so splendid a blossom tile panel that it compares with those in the mausoleum of the much-loved Hasseki Hürrem (Roxelane), whom Süleyman the Magnificent called the springtime of his life. It is a fine introduction to the most beautiful room in the palace and its restoration has been achieved with care. Its proportions are identical to those of the domed area of the Hall of the Throne, but the windows on its south wall have been blinded by the addition built by Ahmet I and one can only imagine the view of the city and his gardens that Murat III enjoyed in what was his Presence Chamber. One cannot say how the windows were originally designed. Possibly they resembled those uniquely surviving sixteenth-century examples in the Süleymaniye Mosque, with all the colour that Venetian glass could supply set in intricately designed beds of plaster. It is also likely that the protective outer windows were a traditional plain bottle glass, clear enough to let in trapped light and tough enough to withstand marauding pigeons.

A broad, three-tiered fountain is recessed in the centre of the south-west wall and forms the aesthetic navel of the room where later decoration has done relatively little harm. The cupboard on the left may originally have been the sultan's entrance to the throne room. The throne of Murat III in his chamber was destroyed by the addition of Ahmet I's library.

The present twin thrones are probably nineteenth-century intruders.

Above the fountain and all the way round the room, a tall frieze is a perfect example of Nakşi script. The liveliness of all the other letters is held rigid by the letter *a*, the erect spear that is the first letter of the name of God (Allah). Also round the room are cupboards and finely carved niches backed with tiles that put those of Mehmet IV in their place – which is second best to those of the sixteenth century. The two thrones belong to the eighteenth century and are out of place, not only because their decoration is so much later but because they clutter immaculate space. The visitor should look up past the restored pendentives, triangles of red, black and gold, to the hemisphere which carries this interlaced design of a later restoration into the crown of the dome. Here an inscription, *sura* 112 of the Koran – 'God is One, the Eternal God. He begot none, nor was He begotten. None is equal to Him' – revolves in the manner perfected fifty years earlier by Ahmet Karahisarı, one of the greatest of all Ottoman calligraphers. From the centre hangs a gilded globe set with semiprecious turquoise from which dangles a tail of gold thread. Such symbols of majesty and eternity were hung in every important room.

Murat III was a most interesting sultan, half-Italian and possessing a strangely complex character. A mystic who was deeply interested in dervish orders and their philosophical differences, he was also worldly and this was not simply due to the grim period of inflation partly resulting from the effluence of silver from South America. Murat approved the arrest of dishonest tax-collectors and tradesmen but he was a poor judge of character and appointed Sinan Pasha to be his Grand Vezir although he was allegedly a coward, a fool and arrogant notwithstanding. The power behind the throne was a Halveti dervish *şeyh* whose ecstatic mysticism and interpretation of dreams were matched by illiteracy and moral corruption. It was due to Murat's much-loved Safiye that harem influence grew and he weakened the authority of his Grand Vezir by insisting on giving the final approval to official appointments. He continued his father, Selim II's, influence

on the arts, however, and he also patronized the wine magnate Joseph Nasi, Duke of Naxos, well aware that he would recoup his extravagance since death duties on this fabulous estate would amount to 100 per cent.

The library – if that is what it was – of Ahmet I is reached through an altered window. It leads under an arch which, surprisingly since the other tiles are elaborate, is covered in more or less green tiles, botched firings and all. Here Ahmet I had ceramic inscriptions all round, in honour of himself, among mainly seventeenth-century tiles (not always in the correct order) which deserve scrutiny. So do the lavish inlaid shutters and the niches with their fine floral tile backs. The inscriptive friezes are small but then so is the room. They frame both windows and pendentives. One can understand why an unloved sultan might be glad to escape pomp and circumstance and relax with poetry books and with his own glory glazed upon the walls around him, but for the visitor the room cannot help but be an anticlimax.

This is not true of the so-called dining-room of Ahmet III, which is as amusing as it is colourful. If one wonders whether it was built expressly for eating, it is because of the Ottomans' tradition of setting up tripods and trays at wherever they happened to be at a mealtime. The name 'dining-room' can only have come from the marvellous display of painted vases of flowers and, the crux of the matter, innumerable bowls of fruit – grapes, quinces, figs, pomegranates, pears and so on. There is no tilework here but only pretty paint on stucco: even on the hood of the fireplace. The entrance to the Hall of the Throne is neatly screened off in order to mask Ahmet III's privacy when eating: among other things.

From here we must retrace our steps in order to reach the two apartments of the heir apparent, the Twin Pavilion, only the first of which has a dome. Spacious and grand with wonderful views, it could hardly be called a Cage and belongs to a time in the seventeenth century when rules had been relaxed if not entirely abandoned. During the nineteenth century, when the *saray* became the House of Tears – and doubtless giggles, too – the women had an upper floor added and the upper rooms had false ceilings inserted.

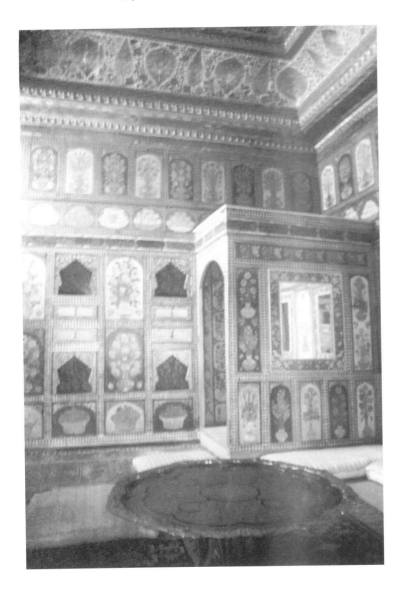

Flowers and fruit in
the cabinet of Ahmet
III

During the restoration period of Mualla Anhegger in the
1950s, the ceiling was seen to be false after the upper floor
had been removed. Little by little, strut by strut, the intruder
was dismantled and Istanbul was abuzz as the news came that
something exceptional was being revealed. I had the privilege
of peering through rafters to see the paintwork of the dome
glowing in what little light there was. The dome is now cleared

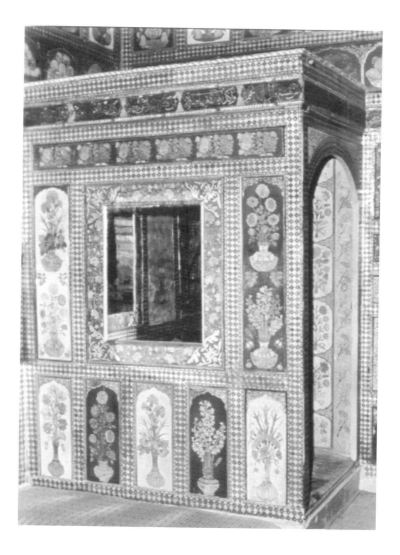

Detail of the
decoration

and restored to reveal the splendour of the *saray* ceilings in
the seventeenth century. This is also the date of most of the
cleaned tilework, both in the first room and in the withdraw-
ing room beyond. In this is the superb gilded copper fire-
place which has been painstakingly brought back to life. Work
on the floor revealed an earlier level and skirting tiles prob-
ably of the sixteenth century. The ceiling recalls work in the
Dome of the Rock in Jerusalem, but is likely to have been
based on an original design. A pleasant luxury is the inset-

The pavilion of Abdülhamit I and the rooms of his chosen girls (R)

ting of taps and basins on each side of the repainted and regilded windows. But a blind should be drawn over the windows themselves. Although the patterns of coloured glass are based on those of contemporary tile designs, this is not a correct solution to an intractable problem. It is a surprise to find that the three external walls are coated with blue and white tiles and are shaded by eaves added at a later date. The external windows may indeed be original since they have plain glass in a thick plaster web that must once have been universal throughout the *saray*.

Beyond these remarkable rooms, a corridor leads to the Golden Road. This is the Portico of the Jinns (Cinlerin Meşveret Yerisi), the meeting-place of the fortune-tellers. 'Jinns' also means demons, sprites or spirits in the sense of ghosts but these are irrelevant here. Above it were the rooms of those princes who were not heirs to the throne (unless the elder brother died) and which are more nearly related to a Cage. The portico is associated with the meetings of soothsayers and magicians. The tiles do not indicate this use and one may assume that visionaries only met there on certain

Detail

occasions and for a certain period. Apart from the forecasting of auspicious dates on which to act, they would explain natural wonders and the significance of weird happenings. On the wall is another tile depiction of the pilgrimage camp outside Mecca almost as if the jinns were travel agents.

At one period, the esplanade opening out to the left (the Court of the Favourite Girls) was significantly called the Terrace of the Cage and the Chosen Women – that is, those with whom the sultan had had intimate relations but without a child being born. Their apartments are behind it and possibly date from the eighteenth century.

The certain date is that of the Hall of Mirrors of Abdül-hamit I, who reigned from 1774 to 1789. This group of rooms includes a *hamam*, which suggests that the sultan could live there privately as does the still remaining furniture. The long line of rooms of the senior members of the harem is permanently shuttered against what was a breathtaking view. They are relatively large but encumbered with heavy nineteenth-century wardrobes, commodes and dressing tables not to mention commodious beds. Space was a sign of prestige in the overcrowded *saray* and here it must have impressed the forgotten ladies who came when the Old Palace was abandoned to become the ministry of war in the nineteenth century.

From the terrace is a far view of the Golden Horn, the Old City and Pera which is as romantic as a folk tale and only excelled by that from the bower of the Fourth Court. Standing in the far-right corner, the visitor can reconstruct the levelled kiosk of the Boxwood Garden, now sometimes called the Three Rooms in a Row, which is exactly what they were. The kiosk faced both ways but the Boxwood Garden was divided by a high wall from the next garden, which was that of the Elephants. Because it was overlooked by the *selamlık* (male area), this could not be used by the harem. There really were elephants, just as the broad sloping approach suggests, but the sole reliable witness reported seeing only a mother with a baby although there must have been a male at some time, it would be reasonable to suppose. Richly draped, an elephant followed Süleyman the Magnificent in the procession to celebrate his accession. There was also a giraffe. Giraffes were always popular and wandered round the city to be fed from upper windows. The death of one such pet in 1702 had the city in tears. One can appreciate the height of the Harem walls, but they were not high enough since it was probably from here that Dallam spied on the girls playing ball.

Opposite:
The chamber of Murat III over the vaults of the indoor pool (*L*), with the kiosk of Osman III beyond. The open pool in foreground

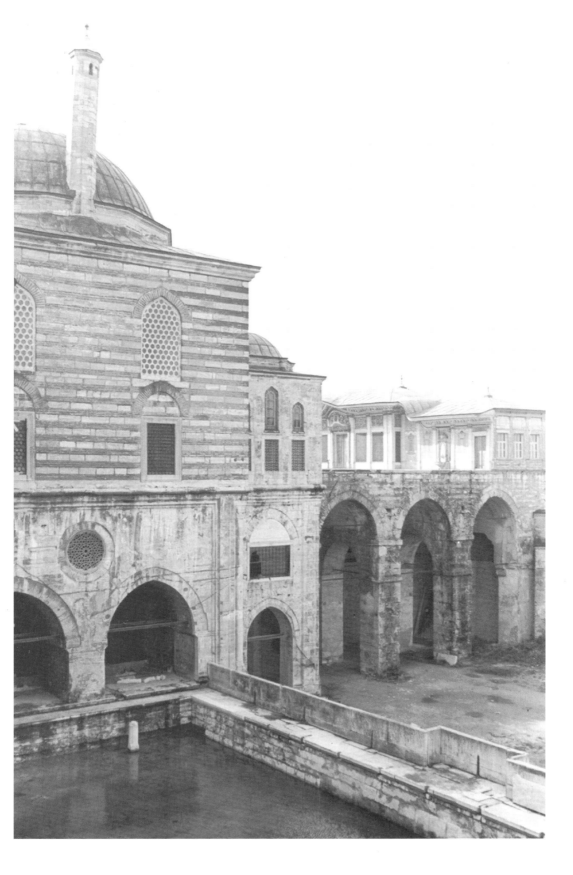

The viewpoint gives a glimpse of the vaults that had to be built when the whole harem was moved to the *saray* from the original home of the sultan. Under the Harem there is a world of masonry on stilts. On the brick piers to the right stand the pavilion and terrace of Osman III. Through these, there is entry to the remains of the once ample Harem garden – the intrusion of the hospital as well as Osman III's pavilion reduced the area by 70 per cent. Immediately below us is a large pool which once had an Italianate parade of flowing fountains, but these have disappeared. This pool was a centre of life at least for Murat III, who floated on it in a small boat from which he enjoyed toppling eunuchs, dwarfs, mutes and, according to one unlikely source, tiresome vezirs. When it was the girls' turn, they usually restrained themselves to knocking off the eunuchs' turbans to throw them as far as they could into the water. How the poor men got their sopping linen back has not been explained, but the pool is shallow. Immediately beyond are the vaults that support the chamber of Murat III, grandly built of stone with a formidably large grille between two of the smaller of the three arches. They had to be big enough to let in the light on the indoor bathing pool, which measures no less than 16.5 x 9 metres.

A stair with a low doorway, through which those with permission may bow, leads down to the pool which was fed by taps in two piers set one third of the way along. Out of sight and immediately behind was one of the largest boilers known at the time. Since the pool is not deep and no one could drown, the favourite sport must have been splashing around. At the far end is a platform for the sultan with a fine window under a tile awning from which to see the city. The stairs may have been lost during the rebuilding work of Ahmet I when he added his library. The roof is in fact the floor of Murat's chamber and is 10 metres high. Beyond the pool there is a whole new world of piers and spaces, some of which have been walled, including one which has claims to be the prison for harem women – the slaves rather than the girls. One inscription purports to be a cry for help from the woman who stole Ahmet I's cradle. This is difficult to believe because it is unlikely that she could write or even had the time to be locked

Opposite:
The Pool of the Maidens under Murat III's chamber

in prison before execution. It is possible to reach what re-
mains of the Boxwood Garden and inspect the vaults under
the Valide's apartments but since they cannot be visited it is
time to leave this world (which serves as an introduction to
the formidable understructure of many great mosques as well
as palaces that underwrite Ottoman architecture) and return
to the corridor, the Golden Road (Altın Yol), which was built
as a short cut.

The Golden Road begins at the end of the passage behind
the apartments of the favourites, where a modest door opens
onto the terrace flanking the Pavilion of the Holy Mantle. By
this, the sultan could proceed the length of the private world
of the harem as if down a spine. It was once rich with splen-
did gold- and silver-embroidered hangings of green or other
coloured silks. When the sultan was away, these were taken
down, washed and stored; and, indeed, he is still away. Lead-
ing out of the Portico of the Jinns, walls of sixteenth-century
tiles appear, even at the beginning of the Golden Road. But
these are satisfactory copies which look well enough – except
that they should not be there any more than the five great
panels from the Pages' *Hamam* which were once moved here
but which have been moved again. Lofty and plain though it
is, mild romantic pleasure attaches to a way reserved for the
King of Kings, or *padişah*, as the monarch was correctly called.

The stark corridor has stone benches in the walls, ledges
and hand basins and also the staircase up which Mahmut II
fled to the room of his old nurse, Cevri (a corruption of
Kariye) Kalfa, and then out over the roof while she bravely
pelted the assassins with handfuls of hot ashes which would
not deter a thug many seconds. Another version of this fairy
tale has her carrying him off in her arms (at the age of 25) as
if he were a baby. Perhaps she hid him in her garret. We also
pass the doors to the hall and service rooms of the thirty-
nine senior pages who were now officers of state, and of the
Harem Mosque which was connected to that of the pages
and projects into the Third Court. Since visitors have not
just succeeded to the throne, lovely girls will not flock to
cover them with gold dust.

Pausing to enjoy a last glimpse of the Valide's Court from

The vaults of the
music room of
Selim III

a new angle, we reach the Eunuchs' Court in order to turn
left down a corridor leading beside the Harem wall to the
Aviary Gate (Kuşhane Kapısı) through which we enter the
Third Court. There was indeed an aviary in the Third Court
between the Chamber of Petitions and the mosque: like the
Kiosk of the Pool, it was demolished to make way for the
library of Ahmet III. It was a practical rather than a hand-
some pigeon loft in which the birds wore pearls round their
ankles and were taught tricks. Later, it was moved to the yard
where the fuel for the Pages' *Hamam* was once stored. The
main aviary appears to have been near the Stable Gate (Ahır
Kapısı) beside the sea. Song birds added enchantment to life
and Murat IV had cages of them hung in his favourite mosque,
Haghia Sophia, when he went to pray. Where else they de-
lighted members of the household does not appear to have
been recorded. When the present palace at Dolmabahçe was
first built, there was an aviary which can still be seen from a
passing bus, but the fantastically ornate cages and perches
were removed towards the end of the twentieth century. There
is not one bird in sight.

The Third Court

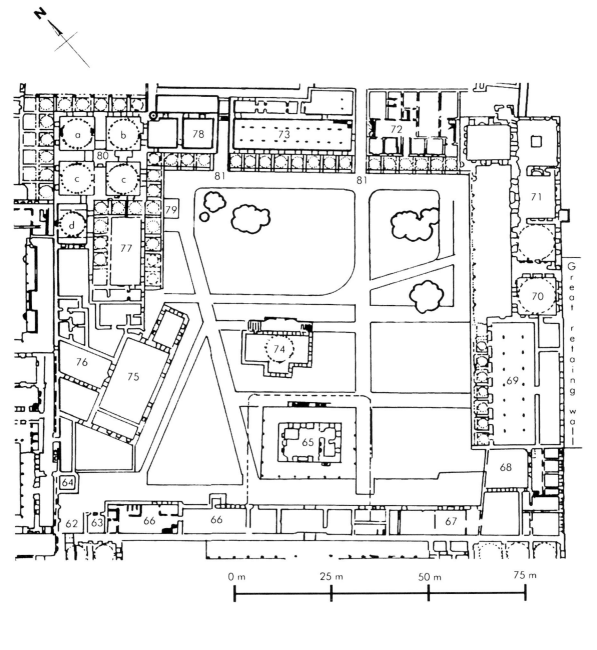

The terrace of the
Chamber of
Petitions seen from
the court

The Third Court

It is said there was a time when men were generous and kind,
a time that knew benevolence the like I've yet to find.
(Vasif)

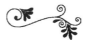

Those who visit the Harem and the *selamlık* after exploring
the Second Court will approach the Third Court by the Avi-
ary Gate. The aviary itself was an important feature of *saray*
life of which singing birds were so much a part even before
the Tulip Festivals of the eighteenth century. Visitors who
enter the Third Court by the Gate of Felicity should turn
sharp left and reach the Harem entry (now the exit for visi-
tors) in the north-west corner. The low building on the left
(now toilets) has an interest all its own because the sultan's
food ceased to be cooked in the main kitchens but was pre-
pared and cooked here. In the late 1950s, it was here that the
bric-à-brac of late Iznik tiles extracted from the drain of the
Barracks of the Halberdiers with Tresses was carefully laid
out on trestle tables so that fragments could be matched by
those expert in jigsaws. Surprisingly few were, although the
game was amusing and educational for its own sake. Diago-
nally opposite the kitchen is an enchanting first-floor room
for the Chief Cook – it can claim to be the most attractive
example of homely domestic architecture in the *saray*, partly
because it projects on consoles. It can seat some thirty people
on the comfortable divans while they enjoy a view of the
court through the large window.

From here it is wisest to walk back to the Gate of Felicity
(past the Dormitory of the White Eunuchs, once the
Embroideries Exhibition Hall) and inspect the Chamber of

Petitions, or of Audience (Arz Odası). This was originally built by Mehmet II and the shell retains its old proportions. Because of Mehmet's close aesthetic relationship with an Italy that he hoped to conquer as emperor of Rome, it is interesting that the plans were drawn on Italian paper. The hall was built close to the gate in order to block the view of college life and it is one of the rooms of state that retained its original function until the court departed in the middle of the nineteenth century. It was here that Mahmut II (1808–39), fleeing over the roofs from the Golden Road and assassins, was helped down from the eaves by officers of the counter-revolution: if he was. The grand portico of the pavilion offers fine views of the Third Court. The eaves were originally supported by twenty-six wooden columns but when the Kiosk of the Pool, in the shadow of the Chamber of Petitions, was demolished to make way for the lopsided library of Ahmet III early in the eighteenth century, its twenty-two marble columns with gilded capitals may have replaced them when they suffered severely from fires. The last, in 1856, gutted the hall except for the chimney and the throne itself which was rescued. Most serious of all was the loss of the inner dome.

On either side of the entrance are fine panels of *cuerda seca* tiles dating from the second quarter of the sixteenth century. Clearly they were not designed for this façade but when a pavilion or other chamber fell out of use, it was the sensible custom to store good-quality tiles in moss and eventually transport them where they could shine again. *Cuerda seca* tiles were fired in the kiln, with fine threads forming a web of moats around each colour so that they did not run into each other, as they do so disastrously in the Eunuchs' *Mescit*. The threads were turned to dust by the heat. On the right of the door is a handsome fountain installed for Süleyman the Magnificent when the pavilion was rebuilt and totally redecorated in 1527 by Alaüttin. Süleyman was known to his subjects as Kanuni ('the Lawgiver'), because it was under him that the mufti of Istanbul, Ebüssu'ûd, rationalized aspects of Koranic law which until then had been regarded as sacred and inflexible. Above the door is a *bismillah*, the Name of God as a blessing, which commemorates a restoration by

Ahmet III in 1724. On the back wall is another of Mustafa IV, who only reigned from 19 May 1807 to 28 July 1808.

The doorway leads immediately into the Chamber of Petitions, which is bare of its lavish hangings of silver, gold and multicoloured leaves and Koranic texts. The panels of Iznik tiles were the greatest loss. The hooded fireplace with its enamelled silver hood was important because the sultan was most often in Istanbul in winter and the winters of that city can be as cold as they are saturating: hence the extension of the eaves of this pavilion, the main gates and elsewhere in the *saray*, especially in the eighteenth and nineteenth centuries. The present throne dates from the reign of Mehmet III and in shape is more like a double bed than a divan. There the sultan sat with one leg dangling or with both legs crossed. He was propped up by giant, stiff bolsters, richly embroidered, and there were several soft but equally ornate cushions. The canopy over this throne is supported on four slender poles and the draperies also survived the nineteenth-century fire. The throne was set in the far corner from the entrance and so delayed the approach of any visitor until his arms were firmly held. It also meant that the sultan was seated opposite the window onto the gate and could see whoever came or went. The floor was covered with woven golden silk carpets which, as can be seen with the rugs in mosques today, did not fit exactly but overlapped. Visitors complained that the pearls woven into them were hard on the feet.

All of this One Thousand and One Nights' worth of decoration, along with the sultan in his dazzling kaftans, has to be imagined. His outer kaftan had open sleeves but the inner was usually closed at the wrists. At one period, he wore a monumentally large turban of purest white muslin which sported a feather from an elaborate clasp. It was to become ever more ornamented by jewels, and by larger and larger emeralds and rubies, and even the smaller clasps on each side were linked by strings of pearls. Usually over the sultan's knee was the stole that those so honoured might kneel and kiss with due humility: but never the royal hand. In strict order of seniority, the Grand Vezir and the members of the Divan were grouped beside the throne with their hands clasped.

When the Grand Vezir and other members of the Divan came to report one by one in private on the decisions taken by the Divan that day, protocol was duly relaxed. The hangings and floor coverings, as well as the kaftans of the courtiers, were only to be seen when a great ambassador or such was invited since such splendour was simply meant to impress and awe the visitor.

There is a fountain in the hall which attracts the legend that the temperate drips drowned private conversation but, in truth, the sweet tinkle would not have drowned the squeak of a mouse. It was there for ritual washing before prayer. Vezirs delivered any secret news alone with their sovereign and, if needed, with only deaf mutes in attendance. On leaving the hall, the visitor may glimpse a lobby. Behind this inner door is an elegant water closet consisting of the same type of hole that all subjects used, albeit this one is of sparkling marble and had a silver ewer. Sultan and subjects all doffed their turbans before going in and no latrine faced Mecca.

From the terrace one can survey the whole court and gain some idea of how its designs were ordered by its various functions and how buildings of all sizes were united by the portico, the core of Ottoman architecture. The portico here is approximately 100 metres square. In the middle a small patch of grass creates a relaxed atmosphere. In theory no one save the greatest in the empire could go farther and official visitors would leave, immediately their audience was ended, by the Gate of Felicity. This was strictly guarded by white eunuchs, who at one period gave their name to it, while the other gates were guarded by keepers of the royal household who had begun their careers as janissary recruits.

The white eunuchs came mainly from the Caucasus and formed the principal teaching staff. Because he was in charge of the *saray* until the end of the sixteenth century, the Chief White Eunuch alone had the right to speak with the sultan without an appointment. Under Mehmet II there were 40 white eunuchs – again that magic number – but these teachers numbered 120 (a multiple of 40) in the reign of Murat IV. The Palace School had been founded at Edirne by Murat II,

the father of the Conqueror. Under Bayezit II in 1500 there were 300 pages, increasing to 500 under Süleyman and reaching as many as 800 by 1612.

These were the children of the Christian levy – the rounding up of peasant boys in the Balkans. There were rigid rules. Only one son could be taken from each family and then not if he had no brothers else the farm would fail. Neither Armenians, Jews nor Kurds could be taken, let alone a gypsy. Up to 7,000 recruits might be culled every four or so years. The boys were marched in a growing group and eventually reached Istanbul, where they were converted to Islam and circumcised. They had already been inspected for their physique and intellectual promise but now they were tested even more seriously by the Chief White Eunuch and his subordinates. The tests included phrenology, and physical grace was essential. The ugly but intelligent were sent to the colleges of grandees such as that of the Grand Vezir at Ibrahim Pasha *Saray* on the Hippodrome while the less alert were assigned to the Outer Service. There was a wide gap in the boys' ages – from 10 at the youngest, if rarely, to youths like the great architect Sinan who appears to have been conscripted when he was some 18 years old. Some parents were glad to be rid of lusty sons whom they could not afford to feed and some hoped that the boys would pursue a successful career and not simply be left dead on their first battlefield. Free-born Turks were soon infiltrating the system and by the seventeenth century the levy petered out.

The palace service was not slavery but liberty was indeed sacrificed to loyalty. For a new recruit, life at the *saray* began with his having to stand for three days on the threshold of the Gate of Felicity before being led to his dormitory. There are worse initiation ceremonies today all over the world. Conscripts were considered to be members of the sultan's wider family and could neither be sold nor given away. The pages were well paid and their quarterly salary was not subject to tax.

The white eunuchs were the real slaves because they had been gelded – though not entirely, as was obligatory with the unfortunate blacks. When young, both black and white

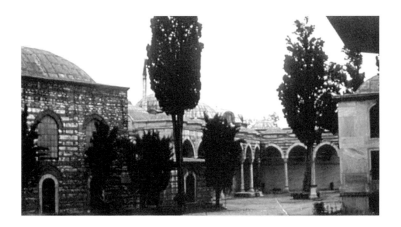

A view past a corner of the Mosque of the Aghas to the Pavilion of the Holy Mantle with the library of Ahmet III (*R*)

eunuchs were educated in the Palace School beside the pages. Like their students, the white eunuchs were bound to the royal service. If they lived, they were freed on retirement and provided for in their old age. Some eunuchs had been castrated voluntarily like the friends of Selim II whom, on his accession, he asked to accept castration else he could never be intimate with them again because they would not have been allowed to enter his privy chambers unmutilated. There is no reason to doubt that they agreed to take the grim risk out of devotion to their agreeable monarch. In obedience to the law of averages, one lived and the other died under the knife.

The Chief White Eunuch, as Master of the Gate, wielded inexorable power over the harem where he came second only to the Valide. On such matters, he had more power than a Grand Vezir. Since he controlled admission to the Third Court, as he did to the Harem, he was the private appointment of the sultan. The senior black eunuchs long schemed to usurp the office, and on the death of Gazanfer Agha in 1587 their ambitions were achieved due to the intelligence and perception of the black Master of the Gate, Habeşi, and his influence with the sultan. Gazanfer is still remembered by his college in the shadow of the aqueduct of Valens – now considered by some scholars to be that of the Emperor Hadrian, who gave his name to the city he founded, Adrianople (Edirne). The religious college, or *medrese*, became a charming museum of trifles but is now a museum of humour, which requires a sound knowledge of Turkish.

The least able boys were sent to the shipyards on the Dardanelles but the majority were leased to Anatolian farmers to improve their strength and also their Turkish. Brighter recruits were enrolled in schools under the auspices of vezirs in Istanbul such as the palace on the Hippodrome which was the home of Ibrahim Pasha. He was the favourite of all the favourites of Süleyman the Magnificent until power destroyed him and he was strangled in a room in the *saray* itself when preparing for a briefer sleep. A glance at his unique palace on the Hippodrome, now the Museum of Turkish and Islamic Art, reveals how the state rooms were divided from those of the 200–1,500 recruits (most of them Bosnians), though much has been pulled down. The ablest recruits of all were sent to Galata *Saray*, still educationally exceptional. Of the 400 pages of Iskender Çelebi, 6 became Grand Vezirs.

The task of rearing these healthy young men made serious demands on the wealth of vezirs, who could not compete with the fortune of the great Ibrahim Pasha so favoured by Süleyman. Under him there were 22 cooks, 11 bakers and 25 launderers, making 48 halberdiers in all. At one time, Topkapısaray mustered 62 cooks with 50 specialist assistants, and 56 water carriers but only 12 pantry boys. Eighteen youths were in charge of the royal ice and there were 113 sweepers and 109 launderers, making a total of 458 on the roll. At another period, the kitchen staff reached 1,277.

One sixteenth-century vezir contrived to have the sultan accept over 100 youths as a gift although there were rogues among them. But, indeed, there were rogues of all classes everywhere. Such was the unknown teenager whom an eighteenth-century French ambassador claimed had climbed over the wall between his residence and the college at Galatasaray and pillaged his orchard. Horror was expressed and the diplomat was promised that the culprit would be punished mercilessly as an example. When working in his study that same evening, the ambassador was surprised to see an open window in the college opposite and then heard the brutal strokes of a merciless beating which, it seemed, would never stop. Shouts and shrieks soon accompanied the punishment until the ambassador realized that the victim ought to have been dead long

before but yet the shrieks grew louder. No diplomat could be deceived by this stagecraft. When the public was allowed to find refuge in the *saray* after a great fire in the reign of Murat III – fires were the perpetual plague of the city – there were those who reported that the 600 pages were great rogues. Like Selim II with the bottle, youths of spirit when imprisoned by discipline have to find some way of retaining a sense of humour at whatever expense to other people.

White eunuchs were cruel masters. A regulation had to be enforced limiting the beating of a page to 100 strokes. These, like the executions, were administered by a deputy of the Chief Gardener. The most frequent misdemeanour was the breaking of the rule of silence but it is clear that adolescents, let alone grown men, contrived ways to enjoy conversation quite apart from seeking refuge in their hospital. Guards were as much employed keeping absconders in as keeping illegal entrants out. Better lascivious dreams and self-abuse, however corrupting, than actual relationships. As the recruits became more and more Turkish, however, they gained certain rights including a glimpse of their family through grilles at long intervals. This was the grilled window in the Hall of the White Eunuchs, which they used as a dormitory at some periods though later it was given up to recruits, while the family was in the waiting-room that had been the first Divan Hall. Moreover, the authorities agreed that it was a pity to turn trained recruits into miscreants and it became possible for a page to petition for his release. He would take his savings from his quarterly pay, abandon his uniform of coarse Salonika cloth and his camel-hair cap to find reasonable work, usually with the Outer Service, at the worst as a cavalry groom or, more likely, as an officer. Salonika had been the refuge of Sephardic Jews who imported cheap cloth from Europe, and from Lancashire in particular, with which to supply the army. The liberated youth or man then cut off his long tresses, like those of the halberdiers, and was free to grow a beard and a long moustache. It was initiation in reverse.

Actual graduates kissed the sultan's sash and were given a ceremonial kaftan, jewels, a fine turban and money. Martial music played, with drums and trumpets, and the eunuchs

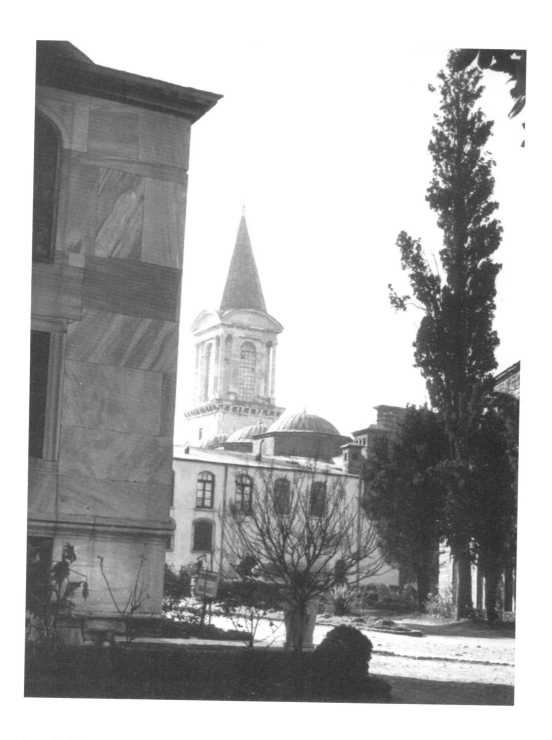

Beneath the Tower of Justice is the rebuilt Hall of the White Eunuchs

carried two silver bowls full of coins to the Chamber of Petitions to be scattered right and left from the portico. A glorious scramble ensued, followed by a fight for the empty bowls which a winner would fling to a spectator to keep for him. The graduate sprang into the saddle of a fine mount given by the sultan and left with his baggage, short of nothing except champagne.

Quite apart from discipline, the curriculum of the pages was exacting. Classes began at 5 am, when the Chief White Eunuch inspected work in progress as he was to do again after siesta time in the afternoon. It was a perpetual examination in which the pages could fail. Mathematics, Turkish history, jurisprudence, languages, music and the keeping of ledgers were taught by *hojas* – tutors who were scholars of the *ulema* class. They complained that the pay was poor since many came from an elite which enjoyed wealth. However, it was not difficult to enlist teachers when they knew that their work might attract the attention of the sultan and lead to preferment.

Half of the pages' time was taken up with swordsmanship, riding, wrestling and the sport of the *jerid* – riding fast to throw a 1.5-metre javelin through a hanging hoop. Bowmanship was taken for granted and aiming accurately over a long distance might be rewarded, if only rarely. Those who performed best had a pillar erected in their honour at the place where their arrow fell: perhaps two or three times in a century unless they were the sultan. Over all, the pages were taught deportment and an urbanity worthy of a sultan's household. If there was the possibility of failure, the pages were schooled in an endurance which meant that those who survived knew that they were fit to rule the empire and could look forward to being ministers, governors and even the Grand Vezir. However dangerous advancement might be, it was the prize in the lottery of life and therefore worth the risks. The system also rewarded the sultan, since, with no noteworthy exceptions, it achieved an almost total loyalty. Even before the eighteenth century, some Grand Vezirs lived in luxury but, like Kara Ahmet Pasha, in the end died legally strangled or illegally torn to pieces by the mob.

Returning to the Chamber of Petitions, the visitor should turn to face the Gate of Felicity and the long stretches of buildings on either side. All the rooms were destroyed in the fire of 1856 and were cheaply rebuilt as stores and offices. Once they were the Dormitory of the White Eunuchs and then the dormitories of the new recruits to the college. Throughout their training, the cadets of the different halls might not speak to each other. At least they saw each other in the mosque on Fridays at noonday prayer. The Large Dormitory (Büyük Odası) had a room of its own for daily prayers. In theory, all that the pages had to look forward to were the two great religious festivals of the Moslem year, when the world was a stage for carnival and excess and when high spirits defeated the eunuchs. What would have happened if the sultan had been rash enough to appear is unrecorded but there are references to emotional encounters in the washrooms.

On the right of the gate was the Small Dormitory (Küçük Odası), with the Large on the left. The members of the Large Dormitory were deemed fit to go to war while those of the Small were considered too young. Yet the two dormitories were equally important and each was divided by a series of daises, some 45 centimetres high with an area some 1.2 metres wide for each student in the Ottoman way. There was room for some eight youths on each platform, which served as their bedroom and their study room. The transformation was simply effected by doubling their blanket into four. The page slept in his undergarments and in winter had a second heavy brocade cover against the cold. Lamps burned and two eunuchs slept off and on between their watches between the student platforms in order to prevent intimacy when friends were close at hand. There were six extra platforms in the Large Dormitory for launderers and other servants of the Inner Service.

Each dais had its nickname and it is not surprising that a newcomer to the Small Dormitory was sent to one named The Louse or another called The Flea. After leaving the exclusive Koran School for Princes, sons of the sultan used the same dormitories but on balconies above some of the daises.

Murat III, in particular, was interested in the school, at least initially, and whenever he could he presided over examinations and studied the intellectual content of the syllabus. He also visited the dormitories at night – as did Murat IV for other reasons. A youth might spend as much as five years in both these dormitories but advancement depended on achievement. The better student was promoted much more quickly. He was then enrolled in one of the specialist halls of the senior school, a decision which was likely to define his future career. Early on there had also been a hall for falconers but this was closed in the sixteenth century.

When Ahmet I closed the Small Dormitory, he founded the Campaign Hall, or Şeferli Koğusu (also known as the Dormitory of the Expeditionary Force), in place of the magnificent Pages' *Hamam* – it is now the main hall of the department of costume. Its students were in charge of the laundering of the sultan's clothes in addition to their normal curriculum and physical training. The next hall was the department of the pantry and stores, or Pages of the Cellar (*kilerli koğusu*). This is situated beyond the Treasury of Mehmet II and is now the directorate of the *saray*. Beyond it is the Hall of the Treasury (Hazine Koğusu), which was the dormitory of sixty senior students in the grand hall and is now the gallery of paintings, miniatures and some of the immense collection of calligraphy. From these sections, pages eventually graduated. Some left rejoicing but not the best because they were chosen to fill the vacancies in the hall of senior pages, the thirty-nine elite of which the sultan was the fortieth. There was no relaxation of any of the disciplines on promotion to the senior schools until the seventeenth century, but individuals were given leave to visit the city from time to time. Senior members of a hall were allowed to carry gold or silver daggers and the juniors might wear night clothes when off duty, a custom still to be found in republican Turkey to this day.

One may suspect that a sultan who was interested in the school was a burden. When he approached, a whistle warned the pages to disappear. It was the one time that they could seek refuge in any dormitory but often they hid where they

The senior pages: water-bearer (*top L*); sword-bearer (*top R*); bearer of the falcons (*bottom L*); and page who has yet to graduate (*bottom R*)

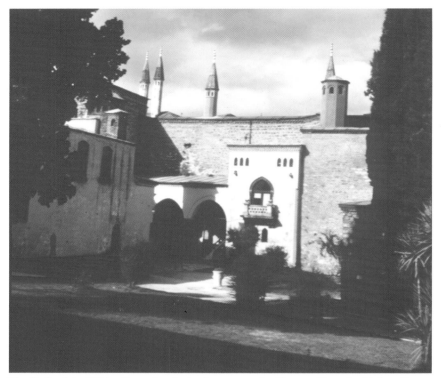

The Hall of the White Eunuchs, the back entry to the Harem. Note the high wall as a protection against the cadets and the romantic loggia of the sultan's personal cook

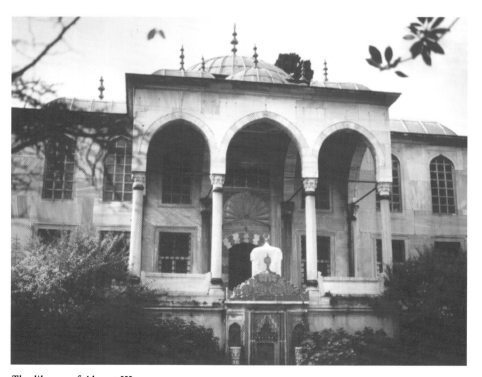

The library of Ahmet III

Top: The facade and door of the Pavilion of the Holy Mantle. Note the Egyptian marble skirting

Left: Window and tiles on the exterior wall of the Circumcision Kiosk

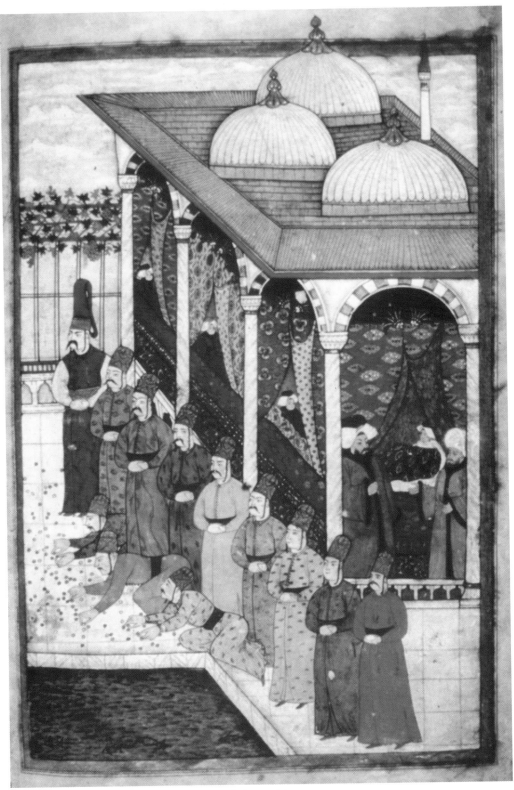

Gold coins scattered to celebrate the princes' circumcision

could, in deep shadows or noisome corners or even up a tree
since a sixteenth-century miniature shows janissaries climb-
ing to escape a flood. But if there was a warning of the mon-
arch's visit, then a dormitory was specially bedecked.

Throughout the seventeenth century, those senior men
achieved ever greater authority. Apart from anything else, it
had become difficult to differentiate between graduate and
student when the latter held a responsible post and at 30
years old was curling his moustaches round his ears. The au-
thority of the white eunuchs diminished over the century
until a remarkably able Grand Vezir, Çorlulu Ali Pasha, placed
all the senior halls under their own authority. The white eu-
nuchs taught and disciplined the junior youths and their
number was reduced from 200 to 60. They were no longer in
charge of the Gate of Felicity, nor of the Treasury, the cellars,
the larders nor the Campaign Hall.

For some years the important collection of embroideries
was displayed in the Small Dormitory. Since Roman times,
the embroiderers had been men, and for the most part still
were so under the sultans. But women produced fine work
on the Aegean islands and elsewhere out of reach of the guilds
of Istanbul. Examples cover Anatolia from Aydin to Antep
and can be met with on the southern coast where one stitch
was already used in the days of the pharaohs. Rhodes and
Thrace were also famous. The gold and silver threads of Is-
tanbul – produce of the Mint in the First Court – were fa-
voured by the court quite apart from the 60 pieces of
embroidered cloth assigned to the Chamber of Petitions: but
not all at the same time. When the hall lost its importance,
all these were melted down as useless and 8,000 kilograms of
silver and 600 of gold were recovered. Other fabrics were
equally splendid and were hung the length of the Golden
Road. More were, as we have seen, hung in porticos for state
occasions. The present collection is rich in surviving cush-
ions and bolsters and 12 mats of intense gold thread.

Sensitive examples include delicate napkins and handker-
chiefs of the type that Lady Mary Wortley-Montagu was re-
luctant to soil when she was the guest at a meal of a princess
or the wife of a vezir. (The wife of the English ambassador to

Turkey at the beginning of the eighteenth century, Lady Mary made many Ottoman friends. Wives of vezirs and consorts of the sultan would invite her to dine where the embroidery on the transparent linen was so fine that she could not bring herself to use it. It was the custom to give a guest handkerchiefs that were equally exquisite and frail and these she treasured.) It would be interesting to know if these painstaking embroideries were washed with soapwort, which grows in Turkey and which is so kind to fabrics that some museums still use it.

The finest examples of handkerchiefs were placed on tombs. Those from the catafalque of Şehzade Mehmet, the much-loved eldest son of Süleyman who died at 21 of a fever, are all the more worth studying because of their subtle simplicity. These were rivalled by those of Süleyman's wife, Hasseki Hürrem, which were far more elaborate and colourful. It was also the custom to cover the catafalques of the great with their richest clothes, men with their turbans at the head. Moreover, clothes woven with quotations from the

The arcades of the Campaign Hall, the pavilion of Mehmet II and of the Pages of the Treasury (*L*)

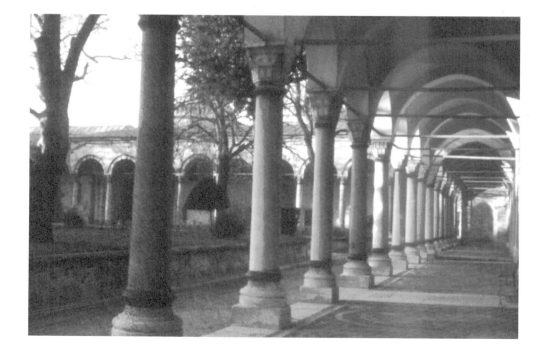

Koran had grown in popularity. At the beginning of the twen-
tieth century, it was wisely decided to guard these precious
fabrics in museums. Dazzling appliqué panels which deco-
rated the interiors of important tents are now in the Military
Museum at Harbiye. There is enough treasure at the *saray* to
hold the visitor's attention when this section is open. They
include such amusing items as a barber's bib. There are exam-
ples of the leather mats that went under trays of food, some
embroidered sheets dating from the sixteenth century, em-
broidered covers for mugs and boxes and even a coffee pot.
Particularly worthy is a dazzling turban cover, while a deli-
cate prayer rug is embroidered with two footprints on which
the owner was to stand.

Passing the Gate of Felicity and the former Large Dormi-
tory, the visitor reaches the end of the south-west wing and
the yard where the former boilers of the Pages' *Hamam* once
steamed. A few steps down a colonnade which is of excep-
tional quality, we reach the entry to the Campaign Hall, built
by 1719. The dozen verd-antique columns may have come from
the Kiosk of the Pool, which was simply an open shelter un-
der a handsome dome overlooking a cool marble basin. It
was there that the sultan might discuss the syllabus and the
merits of some of the students with the Chief White Eunuch
and consider which might become one of his selected pages.
These were dazzlingly dressed in state kaftans and on their
heads the brown sleeves of Hacı Bektaş, honoured by the
janissaries, were replaced by the noble Ottoman red and were
bound to their heads by gilded bands. They had come far
from their days of cheap Lancashire cloth and a camel-hair
cap.

The pages of the Campaign Hall laundered the yards of
muslin that made up the sultan's vast turban, which was
wound round a skullcap. In the *saray* the pages only washed
towels and napkins but when on campaign they were respon-
sible for all the sultan's laundry. Some of them were his bar-
bers and manicurists. At various times, the Campaign Hall
also appears to have been where folk songs and lyrics were
taught for the Tuesday choral concert. It was here that the
Mehter band (the royal band) was trained alongside fellow
students who were learning to become *hamam* attendants and

masseurs. The standards were professional and such was the
care of the turbans, however large, that this fashion did not
entirely disappear until the eighteenth century. The turban
was finally abolished with the reforms of the nineteenth cen-
tury and the adoption of the fez. In a sense, this diminished
the language of authority so that the mere shape of a man's
headgear on his tombstone no longer differentiated the corpse
of a sea captain from that of a nearby gatekeeper. But the
purpose of the school was not frivolous. It trained an admin-
istrative class known as the Men of the Pen, as distinct from
those of the Sword, and it was possible for a misfit to change
his studies.

It was natural that the Campaign Hall should become the
department of costume – it is the most important display
(though items are frequently changed) if one is to understand
the splendour of the sultanate. For example, there is a kaftan
of Murat III where medallions are edged with embroidered
peacock feathers and crescents enclose silk stars. It is interest-
ing to contrast one of the many spectacular designs with the
simple stripes of a kaftan of Kasim, the son of Ahmet I, or
the plain deep blue and ivory watered silk of another robe of
Murat. But splendour is tarnished by grief. Here is a robe
said to have belonged to Cem (the younger brother of the
melancholy Bayezit II, 1481–1512), who attempted to take the
throne for himself. Ensconced in Bursa, he made two attacks
on his brother but his popularity with the janissaries was not
sufficient and he abandoned his wife and family, knowing
that his sons would be executed. With the help of the Knights
of Malta he escaped to France, where the tower of Bourgneuf
was built for him and may still be visited. Later, he was al-
lowed to travel from estate to estate of German princes and
nobles where he was popular and admired for his skill as a
horseman since he passed his time hunting. The evenings
were spent feasting and drinking. Indeed, he drank more and
more. The pope had taken him as a nominal hostage for which
Bayezit paid him handsomely. He was on his way to Naples
when he died in Capua. Rumours of poison were bound to
multiply although it is hard to see who could benefit: cer-
tainly not the pope. It is reasonable to believe that it was the

drink with which he fought the melancholy of a bereaved exile that caused cirrhosis. Eventually, he was sealed in a lead coffin and sent home to be buried in a fine mausoleum in Bursa, now somewhat disfigured by nineteenth-century paintwork: he still lies among members of the house of Osman. Despite the trouble and expense that Cem had caused, Bayezit loved his brother and lamented the inevitable loss. As soon as the ship carrying the body arrived, he decreed a fortnight of mourning.

Another tragic robe is the most resplendent: flowers and fretted leaves of the Magic Forest (saz) cover a dark ground with a splendour that could honour no one more. It is interesting to note that the design is related to that of Iznik titles. This was a feature of Ottoman art, which married different materials and different purposes to create an overall unity. It is the kaftan of Bayezit, the young son of Süleyman and Hasseki Hürrem. The prince was all too aware of the danger of his position after the execution of his half-brother Mustafa. Like him, he was popular with the janissaries whereas his elder brother was not. However, Selim was able to isolate Bayezit and his army in eastern Anatolia until Bayezit finally sought refuge with the shah of Persia. This arch-enemy of Ottoman power initially disbanded Bayezit's troops because they were too costly to support. Finding the prince intolerably arrogant and rude, the shah negotiated his return to his own country with Süleyman, who promised to cede several fortresses in eastern Anatolia, such as the redoubtable citadel at Kars. Süleyman also promised Shah Tahmasp a substantial sum of what could hardly be called ransom money. The sultan then approached his friend, the mufti Ebüssu'ûd, who was certainly the ablest jurist of his time, to ask for judgment; he was also fearless and the treachery of Bayezit could not be disputed. To approve the execution of a prince, the sultan had to ask the mufti to issue a *fetva*, or formal document, advising the sultan that the prince's treachery deserved death. This was immediately presented and, in 1561, Bayezit and his family were handed over by the treacherous shah in return for a modest first instalment of money. The prince and his sons were strangled there and then. It may be some comfort

to the just that no castles were ever handed over to the shah
and no more blood money was sent. It is likely that neither
Cem nor Bayezit ever wore their immaculate kaftans.

There are others of rival splendour with strikingly large
patterns, especially those based on *centomani* designs: waves
or clouds set between three balls, which have been the sign of
a pawnshop since the days of the Medici, who were brokers
on a large scale. Chinese symbolism or not, it is possible that
they represent the planets, and for Mehmet II there is a kaf-
tan of tiger stripes to which the waves might well be likened
and the globes become leopard spots. In a different mood, a
golden kaftan belonging to Selim II is covered front and back
by two huge suns spouting rays of majesty and a third through
which the sultan's head emerged. It is a deeply expressive de-
sign although a cynic might find it somewhat pretentious.
The kaftans of princes who were still boys can also be over-
whelmed by their patterns. Suddenly the mood changed as
the glory of empire declined. This resulted in a pleasance of
delicate silver foliate sprays spouting from crescents. Those
lined with fur were of political importance. Selim III's de-
light in black fox meant that it had to be forbidden anyone
else but also that the merchants of the Kürkçü Han in Istan-
bul grew ever richer. Previously, the mad Ibrahim was infatu-
ated with sable, while citizens had to make do with marten,
lynx and beaver and, finally, rabbit, cat or rat.

There is also a bloodstained kaftan which is said to have
belonged to Osman II, who was murdered by order of Davut
Pasha in 1622 at the age of 18½. The boy had succeeded three
years earlier when his mad uncle, Mustafa, was at last deposed
in spite of the sanctity attached to the deranged in the Is-
lamic world at that date. This was because the insane, or some
of them, appeared to talk to unworldly powers. Osman was
too young to hold power and the visitor is disturbed by a
sinister miniature showing janissaries burning books. Osman
was unwise and ill-advised in his hostility towards them. They
thought him brutal while the populace charged him with
avarice and the *ulema* were shocked by his wish to marry four
wives legitimately. And dark over all was the shadow of his

intellectually retarded vezirs. Osman planned to raise troops in Anatolia to suppress or tame the janissary corps but the secret was soon betrayed and he could do nothing to hold the *saray* against the joint attack of troops and mob. Bravely, he went to the janissary barracks to plead his case. It might even have been accepted were it not for the stupidity of the Captain-General, who insulted the corps and attempted to give orders. It was too much.

The sultan was mounted on a mule – like so many rulers in Byzantine times – and one of the bolder recruits swapped the royal turban for his own cap. At least Osman was spared the final insult of having entrails poured over his head. He was taken to the great fortress built by Mehmet II at Yedikule. Here the four executioners had difficulty in overpowering him until they crushed his testicles and so could strangle the teenager with a silken cord. At the age of 16, Osman had written to King James I of England explaining the nature of the Ottoman succession. Perhaps someone else wrote a postscript as Mustafa crept out of his Cage to be sultan again for little more than a year. Then he was sent back to his prison to languish for fifteen years, devoid of wits or hope.

Each kaftan is of historic interest but one more deserves especial mention because unique: the wool robe in browns and greys of Murat III. It could not be more unlike his other robes because it is ornamented with pieces of material seemingly cut at random to signify rags of humility, although there is an overall design. Dervishes must wear wool next to their skin and the lining of this garment is a fleece for a sultan. If it did indeed belong to Murat III, it shows how the mystic orders had survived the hostility of governments and the *ulema*. Not only did sultans join the orders but so did vezirs and doctors of the law and eventually they included muftis as well, at least in honorary capacities.

First among the orders was the Mevlevi brotherhood, followers of the great thirteenth-century mystic, poet and philosopher Jalaladdin Rumi. The most aristocratic of the orders, the Mevlevi have their headquarters in Konya which were adorned with the most refined works of art although music was their greatest contribution to society. They are known

for their dance, which is not a dance but a symbolic commit-
ment to mystery. The seven participants, who include one
novice, gyrate with one hand pointing to the ground or earth
and the other pointing upwards towards heaven, gestures
which need no explanation. The function of this ritual is not
to produce giddiness but a controlled state of trance. The
Mevlevi order was responsible for the girding on of the sword
of Osman before the holiest tomb in Istanbul, that of Eyüp,
the standard-bearer of the Prophet. This was the coronation
ceremony of the Ottomans and the Mevlevi order has always
been respected above all other because of its saintly rejection
of intellectual discord.

The Bektaşi order is the strangest of the sects and it was so
powerful that its *şeyhs* led the janissaries, even on parade. Its
members were permitted to drink wine and women were ad-
mitted to the *tekkes*, or monasteries. Leaving aside their kin-
ship with the multitudinous but rural Nakşibendis, who had
no power at court, the Halveti order, which had long been
condemned as subversive, in time became accepted and it
was regarded as an educated order. What were not acceptable
were sects like the Rifai, or Howling Dervishes, who tri-
umphed over fire and mutilation. Also beyond the pale was
the Kalendar sect, divided between its settled members with
their headquarters near the mosque of Süleyman the Mag-
nificent and the itinerant groups of beggars which included
women and children and which stopped little short of as-
sault and battery. They would shout their way into a mosque
at prayer time, scrambling over the kneeling devout, and cla-
mour for alms until they were paid to leave.

The foundation of the Ottoman wardrobe was the Bursa
silk industry. It survived a ban on the importation of raw
silk from Persia, issued by Selim I, which resulted in the plant-
ing of mulberry trees all round the province. In the nine-
teenth century, Louis Pasteur visited the area and cured a
disease that had attacked the mulberry groves. Production
was strictly controlled by the guilds and there was a consider-
able export trade with Venice, Florence and elsewhere. Bursa
was famous for its brocades and velvets but supplies also came
from the Crimea, Aleppo and eastern Anatolia. Brocades from

Aleppo and Damascus were cheaper than those of Istanbul but the demand for Bursa fabrics was such that adept prisoners-of-war were employed weaving and, like apprentices, were freed to work for a salary. The shortage of skilled labour created a fairyland of races and strict supervision resulted.

Dyes were also important and while henna was unrivalled for black, it was used exclusively for hair, not fabrics, where the colour was disliked to the extent that even in the years of mourning for Hasseki Hürrem, Süleyman wore grey. Other Anatolian plants produced a rainbow of colours but some had still to be imported, including saffron yellow from Egypt. On the other hand, Turkey red was in demand in Europe and came from local madder.

The sixteenth century was a period when woollens were as expensive as silk. Merino wool predominated and came from western Europe to be sold to the *ulema* before anyone else. Mohair from Angora goats was first valued by the Emperor Justinian in the sixth century. A curious popular belief imagined that it was camel-hair. It was used in periwigs in the eighteenth century and is still much in demand. The international character of the trade in fabrics explains how later patterns showed Italian influence. East and west both influenced each other, the ideas bouncing from side to side like the ball in a game of tennis. But in the kaftan of Mustafa II, which is a landscape of large flowers shining from a dark ground, there is an ideal example that could be nothing else than Turkish. At the end of the collection, the visitor comes upon dresses of princesses before encountering the nineteenth-century state uniforms which were modelled on those of western Europe although the frogging of the jacket of Abdülmecit, or of Abdülhamit II of 1876, takes gold braid to the limit as the ultimate herbaceous border.

The Campaign Hall is built on the site of the cool room and large hot room of the *hamam* of Selim II which he rebuilt for the pages in the 1570s, with his own private section grilled off in the centre. The many basins were made of polished jasper with silvered or gilded faucets set in corners for intimate ablutions and there were fountains on all sides. There was a round marble pool for the pages to swim in. The *hamam*

Shaving a student

could hold some 200 pages and salaried masseurs selected
for their handsome build and looks. The warm air was fra-
grant with sandalwood, musk and other perfumes. Tuesdays
were the great days when the sultan was shaved and royal
musicians played light music as an accompaniment. All these
luxuries were lost in the reign of Ahmet I. Fortunately, the
finest panels ever fired in the kilns of Iznik, dating from
1572, were saved but they await a permanent home where the
public may see them. Originally built by Mehmet II, the
hamam was severely damaged by the earthquake of 10 Sep-
tember 1509 which devastated so much of the city and shook
the *saray* so badly that Bayezit II slept in a tent. Built on a
ridge above the sports grounds, the outward side of the build-
ing showed signs of slipping and it had to be buttressed by a
complete wall which can still be seen. The *hamam* was used
by the pages in shifts and the boilers can only have cooled
during the night. It was the smoke from the furnaces, to-
gether with the smells from the kitchens, that made it impos-
sible for Mehmet II's successors to use his splendid pavilion
with its views over the Sea of Marmara. Fortunately, he had
also built and used the Royal Pavilion, later known as the
Pavilion of the Holy Mantle.

Selim II had various unflattering nicknames such as Mest
('the Sot'), the title by which he was known abroad. There was
also Sari ('Jaundiced'), Sigir ('Stall-fed Ox') and Sarhoş
('Drunkard'). Joseph Nasi, whom he made Duke of Naxos,
became a friend by supplying good Cyprus wine out of which
he made a fortune. Selim's father, Süleyman, had appointed
Sokollu Mehmet Pasha his Grand Vezir and the son left the
government to this able but unpopular autocrat who con-
ferred offices on so many of his Serbian relatives. Selim mar-
ried him to his daughter Esmahan Gevher when she was 17
and the Grand Vezir was 57. It is through her that the Sokollu
family has continued to this day.

It is of interest that Selim requested Ibn Kemal Pasha,
who died in 1573, to write a book on how an old man recov-
ers his youth. Based on all serious research of the period, the
book was written for the sexually handicapped unable to per-
form in a lawful manner. Concerned with the arousal of de-
sire, it deals with poetry, perfumes, techniques and positions,

drugs and so on. The satisfaction of sexual appetite was legiti-
mate and the book invaluable.

Selim's son, Murat III, was the child of Nurbanu and he
certainly benefited from her Venetian influence on his edu-
cation – as did his father, who is mocked, somewhat unfairly.
He had a claim to be the best poet of the Ottoman family.
Moreover, he was of a kindly disposition. Nobody in the
sixteenth century appears to have discussed why he drank so
much but if one considers the burden of ceremony, of in-
soluble jealousies and battles for power with which he had to
contend and add the sense of confinement bred in the in-
ward world of the *saray* and of the harem in particular, one
might forgive him for finding an imaginary freedom in alco-
hol. Besides, we have no record of the quantities of opiates
and other drugs that other sultans indulged in along with
their vezirs, courtiers and pages. All sultans revelled in hunt-
ing and some in going on campaigns because of the freedom
of the open air, especially in summer when the sultry city was
besieged by epidemics.

Selim II was the boon companion of a notable poetess,
the beautiful Hubbi Hatun, which, perhaps significantly,
meant 'the Loving Lady'. She was married to his religious
tutor and remained at court when he died. Gossip being what
it is, she was alleged to have had affairs with young members
of the household and, suddenly, the college appears to have
been a little less of a monastery. The sexual mores of the
period were ambivalent. For example, one Mehmet Çelebi
wrote from Salonika to one Ali, a jurist at court, asking for
help. Mehmet was a famous pederast who vowed that he would
give up boys if he survived a serious illness. He did, but re-
verted to his pleasures. The *ulema* ordered him to keep his
vow so he appealed to rabbis and Orthodox and Catholic
clergy for help but to no avail. Ali merely told him that he
would get more pleasure from women – besides which, it was
more hygienic and manly. However, this did not stop Ali
sending Lala Mustafa Pasha, a power in the land, two tall and
handsome Bosnian youths. Homosexuality could only have
occurred in the sealed enclave of the Third Court. But where
did Hubbi Hatun educate her pupils and were there other
widows like her?

On leaving the Campaign Hall, we go down some steps and pass under the colonnade of the Imperial Treasury (Hazine). The first and separate hall of this museum appears to have been added to the pavilion of Mehmet II and is identical in proportion to his next hall. Some 10 metres in diameter, the dome is a twin to the earlier example. The room has no inner access to the Royal Pavilion and was the disrobing room of the bath of Selim II to which the bather returned to relax, sip coffee or sherbet, gossip or sleep off his exertions. It was rebuilt by Süleyman, along with the *hamam*, in 1528, only to suffer damage in 1556. In 1574 Selim II recalled masons working at his mosque at Edirne to work on the disrobing room. The placing of the windows was altered so that they matched the design of those in Mehmet II's pavilion. The floors were carpeted, as was the sultan's dais where it was noted that he disrobed himself while pages stood around to honour him.

From this hall, we must come out onto the spacious portico in order to enter the pavilion of Mehmet II, where one hall is domed and the other rectangular. Both have staircases concealed in their walls which lead down to the basements and a small cellar or icehouse beneath. In the basement the sultan stored his treasure, which was carefully listed and accounted for to the degree that the keeper, a vezir and, sometimes, the sultan himself had to be present at the breaking of the seals. It was a refuge from the public eyes and ears and it was here that, during the reign of Mehmet II, a Czech janissary was trapped when paying a secret visit to his brother who was custodian of the treasures. He had no sooner arrived than the two senior vezirs came down because it was the only place in the *saray* where they could confer in private. All the time that they were there, the unintentional spy crouched out of sight in the shadow of a chest, desperate with cramp and in terror of coughing. (He would have been put to death had he twitched or sneezed.) His brother spread a carpet for his unexpected guests and retired out of earshot in equal terror of

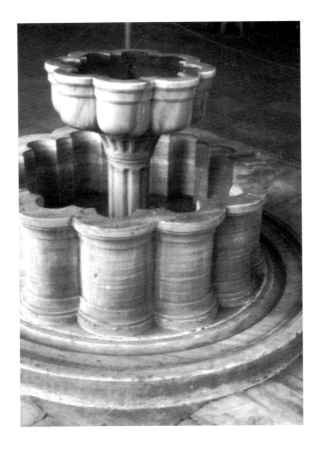

The fifteenth-century
fountain in the
belvedere of Mehmet
II's pavilion, now
the Treasury
Museum

hearing a cough. There was no sneeze and no execution but
possibly a solution to the vezirs' problem.

The great pleasure of the pavilion is the open but shel-
tered terrace with a fine but simply designed fountain and
which makes a perfect belvedere. From here the sultan could
look out on the shipping in the Marmara, the beginning of
the Bosphorus, the uplands round Bursa and, on a clear day,
as late as the 1950s, the snows of Mount Olympus in Bythynia,
now Uludağ, the great mountain. It supplied the city with
compacted ice which lasted all summer long. There is a final
display room beyond a latrine passage. This abuts on a small
yard beside the Hall of the Cellar with a door onto the Fourth
Court.

Treasure overwhelmed the pavilion, and after these fine
rooms were finally abandoned by the sultans in the sixteenth

century because of the smells from the kitchens, they were converted into stores in addition to the overflowing cellars. Later, even the colonnade was walled in as a further depot. The treasure, now elegantly displayed, gives one an idea of the size of the collection of the trappings of majesty, including jewel-encrusted utensils or even cups. Much of what is on display dates from the nineteenth century and is in a curious nouveau riche taste at a time when display did not make for comfortable eating. A large vase with a portrait of Charles V, who had fled into exile in Turkey, was a gift from King Oscar II of Sweden. With the dying breath of the Ottoman dynasty, Mehmet V was presented with a model of the Selimiye Mosque. The sad lack of older plate was due to the need to melt it down when economic crises ate up the sacks assigned to pay the army and the civil service salaries were in arrears. The loss of sixteenth- and seventeenth-century craftsmanship is sad, but there is still enough treasure to fill four rooms and jewels were laid out by Cartier. The visitor should wander freely according to taste, not ignoring the deep teardrops, the size of eggs, that are cabochon emeralds, including a huge example that was intended for Mecca. There are also rubies, diamonds and semi-precious crystals while the daggers of state seem to be encrusted with every kind of stone or brilliant known to man.

The first throne that we encounter is the relatively modest walnut Chair of Estate inlaid with mother-of-pearl, garnets, enamels and gems and made for Ahmet I. The elaborate canopy with its crystal pendant can prove an amusing test of a friend's powers of observation: it may take ten minutes to work out the origin of the ornate and perforated case which crowns it. It is, in fact, a clock case from Augsberg. When the works of the clock failed and there was nobody to repair it, in a very Ottoman manner it was not thrown away. There are other thrones, including that alleged to have belonged to Nadir Shah (1736–47) and, above all, the seventeenth-century Bayram throne which was set before the Gate of Felicity. Possibly made in Egypt, the earliest record of its use dates from 1680. Broad and deep in the traditional manner, it is made up of ten sections which are covered in gold plate inset with

semi-precious stones. A miniature shows the ceremony of loyalty early in the nineteenth century when Selim III was still sultan; he is shown seated on the throne. It also shows janissaries, screened by the ranks in front of them, and whispering since there was no equerry with a white wand at hand with which to rebuke them. Elsewhere, the chest in which the standard of the Prophet was transported on campaign is to be seen, and also the famous cradle of Ahmet I which is so heavy with jewels and other embellishments that it can hardly be the one which was allegedly stolen by a *harem* servant: even a weightlifter could not have stumbled away with it. There is writing on the wall of the prison in the *saray* vaults which refers to the theft of a cradle, but it need not have been this particular one.

Even for a court devoted to riding, there are some exceptional bejewelled harnesses of fine workmanship. The royal weapons and armour include a coat of chain-mail which was probably made for Mustafa III in the eighteenth century rather than for Murat IV a century before. The pious Mustafa was prevented by his ministers from leading the army into battle. One of the swords is said to have belonged to Süleyman the Magnificent. Of historic interest are the aigrettes that decorated the turbans of the sultans, not to mention the *naghiles* – hubble-bubble pipes – with which one could smoke tobacco from the New World or opium from Afyon Karahisar. Less immediately arresting is the green jade pot believed to have been taken by Selim I after the defeat of the shah of Persia at the battle of Çaldiran in 1514. There are rock crystal chessmen of the sixteenth and seventeenth centuries duly capped with rubies and diamonds. About 1850, French craftsmen made a perfume tree which sprinkled rose-water when it was shaken. There is an ice-cream service, also French, which was given to Abdülhamit II (1876–1909) and which either reaches the lower depths of vulgarity or the higher peaks of kitsch. There are some fine clusters of spoons which show that the goldsmiths and silversmiths of Istanbul were superb craftsmen. It would be a pity to pass by a remarkable collection of jewelled Korans, but one may well wonder why men took such pride in wearing nineteenth-century orders of chivalry

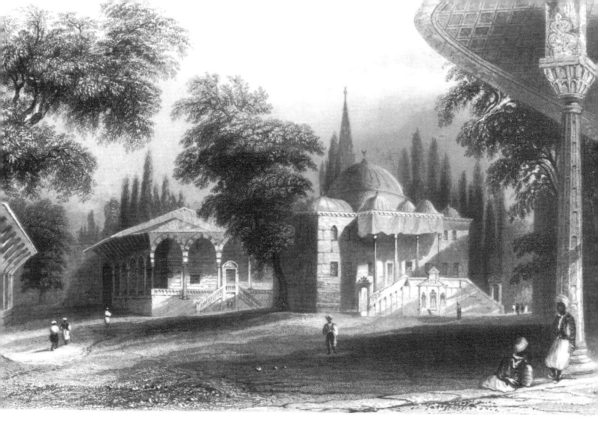

The library of Ahmet III with the terrace of the Chamber of Petitions behind

which here, like unused pearls, can feel the cold and are clearly out of sorts. We finish, then, with the cover of a book of modest verses by Murat III made of *repoussé* gold and niello which is indeed refined.

The spacious portico in front of the Treasury, which is so pleasant to saunter in, has a unique series of Ionic capitals for its colonnade which are difficult to date. A few paces bring us to the Hall of the Cellar. It is large because there were storage rooms as well as the dormitory for students. The department had to account for all the gold and silver plate and porcelain used by the sultan under the authority of the Master of the Cellar or Chief Butler. He also controlled the supplies for all the kitchens. Any surplus was sold to the public. The sherbet-makers produced drinks made with rare syrups from Cairo and elsewhere and from large pieces of ambergris sent from Yemen although it is also native to Anatolia. They were not only responsible for supplying these drinks to the sultan when he was in residence, but also accompanied him when he left the *saray* to retreat to the palace at Edirne or elsewhere, including the camp of his army.

The fountain of the
library

The large supplies of amber were also used for the mouth-
pieces of pipes – and also for rosaries, which develop a fine
polish and give off an aroma when stroked by the finger. For
the fourteenth-century mystic, Sheik Nefzawi, this added an
erotic, tactile pleasure: to tell his beads was like caressing a
woman. He advised men that: 'A woman is like basil; if one
wishes to savour its perfume, one must take its leaves be-
tween one's fingers and rub them; then the plant will give off
its scent. Otherwise one will get nothing, for it will jealously
keep its delectable essence.'

The sultan never left with less than two mule-loads of food
and drink besides jugs and ewers for washing. There was a
fruit-server and a pickle-server and the senior Bearer of the

Royal Tray who handed spoons to the sultan. At the *saray*, this official was also responsible for the lower kitchen.

It was in this hall that the Page of the Key resided. Accompanied by watchmen, he patrolled the dormitories at night. There was a Candle Master, who eventually did not supervise the supply of candles but of matches for the wicks of oil lamps of which there were countless numbers, all listed meticulously. His deputy attended to the Royal Pavilion (since the foundation of the Turkish Republic in 1926, known as the Pavilion of the Holy Mantle), where, exceptionally, candles were still in use. There were also huge mihrab candles from Wallachia in the store. Finally, the department was responsible for a supply of drugs and instruments for bleeding, along with antidotes for poison, aphrodisiacs, rose-water and costly aromatics from Arabia, Africa and India. One student was trained as a master craftsman at extracting marrow from bones, a gourmet dish for a sultan. Originally, there were no back windows to the hall in order to preserve the privacy of the Fourth Court, a haven for the sultan. Apart from duties which were special to the hall, the students continued their academic education and sports. Although these included archery, the students were likely to be Men of the Pen and would later achieve senior appointments in government. The Palace School produced not only soldiers and clerks but scholars and artists and for these in particular Ahmet III built his library.

Set back in the direction of the Royal Pavilion, the library is reached by twin flights of stairs rising over a fine fountain. In the 1980s this was painted, in the old style, with bright colours which might be said to have glamourized the graveyards. Just as the old cemeteries have lost all trace of their previous lustre, so here the colours have faded but they are still bright enough to show how such monuments were intended to look. The stairs lead to a handsome portico. Inside, the bookcases are of distinguished craftsmanship with small piles of books laid flat on the shelves and not upright in the European manner. Curiously, the north-west side of the building is a third wider than the south-eastern side, but when inside, the cabinets and shelves mask this distortion.

This library is one of several coordinated by the librarian of the *saray*, whose office is in what was once the Mosque of the Aghas. It contains 25,000 manuscripts, many with precious bindings. The Chief Librarian had great responsibilities and yet thieving western collectors succeeded in smuggling out miniatures cut from the manuscripts until the end of the nineteenth century.

The Mosque of the Aghas was extended by an invisible annexe for the women of the harem which is one third the size of the mosque itself. It would have had difficulty in sheltering over 200 women, let alone an imaginary 1,000. The annexe, of course, is reached from the Golden Road. It was originally built by Mehmet II when there were few women in the *saray*. On leaving it, the senior pages could immediately enter their quarters which were opposite the mosque door. There could be as few as 12 men on each floor and there were washrooms and other spaces but it is difficult to guess their uses.

Across the courtyard from the mosque there is an arcade with eight domes. This is the portico of the Hall of the Treasury, the most senior division of the college. There were found the most promising students of all who would one day become viceroys (*beylerbeys* or Lords of Lords), vezirs and commanders of armies. Some would have been all of these at various stages in their career; others would not because they lacked verve or talent – or influential friends. They would have to be content with humdrum posts but these would not be without a modicum of authority, prestige and reward. What was important was that a career owed everything to merit and nothing to birth – except in the case of the sultanate: heredity was its inherent weakness. The hall itself still evokes a ghostly relationship with the past, with its daises, accoutrements and, in a far corner, the barely perceptible shell of the washroom. It was lost in the nineteenth century to intruders but originally the walls were plastered while the gallery rose on posts of red varnished timber. In principle, as with most societies, the higher the rank, the richer the decor.

Built by Mehmet II like the Campaign Hall, the Hall of the Treasury is softly lit because it now displays a fraction of

the monumental collection of drawings and 13,000 miniatures which are still in the custody of the *saray* for whose sultans they were executed at his command or received as gifts. The miniature collection is universal in its interest and examples have come from all parts of the world of Islam. There are fine examples, not always on display, depicting the constellations or, in quite a different mood, the intricacies of the al-Jazari water clocks. There is veterinary material from Dioscorides' *Materia Medica* and, by contrast, and in splendid colours, the 1330 *Shahname* [Book of Kings] by the immeasurably great Persian poet Firdausi which exemplifies all that is most romantic, intricate and dynamic in Islamic miniatures.

The Mongol *Mirajname* (1360–70) from Tabriz almost uniquely depicts the face of the Prophet, which was strictly forbidden later and had to be hidden by the flames of heaven – which in a modest form became a halo – or veiled beyond the impertinent imaginings of any artist. There are also the albums of Ziyah Kalem, or 'Black Pen', once said to be a Kipchak because scholars were misled by the later added signatures. Now he bears his true name because of studies of the records of his contemporary, Kandemir, as Haji Mehmet Nakkaş of Herat, who worked in the mid-fifteenth century. Haji means one who has made the pilgrimage to Mecca and Nakkaş simply means 'illuminator' of a manuscript. Kandemir commented accurately on his drawings of strange events, queer figures on the pages of life in Central Asia, the bizarre and the grotesque. There is Chinese influence among many others in this unique record of life as a nomadic and trading society. Humour dominates scene after scene and it inhabits the rocks as much as the genes of the extraordinary animals and travellers, rebellious horses and shaggy masters. The men are jesters in winter coats, their mystical beliefs vividly alive in their faces and even in their walk. It is perhaps as well, but also a loss, that there are no heroines taking part in these visions of a harsh world made risible. The fame of these ribald drawings in colour, rather than paintings, is well deserved.

In the context of the *saray*, the Ottoman sixteenth- and seventeenth-century miniatures are important for revealing

the facts of *saray* life, quite apart from their aesthetic value. The Ottoman style was concerned with the real as opposed to the mystical and imaginary stylizations of the Persians, for example. They not only show how life was led but illuminate the symbolic role of the sultan, which had nothing to do with his carnal experience. Typical of these are the pictures that form a biography of Süleyman the Magnificent. To take but one example, we see him enthroned in a court paved with coloured marble designs. The two graduate pages of his entourage wear the sleeve of Hacı Bektaş, falling from the back of their heads like any janissary, except that the wool of the finest quality has been dyed the royal red, chosen by the first ruler of the dynasty. They had graduated indeed. Uniformed statuesque figures, the playing of the fountain and the musicians depicted are a formalized expression of the essence of royal existence. Behind this lie techniques acquired over many years. Since a figure in the foreground should not mask those set behind, the scene is watched as if from the gallery of a theatre with a stage that is so raked as to be almost vertical. The chief actor is depicted near to the centre of the composition but never actually in it. It is a language opposed to that of the Renaissance artist, where early perspective was based on a vanishing point and graded diminution. A master could, of course, modify the discipline to suit a particular composition, and this is also true of the miniaturist.

In the middle of the sixteenth century Shah Kulu from Baghdad was exploring the *saz* style, that is, the symbolism of the Magic Forest that is so clear in the kaftan of Prince Bayezit. Shah Kulu was said to be rude, but he had an inspired understanding of design and an elegant brush which suggests the influence of Tabriz. In the middle of the century, his place was taken by Kasim Memi, a great calligrapher whose designs make spring flowers bloom all winter. It was Ahmet Nakşi (d. 1622) who accepted western concepts of depth and perspective, reducing the size of the figures and objects. Finally, there was Levni at the beginning of the eighteenth century who copied portraits by Cranach and other western painters to whose works he had inexplicable access. His formal

paintings of women are anatomically credible and as full of verve as his record of the festivals that delighted the populace and the sultans alike. These are some examples of the unmistakable Ottoman style.

Leaving the hall, there is a small chamber on the right which was an annexe of the Royal Pavilion of Mehmet II, where the collection of clocks is now displayed. Originally every room had an hourglass since time had to be exact in Islam because of the hours for prayer. It followed that the sultans were deeply interested in clocks and they multiplied from the end of the sixteenth century onwards. They came from Augsberg, Nuremberg, Vienna, London and other cities. English clock-makers settled in Istanbul and the business still exists. At first clocks ran until they could work no more, as is exemplified by the throne of Ahmet I, but soon French and other craftsmen were employed to keep them in repair. Aubry de la Motraye left an account of the harem when he was supposed to be the assistant of the actual craftsman. The harem was cleared on such occasions while the sultan was in Edirne or elsewhere. Only the eunuchs of the lower grades idled in their portico. Queen Victoria sent clocks to Moslem countries with their dials marked in Islamic numerals. The harem once received her gift of a white and gold post-rococo example which added a certain air of frivolity, apart from its sonorous chimes.

We can now cross to the major building of the Third Court: the Royal Pavilion (now the Pavilion of the Holy Mantle), where the happy graduate joined the household of the monarch. In a sense, after over a decade of arduous training, he was fit for no other appointment. He would have saved the greater part of his pay and it is noteworthy that if a student died, his comrades in his dormitory inherited his goods and savings. Unlike an honoured graduate, a disgraced page was literally chased and kicked out through a back gate with none of his possessions, which were abandoned for others to purloin. But the sole heir of any eunuch was the sultan, which was important because many eunuchs grew rich over the years. The sultan would inspect their valuables; those that he rejected were taken to the bazaar, with the hawker

calling the first bid and then inviting higher. This also applied to ordinary people and, surprisingly, goods brought out of a house afflicted by the plague were treated as if they were not infectious. Ottoman wealth was in perpetual motion; outward as pay and inward with sweeping death duties that left not a jot behind. Only the *ulema* escaped this ultimate tax.

Mehmet II built his residence as if it were a fortress. Not even an earthquake disturbed it. Between nineteenth-century lanterns in large globes is a grand entry where a sign invoking the blessing of God on Ahmet III invites one in. Just outside are a large fountain and an equally large dismounting block for the sultan. The visitor enters a spacious hall beyond which is a raised open room almost as large. Beyond this on the left is a smaller chamber which was originally used for circumcision ceremonies. Through a modest door, the sultan could reach the Golden Road leading straight to the Harem and, in theory, off limits to anyone else. All the halls in this presently austere but grand building have treasures associated with the Prophet and his first successors, the caliphs. They include symbolic swords of a particular brilliance, manuscripts and texts and a piece of the Black Stone from the wall of the Ka'aba round which the pilgrim circumambulates. Another piece can be seen at the Old Mosque (Eski Cami'i) at Edirne and there are four in the mosque of Sokollu Mehmet Pasha at Kadırga below the Hippodrome. They were brought back by the royal architect Sinan after he had organized repairs in Mecca, along with a splendid gilded gutter pipe which had been replaced.

The hall is clad in a compendium of late sixteenth-century Iznik tiles of varying intensity of colour and quality. There are curious skirting tiles which follow tradition in that they represent marble. The large basin under the dome is a remarkable fountain of strong jets which cool the hall in summer. The greater part of the decoration here dates from the reign of Murat III but the proportions remain those of the fifteenth century. Off to the right is the former Throne Room of the sultan. It is the most sacred room in the country. The anteroom's cases of illustrious exhibits include objects like a

hair of the Prophet's beard – and also his footprint, which is strange enough for the visitor to pause and speculate on its story. Beside it was the royal bedchamber from the time of Mehmet II. The doors were hung with cloth of gold like the bed itself, surmounted by silver posts crowned with hollow lions. The central lantern was made of silver gilt with cabochon rubies while the candlesticks were guarded by pages so that no assassin could creep in under cover of the dark. There were also aged women to replace the bedcovers if they fell off. It is hardly surprising that Selim II escaped to the Harem. This bedchamber became the Room of the Holy Mantle and the sleeping sultans are now forgotten. The room is well lit and the Koran is now chanted by finely trained muezzins all day and all night without a break. Although the crowds make it impossible to linger, this is very much the climax of the visit to the Third Court.

Braving the crowds, the visitor can catch a glimpse of the room and appreciate the beauty of the unsurpassed tiles produced when Iznik was at its zenith. What is particularly remarkable is the purity of the white grounds, of a quality that could not be sustained. Under a canopy is the gleaming gold chest in which the royal robe is kept wrapped in forty layers of cloth: one cannot escape the magic number. There were originally two mantles of the Prophet but one was removed to the Mosque of the Holy Mantle (Hırka-i Şerif Cami'i), built in 1851 by Sultan Abdülmecit I (1839–61) on a site north-west of Mehmet II's grand Fatih complex.

Abdülmecit was proud of his writing and there are examples of his calligraphy hanging on the walls of the Mosque of the Holy Mantle. His character was a mixture of piety and enlightenment which made him unique as an Ottoman. The standard of the Prophet (which is kept in a second chest below the mantle) was taken on several campaigns and flown in face of trouble in Istanbul. In 1826 it was unfurled from the mimber of the mosque of Sultan Ahmet when Mahmut II crushed the janissaries for ever.

Mustafa II became sultan on 5 February 1695 at the age of 31. He was a gentle man who was the friend of scholars but he was averse to the growing laxity in women's dress and decreed

that they should wear heavy black overgarments and thick veils when out in the street. This made him unpopular and, after a severe defeat of the army in 1703, an old-fashioned revolution broke out which closed the shops and led to an attack on the palace of the Grand Vezir on 17 July. On the 21st, the mob broke into the *saray* itself led by one Hasan Agha who was an escaped prisoner under sentence of death. He appeared to know his way around the *saray* since he led the rebels to the royal pavilion and blasphemously unfurled the standard of the Prophet. Flag flying, the rebels set out for Edirne, where the sultan was in residence. Travelling at the rate of 8 kilometres a day, it took them a month and yet the government appeared to be incapable of organizing any form of resistance. Hasan Agha forced Mustafa II to abdicate in favour of his brother, Ahmet III. Within four months, deserted by his pusillanimous Grand Vezir – Rami Pasha – and any other help, Mustafa died of chagrin and dropsy when only 39 years old. And where, one might ask, were the pages of his household?

Before leaving the pavilion, and the Company of the Forty who were stationed there, we should look a little closer at their duties. First among the offices was that of the Swordbearer: he carried the royal sword on his left shoulder except on state occasions when he dressed in armour and moved it to his right. The importance of the Master of the Horse has already been noted. Very few other pages were permitted to talk to their sultan and they had to make do with sign language. All communications between the sultan and his government were delivered by this officer. There were also the Bearers of the Royal Turban, the Cup, the Golden Water Jars and the Bow. Some pages were responsible for the sultan's meals and his coffee pot. Hunting required supervision of the muskets, greyhounds, hawks and cheetahs, ensuring that they were all, so to speak, straining at the leash. The household was responsible for all ceremonial and also for the discipline of the students, although they delegated part of these duties. When they reached maturity and acquired the authority that was essential to their future, they were promoted outside the *saray*. Sokollu Mehmet Pasha became Grand

Admiral, for example. It is clear that these pages were on duty from early morning until late at night. Some acted as domestics who made the sultan's bed (if he had used it and not retreated to the Harem), lit the fire, and scrubbed and polished the whole room. Let us wish them well and proceed to the Fourth Court down one of the two passages between the dormitories, turning sharply to our right.

The pebble path leading to the Fourth Court

The Fourth Court

82. Mecidiye Köşkü (Kiosk of Abdülmecit I): refreshment terrace
83. Sofa Cami'i (Sofa Mosque)
84. Esvap Odası (Room of the Wardrobe)
85. Başlala Kulesi (Hekimbaşı Odası) (originally Tower of Senior Tutor, then of Chief Physician)
86. Sofa Köşkü (Sofa Kiosk)
87. Gate to Kiosk and Physician's Tower from lower garden
88. Revan Köşkü (Revan Kiosk)
89. Pool of Süleyman the Magnificent
90. Hırkai Saadet Revakı (Colonnade of the Room of the Holy Mantle)
91. Sünnet Odası (Circumcision Kiosk)
92. Bağdat Köşkü (Baghdad Kiosk)
93. Iftariye Kameriyesi (Sundown Bower of Ibrahim I)

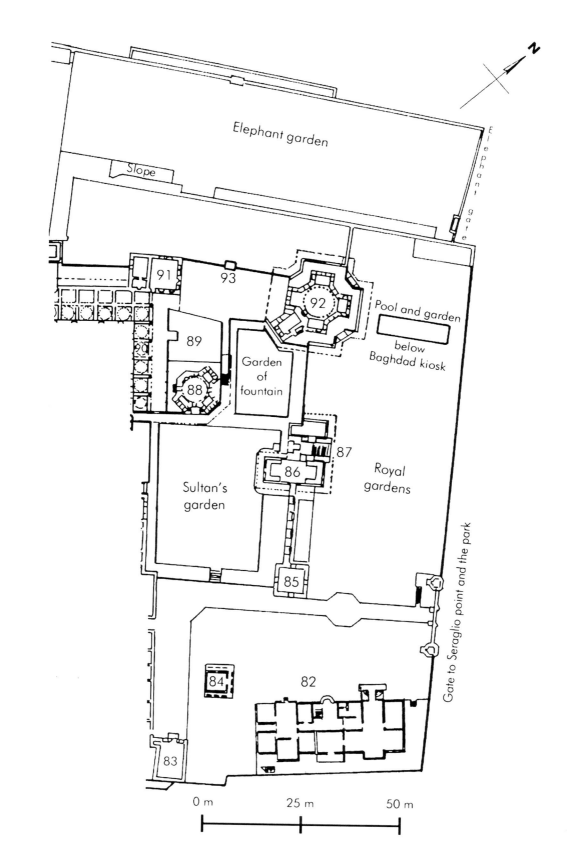

Elephant garden

Slope

91

93

92

Pool and garden

below
Baghdad kiosk

89

88

Garden
of
fountain

87

86

Royal
gardens

Sultan's
garden

85

84

82

83

Gate to Seraglio point and the park

Elephant gate

N

0 m 25 m 50 m

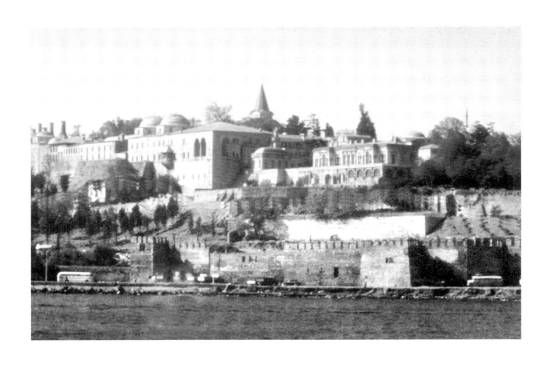

(*From L*) the kitchens, Campaign Hall, Mehmet II's pavilion and belvedere. The Mecidiye Kiosk (*R*) with the gardens of the Fourth Court in the distance

The Fourth Court

The trees are everywhere of light,
And every one with silver leaves,
And as they grow their tender buds
Shout, the name of God repeating.

Clearer than any moon each face,
Their every word a perfumed thing,
The blessed maids of Paradise
Stroll, the name of God repeating.
(Yunus Emre, d. 1321; trans. John R. Walsh)

The Fourth Court is not a court at all but a series of spaces set in greenery where life in the *saray* burst at the seams. The term is simply used for convenience and would have been meaningless to anyone in the sixteenth century. Beyond it, but incorporated within the outer walls of the *saray*, were well-defined gardens which faded over many years. Süleyman the Magnificent developed the inward core of the *saray* from a nucleus which had been planned by Mehmet II as an area for relaxation. Pavilions grew in number while the *selamlık*, or (men's) reception area, between the men's and the women's domain also expanded. Various Byzantine defensive towers were altered and the terraces remodelled, especially by Ibrahim I. The rigid series of gardens within the acropolis walls was modified and reborn.

The path between the Treasury and the Hall of the Cellar, with its cobbles of black, white and grey in the old manner, leads the visitor into this liberated area. Ahead is the Mecidiye Kiosk, to which we are proceeding, past the Sofa Mosque of

1740 (on the right) and the curious Wardrobe (on the left), the precise function of which is debated. Ahead, Abdülmecit's large nineteenth-century mansion was built over two decayed belvederes of Mehmet II, the Tent and the Terrace Kiosks. Their undercrofts and some of their upper masonry were incorporated into the new building. It was built in 1840 as a pied-à-terre for the sultan before the removal of court and government to the palace of Dolmabahçe on the Bosphorus in 1853, because he still had to be present on certain ceremonial occasions such as Sugar Bayram – the three-day holiday which marks the end of the four weeks' fast of Ramazan, the heart of the Moslem year. It was then that homage was paid to the sultan on the gold throne before the Gate of Felicity in the Second Court as it had always been, and it continued to be, until the end of the sultanate.

Abdülmecit was an interesting sultan because so much of his short life – he was to die of tuberculosis at the age of 38 in 1861 – was contradictory. He was a patriot, as any absolute sovereign has to be, for himself: as the Emperor Franz-Josef once explained. But the Dolmabahçe palace on the Bosphorus was a gross extravagance that the empire could not afford if only because so much of the furniture, including seventy brass bedsteads from Birmingham, was imported from Europe along with porcelain from famous kilns such as those of Limoges and Meissen. The purpose of the new palace was to impress on western governments that the young sultan was intent on establishing the new order begun by his father, Mahmut II. This was to lead to a liberal revolution contained in proposals for reform (the Tanzimat), which were to be initiated later in the century. Whenever he could, Abdülmecit took refuge from the oppressive palace by retreating to the small kiosks which he built in little parks and gardens in the neighbouring countryside. The days of holidays in Edirne were ended. It was symbolic that he founded the private library at Dolmabahçe. This included western works of prose and poetry which were so up to date that it contained first editions of Stendhal and Baudelaire: annotated. Everything about Abdülmecit's appearance might have been modern, including his uniforms (seen in the Campaign Hall) and his

Interior of the Baghdad Kiosk

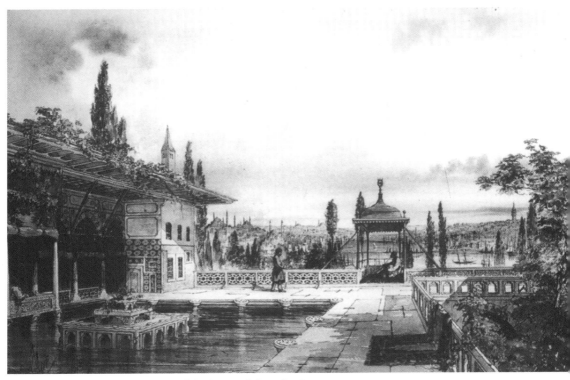

Romantic eighteenth-century view of the heart of the sultan's quarters

A loggia of the Revan Kiosk

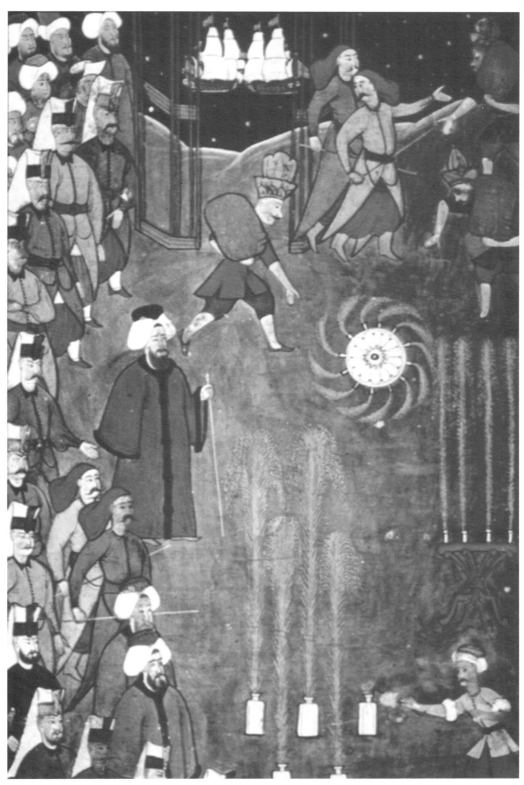

A sophisticated firework display at the saray

Under the arcade of the Tile Kiosk

The lower garden of the Sofa Kiosk

rejection of the turban in favour of the democratic fez, common to all ranks and classes. But he still maintained a large harem and was the father of many children. There is a very good reason for the visitor not to miss this pavilion: its splendid terrace is used as a restaurant and cafeteria. Thus, in the shade of awnings, we may enjoy a sultan's view of the Marmara and, appropriately, some of the best food in Turkey. Alas, it therefore cannot be cheap.

Leaving the Mecidiye Kiosk, to our right is the park gate, which is closed, as is the lower garden. Ahead and to the left, a short flight of steps leads up to a garden that is living. But first we pass a stout tower, known as the Tower of the Chief Physician (and also of the Senior Tutor), in the corner of the Byzantine walls. It is remarkable for the rows of small square windows at roof level on all four sides that served as skylights. Like the conical restoration on the Galata Tower, there was once a wooden structure above roof level with a similar conical cap. This was true of many of the towers of Topkapısaray which, in the Venetian manner, must have been pleasing vantage points from which to enjoy the view. Perhaps too much could be seen since they have all been demolished. But, equally, fear of fire plagued the wooden houses of Istanbul.

The importance of the Chief Physician was such that he

The Tower of the
Chief Physician (R)
and a window of the
Sofa Kiosk

could be a rival to members of the *ulema* themselves. He had
eighteen doctors on his immediate staff although several were
in semi-retirement. There was the Valide's doctor, who was in
charge of the Harem hospital, and another who was respon-
sible for the hospital in Bursa. Two were assigned to the gar-
deners and another to the preparatory college at Galatasaray.
There were also two or three students and the Chief Surgeon.
Seven Mevlevi dervishes were probably concerned with nurs-
ing services but the stipulation that there should be a *bastard*,
even if only one, taxes the imagination – although '*pıç*' has
vague connotations of immaturity. There were forty Jewish
doctors whose duties are not precise. They could never all
have been in the tower at the same time. Also on the staff was
the Master of the Magicians, whose chief task was to prepare
the calendar recording propitious and unpropitious days and
hours in the year ahead. These included the day and hour to
set out on campaign and to lay the foundation stone of a
great mosque (the stone was always set at the centre of the
mihrab).

Sometimes a notable might have to wait patiently for ac-
tion until the propitious hour was reached, while inwardly
fuming. Politically, as in all things, resignation to one's fate
– *kısmet* – seems to have weakened towards the end of the
seventeenth century in Ottoman circles. Office-holders needed

strong nerves and perhaps a kind doctor might supply a course in opium from his store in the tower, to help the sorcerer have new visions. These might be apposite or inapposite but were more probably in step with the wishes of the Shadow of God on Earth, who, after all, could hardly be wrong.

Some ten doctors working at the *saray* (most of whom were Jews, who were held in high esteem) came to the Chief Physician's store to be supplied with remedies, palliatives and rare syrups and perfumes. There were also store cupboards in the Hall of the Cellar. Amber, as opposed to ambergris, was consumed in remarkable quantities for many complaints. It was also used as a blender in the kitchens, as we have seen. It was imported via Danzig and Poland to both the Ottomans and the Persians. The Tower of the Senior Tutor (Başlala Kulesi or Hekimbaşı Odası), as that of the Chief Physician was first called, kept this name long after the tutor had relinquished his quarters there. The shelves for books were soon filled with drugs, herbs and potions, including hyssop for perfumes as well as upset stomachs.

The doctors were also important because of their intimacy with the sultan and for that reason many of their names are recorded. Among these is Moses Hamon, who was doctor to Süleyman the Magnificent. But in 1555 a rival, *Şeyh* Mahmut al-Kaysuri, prescribed opium as a cure for gout, from which the sultan suffered so seriously that it could have been gangrenous. When Moses heard, he was dismayed because opium soothes without curing. However, the relief from the pain had turned the sultan against him and he was dismissed, to die soon after. In his older years, Süleyman had other complaints since his body had aged under the strain of ruling so vast an empire. His face was particularly haggard, but he did not attempt to conceal it or his pallor unless he was receiving foreigners, when he used red powder.

Süleyman carried out extensive works at the *saray*, which was renovated by the architect Alaettin between 1515 and 1529. He was also a collector of Yuan and early Ming blue and white porcelain and his patronage had a considerable influence on the potteries at Iznik and Kütahya. The royal library was enriched with the volumes belonging to Matthias

Corvinus, following the capture of Buda in September 1529, while the sultan's own calligraphers included such international masters as Ahmet Karahisarı. Under Süleyman, the design of the royal seal reached unique proportions and intricacy. The sultan also collected clocks and even a gold ring inset with a striking watch that came from Vicenza. His piety was unquestioned and he made eight copies of the Koran in his own hand. He was also humble and helped bear the coffin of the saintly mystic Gül Baba in Buda in 1529.

At the *saray*, Süleyman kept his state, as miniatures show, yet he was not the slave of Islamic rules of dress, nor was he a bigot. Above all, he was a great commander of men and was also endowed with almost limitless wealth, at least in the first half of the sixteenth century. When he set out for Hungary to re-establish law and order, he had a team of 2,000 mules, 900 horses, and 5,000 camels in pairs because while one carried cannon and other weapons the other carried food for them both. These were groomed by the nomadic Turkmens who had reared them. Seven hundred men were employed setting up camps ahead of the army, while the troops consisted of 4,000 cavalry and 12,000 janissaries. There were also 400 *solaks* (royal guards) with their plumed helmets and *peyks* (foot guardsmen) of the elite guard with their gilded helmets and spears, 100 trumpeters and 100 kettledrummers besides huntsmen, houndsmen, falconers, orderlies and cooks. At the end, Süleyman was to die in his tent before Temesvar.

Süleyman married the pale and smiling woman whom he loved until the last minute of her life and beyond. Hasseki Hürrem (or Roxelane, meaning the 'Red-Haired') was his legal wife although for a sultan to marry was unheard-of at that date. He had many foreign visitors and through Ibrahim Pasha he was a friend of Alvise Gritti (the bastard son of Doge Andrea Gritti), who prospered and built himself a palace in Pera. But Süleyman was not hoodwinked by flattery or cunning. During an economic depression in Venice in 1532, the goldsmiths banded together to produce a crown or, worse, a tiara simply because they had heard of the sultan's lack of one. This weighty hat was divided by a succession of bands to represent areas of his empire – incorrectly. Perhaps Gritti

had forewarned him, for when the merchants arrived and asked a fabulous price for their tiara, the sultan was not impressed and only offered the value of the gold and gems. Since there was nobody else who would buy such a thing, the merchants were forced to accept his offer. Süleyman is said to have placed the tiara on the head of the nearest page. Although this detail may be apocryphal, the crown was melted down and the gold and gems were reused, reminding one of Elizabeth I of England who employed some twenty needle-women to remove the gems from an old dress and sew them on a new.

Süleyman survived problems of rule and even the rebellions of his sons Mustafa and Bayezit whom he deeply reproached, for it could only mean their execution. He also lost their brother, the tender-hearted poet and hunchback, Cihangir, who died of grief for Mustafa. Like his father, Selim I, Süleyman left no one who could challenge his only remaining son, Selim II. There was no Ottoman male who could rebel: only ghosts.

Süleyman's family life was gilded by his daughter Mihrimah, who was to act as her brother's Valide. She was a woman of prodigious wealth matched by that of her husband, Rüstem Pasha, who had an unfortunate reputation for avarice and for being a grasping collector of taxes. It was in this that his genius lay, since he subdued an inflation that defeated his successors. It was said of him that when his uncle and nephew came from their Balkan village to seek his help, he left them begging in the streets. The Grand Vezir Ibrahim Pasha, on the other hand, had set an example by rescuing his alcoholic father. Rüstem was also said to have a bullying manner but some found him serious and courteous. Perhaps he did not suffer fools gladly. Mihrimah built a most original and handsome mosque in Istanbul in memory of her husband. She also worked devotedly for his restoration to the Grand Vezirate during a two-year period when he was kept out of public life because of taking the blame for the execution of Şehzade Mustafa and so protecting his sultan, who was not as popular with the troops as his wayward son.

There is a melancholy miniature depicting Süleyman's last visit to Mustafa at Konya. It is night, there is a little music in the shadows, and father and son sit apart so that each seems sadly alone. One is glad not to have been an Ottoman. Notwithstanding all this, Süleyman was known within his empire as the Lord of his Age. He also had the support of Ebüssu'ûd, the greatest mufti of the century. The jurist was born in 1491 and, when still a youth, the then sultan Bayezit II had been drawn to him. When Bayezit was deposed by Selim I and died on the road to exile in 1512, the new sultan did not dismiss the future mufti of whom Süleyman was to be a profound admirer.

The legal reforms of Süleyman's reign which gave him the title of 'Lawgiver' were due to this mufti, who was unopposed because of his intellect and his recognized integrity. When the sultan asked Ebüssu'ûd for his opinion in the cases of Mustafa and Beyazit, he issued a *fetva*, or legal opinion, as Chief Justice. He found that both princes were guilty of plotting the overthrow of their father, who was the sultan. Ebüssu'ûd feared no one and had no reason to go against his own convictions. The executions followed. When he died in office on 23 August 1574 at the age of 83, it was the end of enlightenment in the *ulema*. For example, the royal observatory was demolished because it was the work of Satan. Ebüssu'ûd had preached tolerance and had even licensed coffee houses. Such laxity was seen as a threat to the power of the *ulema* and also its wealth. Its members might even be taxed. It was not for nothing that a young soldier of rank with powerful relatives was struck by the respect shown to a ragged imam. When he discovered the high salaries paid to the judiciary, he abandoned the army and studied law. Kemalpaşazade was the mufti before Ebüssu'ûd. The *ulema* were now free to repress any whispers of criticism and banned Karagöz, the shadow-puppet theatre where common folk could enjoy themselves but also hear political references which could be subversive.

It was Hasseki Hürrem who mattered most to Süleyman, however. 'Throne of my lonely niche', he wrote to her: it is a good beginning to a love poem but she was then likened to

thirty-six other things – Joy, Heaven, Intoxication . . . These become banal but there are also illuminating references to the Light of his Bedchamber, her eyes full of mischief and his the intoxication of her love. Not a great poet but certainly a great lover. Hasseki was probably kidnapped from her home village early in the sixteenth century and was likely to have been so appealing that the Tatar raiders did not debase gold by raping her since she was a valuable commodity – as indeed she proved. An agent informed the Valide Sultan of the arrival of this remarkable girl and it is unlikely that she was ever publicly on sale. She was immediately acquired by the Valide and presented to her son. It was soon after his accession that he received her: there was no question of an apprenticeship. From their first encounter, he was totally in love.

Leaving the Tower of the Chief Physician, we cross the sultan's terrace, effectively the Fourth Court at the time of Süleyman. It was open to the old tower where the Baghdad Kiosk now stands and was to become a garden enriched by two marble basins and an exceptionally large fountain in the late Ottoman baroque style: when working, it is explosive with jets. We walk on to the eighteenth-century Sofa Kiosk, at one time misleadingly called that of Kara Mustafa Pasha because in his day the Grand Vezir's seal of office was kept there. It was built of wood with large clear-glass windows in 1704 as a pleasure pavilion for Ahmet III. It was redecorated for Mahmut I in 1745, when the elegant poem in praise of the Prophet was inscribed at ceiling level by Hakanı Mehmet in the principal hall. This is shaded by trees and looks out on the garden, which today is planted with tulips in season and kept in order by boxwood hedges. It may now seem peaceful, but it was in this pavilion that in 1710 the foolhardy decision was taken to go to war with the tsar Peter the Great. At the far end of the salon there is a second sofa with windows on three

sides looking out, over the old gardens beneath, to the city and the Golden Horn. A flight of stairs between the two gardens divides the kiosk from a smaller room, possibly for attendants.

Returning to the Sofa Garden, and mounting the stairs beside the Revan Kiosk, we reach the terrace which was rebuilt by Süleyman at the beginning of his reign and laid with marble paving. His pool has lost its goldfish, one hopes only temporarily, but not the nineteen spigots set along its sides. In the middle is a fine example of a low, tiered, sixteenth-century fountain trained to emit sparkling jets of modest strength precisely because conversation should not be drowned when the sultan was at ease in such a perfect setting. The sultan's cushions and bolsters were arranged on a small projecting balcony. There was no gold, only cushions under a canopy. This is the true heart of the *saray* and the place where the visitor is most conscious of Süleyman as a real person. Here it is that we may imagine what the loss of Hasseki Hürrem meant to him. She was buried in the garden of graves behind the Süleymaniye Mosque, in a mausoleum decorated

The Sofa Kiosk gardens and fountain

with tile panels of spring blossom and trees budding into leaf. She whom Süleyman declared to be the springtime of his life died on 15 April 1558.

In Venice and elsewhere in Europe, it was considered fashionable to hang engravings of Hasseki in one's salon but all of these pictures are imaginary and the only thing of which we may be sure is that she looked like none of them. It is probable that she was small and graceful but not beautiful, according to the more reliable contemporary reports of Ottoman sources. Her spirit defeated her many enemies, including those who spread rumours that she was a witch because she seemed to have superhuman insight into Süleyman's mind. It must be admitted, however, that those of her letters which have been published were written to him when he was away on campaign and were merely concerned with requests for money and other matters. They also contained conventional references to their family. Clearly she knew every cell in her sultan's mind and she used this knowledge and her power with an intellect that matched her spirit. Facing the throne, a multicoloured crystal and coral pavilion was built between 1510 and 1513 for Bayezit II but this magical building was soon lost.

Behind the pool there is the grand colonnade of the Pavilion of the Holy Mantle, which stands before the north-east wall of what was then the Royal Pavilion. There is one window in the wall through to the inner room which actually houses the mantle, and there is a striking use of Egyptian marble strips rather than panels. Because the Mamluks were without the marble revetments left by the Byzantines and reused by the Ottomans, they resorted to cutting columns lengthwise. The result was slim strips which perforce formed much more intricate patterns than those of Ottoman buildings. There is one other example of this marblescape in Turkey: it is that of the mosque of the prodigiously fat Çoban ('Shepherd') Mustafa Pasha, who was briefly viceroy in Cairo in the 1520s. It is at Gebze, some 45 kilometres from Istanbul.

Selim I had brought architects and craftsmen back with him from Cairo and it is pleasing that one of the first acts of the new sultan, Süleyman, was to send them home. The

columns of the portico were local. The painting in the voussoirs of the capital is of relatively recent date but it is likely that these capitals were gilded as soon as they were erected. Between them, green hangings were embroidered in gold with inscriptions from the Koran. But now we need to walk down past the Circumcision Kiosk (Sünnet Odası) because it was in this part of the colonnade that Thomas Dallam was told to set up his organ. With the Harem garden a mere 45 metres away, it is easy to understand how he was able to glimpse the maidens through the last arch at the end of the colonnade. It is significant that the sultan, Mehmet III, was astonished that Dallam looked so cheerful. If, on the contrary, we cross the terrace to the Baghdad Kiosk and look back, we see that the tall, slender chimney stacks of the Pavilion of the Holy Mantle are deceptively like minarets. It is for the visitor to decide whether this was intentional.

Across the pool is the Revan Kiosk where, as with the Baghdad Kiosk, there may once have been a pavilion restored by Süleyman. The Revan Kiosk was built for Murat IV in 1635 to commemorate his great victory over the Persians at Erivan (Yerivan), the first Ottoman defeat of a foreign power for a long time. The architect was either Hasan Agha, whom Murat seems to have treated as his imperial architect, or Koca Kasım Agha, who officially held the post although he was dismissed in 1642 only to be reinstated the following year. He was finally dismissed in 1651.

One is inclined to believe that Hasan was the actual builder of the kiosk, which is a domed hall with sofas in bay windows on three sides with views towards the city or Galata. On the fourth side is the grand fireplace. The kiosk was also called the Room of the Turban, and from the eighteenth century it housed the library of 1,000 manuscripts collected by Mahmut I which has now been transferred to the main library. It served as a royal *çilehane*, or place of retreat. A person who was deeply pious or a dervish of an intellectual order would observe a fast and penance locked up, usually in a cell, for forty days and nights. But no ruler or member of the government could retire for forty days and a sultan was likely to make do with two or three at the most. We may note, however, that there is

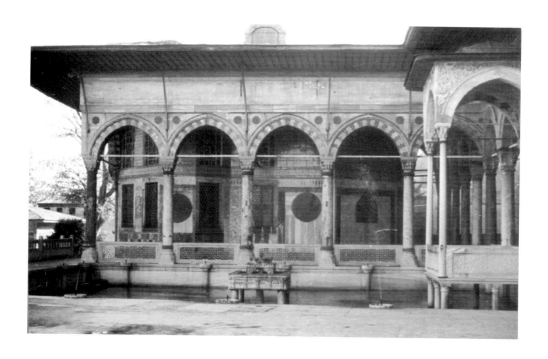

The pool, fountain and (R) bower of Süleyman the Magnificent, with the Revan Kiosk and its arcade

a royal retreat beside the mihrab of the mosque of Selim II at Edirne which is now used as a broom cupboard. It is hard to imagine Murat IV repenting his sins and, if he did, it may have been for a mere forty minutes.

The kiosk is clad in former Byzantine revetments which suffered from later repairs. They were clumsily reset, which detracts from the magnificence of the rare porphyry disks, nor is the interior decoration related to that of the seventeenth century. As so often, the original glass has been replaced by the large panes and crude colouring fashionable in the nineteenth century. If Hasan Agha were the architect, he was an old man who had known such students of Sinan as Mehmet Agha, who build the mosque of Sultan Ahmet with its six minarets. Hasan was fortunate to have an important commission at a time when grand building projects were no longer possible. He was clearly a man who took pains and used only the best craftsmen available. At the time of building the Revan Kiosk, there were no expert marble-cutters and Hasan had to make do with such pieces as he could find if he were to face the building with imperial purple porphyry, the

The Baghdad Kiosk
from the sultan's
garden

marble of the Caesars and the hardest of them all. There is a
tile frieze below the eaves. The quality of ceramics of fifty
years earlier could no longer be achieved but the Valide Kösem,
Murat's mother, was devoted to tilework. Since her son was
away on campaign so much of the time, she must have influ-
enced the decoration of this and also the Baghdad Kiosk,
which would appear to be by the same architect.

The Baghdad Kiosk was begun in 1639 on the site of the
first Ottoman pavilion, itself built on the foundations of a
Byzantine tower and then rebuilt by Süleyman because of its
magnificent view over the city, the Golden Horn and a green
expanse of fields and woods beyond where brick and con-
crete now crush the vision. The kiosk was built to celebrate
the recapture of Baghdad in 1638 and the fulfilment of Murat's
vow (made when the city was taken and he was a newly en-
throned adolescent) that he would drive the Persians out. It
can claim to be the most beautiful pavilion of them all and it
has a charm as well as splendour that one would not readily
associate with the conqueror of Baghdad for whom it was
built. It is a belvedere, raised on 5-metre-high arches above

the garden beneath. The single room is surrounded on all sides by a roofed balcony with perfect views over the city. At a later date, closets were inserted at the back which project and break the continuity of the walk. Again, the supply of marble was inadequate, porphyry in particular as one would expect, and so the facings of the pavilion are not in perfect balance.

The interior is dominated by the restored dome, which has been repainted inoffensively in red and gold. It is some 8.5 metres in diameter. Below it is a fine inscriptive frieze. There are four grand bays, with sofas on all sides, which could serve as separate rooms out of earshot of each other – but not of anyone on the balcony, and this recalls the Ottoman tag that to open the shutters is to open one's mouth. Dominant, between two of the bays, is the hooded fireplace (*ocak*), which reaches upwards to the dome and is of unsurpassed

The Baghdad Kiosk seen across the terrace from the Circumcision Kiosk, with the Sundown Bower of Ibrahim and the Elephant Garden below

elegance. On either side of it are blue and white tiles, white in the unblemished manner of the sixteenth century. The ballet of leaves growing from vases is in the *saz* style, already seen in the manuscripts of the Hall of the Treasury, and so represents the Magic Forest. The leaves are later copies of the tiles of the Circumcision Kiosk, which we have yet to visit, but without the gazelles and birds.

In the centre of the room is a *mangal*, or brazier, allegedly a gift from Louis XIV of France. All round the walls are cupboards lined with *cuerda seca* tiles. Like the doors, the shutters are outstanding examples of inlay – ebony, bone and mother-of-pearl. That these have been so perfectly restored is a compliment to the commitment of the museum craftsmen. To the north-east, the balcony looks down on its own garden, which is laid out on each side of a long basin in a very classical manner. Its ghost can be made out sufficiently in the shadows to give some idea of past splendour. The falling water between the vaults of the supporting piers has been dry for a long time and so the pool is empty. It is a garden which was designed to be looked down upon. Although large, it was only a part of the terrain, the *avlu* or walled area into which this garden was cut. From the balcony is an idyllic view of the city across the narrow Fig Garden, 9 metres below, and then that of the Elephant, which has lost the pavilion that divided it from the Boxwood Garden and Murat III's open pool. Long and lean, these gardens reflect the constrictions of the wall of the park and game reserve.

Who, then, was Murat IV? First, he was the son of Kösem, the most redoubtable of all Valides. He succeeded the insane Mustafa I, who had become sultan again after the murder of Osman II in May 1622. Mustafa was indeed mad, however, and by September of the following year he was deposed, leaving the economy bankrupt and the provinces in open revolt. He was only 33 and his life dragged on for another fifteen years. Murat was barely 14 when he succeeded, to find that the sluggish regicide Davut Pasha was Grand Vezir: not for long. Reaction, the lack of a policy, purpose or wisdom, together with the plotting of the Valide, deprived the vezir of both his office and his life within a few months. It is a little

late to cheer. But Murat was too young to rule even if the city had not been in turmoil. The government was in the fists, rather than the hands, of his mother and a sordid succession of scheming ministers whose power shrank the more that they struggled for it. Then Shah Abbas captured Baghdad on 12 January 1624 and slaughtered the Sunni citizens because of their natural loyalty to the Ottomans against the Shi'ite Persian sultan. However, the shah had those treacherous janissaries who had come over to Abbas' side boiled in oil, since if they had been traitors to Murat then they might well be to a shah. For Murat, as we have seen, the wound went deep as the unrest spread. He escaped into his own world of ruffianly youths who were sufficiently handsome to lead a carnal, fraternal life. One example was the handsome Armenian youth, Musa Melek Çelebi, whom Murat heard playing in the Mehter band. Later, another Çelebi, the famous Evliya, claimed to have been raped by his sultan. Murat certainly was attached to his court. It was not a good education and, as sultan in fact and not just in name, Murat had no respect for human life.

Escaping from his riotous boon companions, Murat took to sport and by the time that he was 20 he was seen to be exceptionally strong. He had grown tall and bronzed, with a splendidly luxuriant moustache and a fist that was powerful enough to make him feared. The hour had come to take over power from his mother and to literally sit on the throne. Perhaps his pleasure in being accompanied by a procession of wild animals on his accession was significant. He was no fool, however, and his few advisers included able men. In fact, it was either now or never as the janissaries and the *sipahis* saw hopes of leading a tyranny while their commanders had less and less authority over them.

Murat had gathered a number of followers within the *saray* and on 18 May 1631, still aged only 21, he struck. The Grand Vezir Recep Pasha was strangled and his corpse thrown in front of the Gate of Majesty for all to see. For the present, all that Murat could do was to set rebel against rebel and mutineer against mutineer. But he also appeared to side with the janissaries against the *sipahis* and once he had their allegiance

he used them. Every officer or member of the *ulema* still in the city was summoned to swear allegiance and sign a document of loyalty. If Murat cowed them with a personality even more formidable than that of his mother, he also gave them hope – the more so when he got rid of his licentious companions. His new Grand Vezir had been a secret adviser but it was the scholar Koçu Bey who was briefly the most valued by his sultan. He was the author of a famous document damning corruption all over the empire and in every latrine of the *saray* while retaining a genuine belief in the worth of the structure of the Ottoman state.

One example of Murat's ruthlessness must suffice. He had reason to believe that the young mufti of Bursa was corrupt, or at least lax in his duties, and that he was responsible for the road to the capital being unsafe. His father was the mufti of Istanbul, and therefore head of the *ulema*, but Murat had no respect for him. Sent to forewarn his son and remonstrate with him, the mufti arrived in Bursa only just in time to find Murat's command that father and son were to come to the *saray* immediately. When they eventually arrived, both were executed. The unprecedented execution of the head of the judiciary scorched the roots of society, and the muttering which had dwindled into whispers was succeeded by total silence except for the waters of the fountains. While at work on the morale of the janissaries, Murat IV deliberately went on campaign with them, scorning a royal tent and living as roughly as they did themselves, using his saddle for his pillow. He also cleaned up the city with a puritan zeal which extended to everybody except himself. Patrols, which sometimes included Murat in disguise, went out in the evening to make sure that coffee houses and, worse still, wine cellars were closed. If they were not, the proprietor and his customers were hanged without mercy, there and then.

Murat was also a strong believer in the guilds and it must be

admitted that part of his pleasure derived from the guild processions, which had always enjoyed playing down to baser spectators. Bears and bulls might be let loose among the crowds or cooks christen them with grease from the pan. Grocers, who were regarded as low fellows, threw rotten fruit and vegetables but confectioners cast sweetmeats so as to please their customers. Seated in the review tower overlooking the palace of the Grand Vezir (now the *Vilayet*, or police headquarters) and the present morgue, Murat enjoyed the wilder scenes and in the evenings was said to use anyone who strayed out late as a target for his bowmanship. One weekend, he was relaxing in a favourite pavilion with a splendid garden and orchard situated outside the walls of the city, now the headquarters of the First Army. He was sleeping alone (because he would have no truck with pages holding candles to guard him against intruders), when God suddenly intruded with a roll of thunder and the room was struck by lightning and the bed singed. Already on the edge of mania, the great soldier was finally unhinged. Later, an eclipse of the sun preyed upon his mind as if heaven had sent the bill for his years of debauchery.

Murat did not just distrust and loathe his family; he also seems to have distrusted himself. As he saw it, the Ottoman dynasty had reached the last dregs. If it were extinct, the succession would be the accepted right of the Khan of the Crimea. The current leader of the Giray family won Murat's respect; he was designated the heir and attended sessions of the Divan. One by one, Murat's half-brothers were executed until only the unbalanced Ibrahim was left. Fortunately or not, Murat's five sons had all died young: one at birth in 1636 and the other four all at once in 1640. The sultan was mortally ill when he ordered the strangling of Ibrahim but Kösem Valide delayed the execution just long enough for Murat to die of cirrhosis and for her to regain her position of power.

It was Ibrahim who repaired the terrace which became known as his. In the centre of the side open to the city he built his Sundown Bower (Iftariye Kameriyesi) in 1640. Designed for the sultan to feast in after the Ramazan fast, which ended at sunset, the kiosk consists of little more than four

Gazelles in the
Magic Forest with
interlocking stars
above

bronze poles supporting a once gilded metal roof crested with
a large and splendid finial, the name of God. A curious fea-
ture is that the tops of the supporting poles are slightly out
of alignment: not, one would suppose, to symbolize the un-
balanced mind of the ruler. Between the bower and the Bagh-
dad Kiosk at the northern end of the esplanade and the
Circumcision Kiosk on the south, from which the bower is
equidistant, Ibrahim had trellises hung with vines. Travellers
remarked on the quality of the delicious grapes grown at the
saray, their abundance and their sale, along with other *saray*
harvests, from the multitude of gardens in the *meydan*, or
level ground, beyond the Gate of Majesty. The terrace was
designed for relaxation and the sultan was amused by those
buffoons and dwarfs whose predecessors were tumbled into
the pool of Murat III.

The Circumcision Kiosk was used as a committee room
until Ibrahim, who was meticulous in his observances of

prayer times, made it his oratory. In 1640, with an unexpected respect for economy, Ibrahim did not pull down but restored and enlarged the existing kiosk: some of the original workmanship can be seen in the lower courses of stone. It is the last pavilion in this court, and beyond it the colonnade continues down the west side of the Pavilion of the Holy Mantle with a broad terrace overlooking the Fig Garden some 9 metres below. The Elephant Garden lies beyond. The end is abrupt and the wall masking the Harem quarters is impressively lofty. Indeed, these walls with their often triangular buttresses are very much a part of Ottoman architectural history. A small door opened into the sultan's apartment when he visited his chosen maidens. Retracing our steps to the Circumcision Kiosk, and peering in if possible, we may glimpse Ibrahim's changes, including its division into two rooms which retain some of their original windows. The small room was a place for ritual ablutions before prayer and when a circumcision did occur it was here that it took place. However, the princes were then taken to sofas under the eaves of the Baghdad Kiosk, with curtains under each arch for when they were feverish.

The first Circumcision Kiosk was built for Selim I but was transformed by new appointments such as its renowned carpets and rugs. It was in this original room that the most terrible circumcision ceremony of all took place immediately on the accession of Mehmet III: it was here that, on 28 June 1595, nineteen brothers and half-brothers kissed the new sultan's hands, were circumcised and then strangled with a handkerchief. Abdullah and Mustafa, who were probably the eldest at the age of 10, Abdurrahman, Ali and Bayezit who were 9, Hasan and Mahmut who were 3, Yusuf . . . all died as princes should. Their names are all recorded. The overpretty story of one boy asking the executioner to let him finish his cherries is a fable. The executioners were deaf mutes and could not be witnesses either to the courage of the little boys or to their shame at their own actions. The law said that the princes must die and religion said that they had to be circumcised for the good of their souls. The population thought otherwise and Ahmet I was to abandon such

executions. The broken-hearted mothers were sent to the Old Palace to be married off.

At each side of the entrance to the kiosk is a unique display of tile panels from Iznik. The earliest are those of hexagonal designs, like blue stars round a white ground. Because each ray is shared with the adjacent star and those around it, the eye does not rest but roves over this extraordinary sky. Such designs are seen at their finest in the Green Mosque in Bursa, where they date from about 1420 and are the work of potters brought from Tabriz. They are distantly related to examples inside the Tile Kiosk built by Mehmet II. *Cuerda seca* tiles have been met before at the Chamber of Petitions and these before us now are excellent examples.

The tiled panels, copied in a later mood for the fireplace wall of the Baghdad Kiosk, are exceptional. Here the coiled, feathery leaves climb up the white ground and the pheasants sheltering on the upper branches are unique. Below are mythical Chinese *qilim* similar to gazelles. This magnificent monument to the blue and white style appears to date from the first half of the sixteenth century. Between these panels is one belonging to the great Iznik climax of the 1570s and which is brilliantly in bloom.

There were other kiosks built by Ibrahim elsewhere. They were to be notorious because of his passion for sables, which was but one reason for his deposition. Ottoman gold flowed into Russian coffers like corn into a nosebag. The sables were for the walls and floors of the chambers of the sultan's women – of whom there were all too many, including the daughter of the mufti, who refused permission for her to marry Ibrahim in alliance with the Divan which also protested vigorously. The will of a sultan was law, however, and adding yet one more humiliation, the mufti was required to conduct a genuine wedding ceremony. Extraordinarily – the only time in the recorded history of the dynasty – Ibrahim even forced the Grand Vezir, Ahmet Hezarpare Pasha, to swap his wife for one of the sultan's own daughters. Another girl he had kidnapped from a *hamam* because of her father's guard over her but Ibrahim was either shamed or disappointed because he soon sent her back. Like Ahmet I, from whom he descended, Ibrahim liked fat Armenian girls. He took Şekerpare

('Sugar Lump'), who weighed 140 kilograms, but he died shortly afterwards and she was tactfully exiled to Egypt. There she married Kara Musa Pasha, who was executed a year later.

Ahmet Pasha's nickname, Hezarpare (meaning '1,001 Pieces'), refers to his subsequent appalling death when he was hacked to pieces by the mob, a death that he might be said to have deserved. During his lifetime he was called Şeyri, or 'the Urbane'. His new wife, Princess Bibi, was only 3 years old and so no consolation for the loss of his first wife to his sultan; but he did have a son born to another wife in 1640. He became engaged in childhood to another of Ibrahim's daughters, but she did not live. There is no more known about the boy, appropriately named Baki ('the Enduring or Surviving Bey'), nor whom he eventually married of his own free choice: if he did. His father, who was Grand Vezir and besotted with bribes, was executed on 7 August 1648 – the day before Ibrahim was dethroned, to be executed himself eleven days later. Bibi lived until 1700 when she was 53 years old.

Ibrahim abandoned all the considerable economic reforms of Murat IV and the refilled treasury was squandered. Once again there was unrest among the janissaries and, indeed, everyone who was not being paid. His one remarkable Grand Vezir was Kara Mustafa Pasha who, as we have seen, is associated with the Sofa Kiosk. His integrity upset both the Valide, Kösem, and Cinci Hoca, the sultan's poisonous tutor who was young and had the sultan on a leash and yet intrigued against him. In despair, Kara Mustafa roused the janissaries but too late and on 31 January 1644 he was executed. This triumph meant the return of rule by bribery, a debased coinage and unpaid officials. Finally, in 1648, at the age of 33, Ibrahim was overthrown by the janissaries. He was confined in the Sirkesaray, or Vinegar Palace (also known as the Palace of Nits, echoing the nicknames of the daises of the pages' dormitories). Either way, it was a bitter fate and, as we have seen, it could have been an attic room opening onto a landing, both without windows. Ibrahim was now so clearly demented that the mufti issued a *fetva* authorizing his death. He was strangled with a garter by the then-famous executioner, Gloomy Ali, who was advised to accept 500 ducats and go on

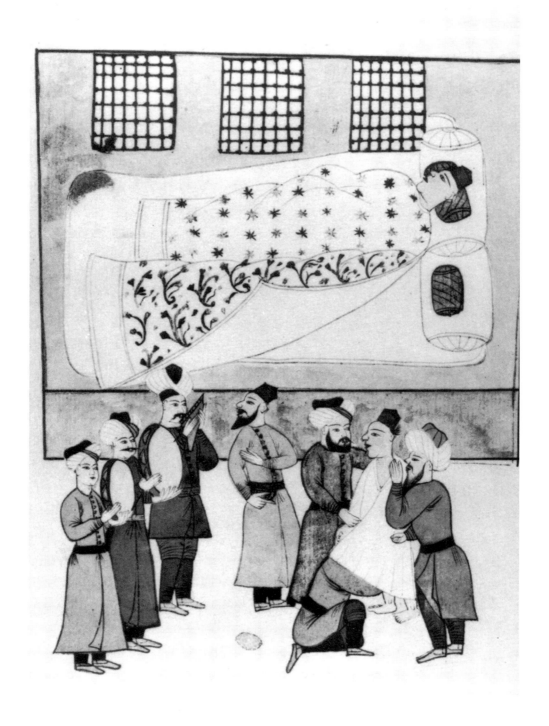

The circumcision of a prince
Music to drown any cries and the bed of honour

the pilgrimage to Mecca. Ibrahim was succeeded by the 6½-year-old Mehmet IV, who lived mostly in Edirne. Murat IV had surely been right to name the Khan of the Crimea as heir to the throne.

Just as it was essential that a male should be circumcised before his death, so was it essential to circumcise a prince as soon as he was accepted as sultan. This had been the case with both Ahmet I and Murat IV, who were 13 and 14 years old respectively. But Mehmet IV was too young to understand the meaning of the ceremony and there was the minor matter of pain, although by then the *ulema* reluctantly permitted the use of anaesthetics. Mehmet III was not circumcised until he was 16, well before his father died. In his case, the problem was that celebrations were so costly that it was sensible to operate on all the sons at the same time and even include the marriages of daughters too.

Mehmet IV had no interest in the *saray* except perforce the restoration of the Harem after the fire of 1665. It was not until the troubled accession of Ahmet III in 1703 at the age of 30 that there was a sultan who cared about the *saray* in Istanbul as opposed to that in Edirne. Once the worst troubles were over, he could revolutionize Ottoman life – and thus create new unrest. The reforms that he achieved were due to his sensitive and highly intelligent Grand Vezir, Nevşehirli Ibrahim Pasha. He had risen from being a minor clerk in a far-away Anatolian town, little more than a village, to be called to the capital to work in an office of the *saray* where Ahmet III came on him by chance. Friendship flourished and the administrator not only became first minister but also married the sultan's daughter, Fatma Sultan. At the age of 16 she was already a widow. It was part of the usual policy of entwining powerful officers of state in the web of the imperial family. But this marriage was different because Fatma adored her middle-aged husband for whom she battled even when he had to be abandoned by her father. Nevşehirli Ibrahim Pasha was executed in September 1730 in order to save him from the horror of a lynching. For Fatma the fight went on until she herself, sick with grief, died two years later. She left two sons to mourn her. Mehmet Bey died aged 14 but Young Mehmet married an aunt of 12 who died when 25. He became a pasha and lived until 1768 when he was in his 40s.

Damat (meaning 'Son-in-Law') Nevşehirli (from Nevşehir) Ibrahim Pasha inspired Ahmet and it was he who sent Yermisekiz ('Twenty-Six') Mehmet Agha as ambassador to Paris: twenty-six was simply his regimental number in the janissary corps. The ambassador rented a fine mansion in the centre of Paris and brought with him a suite of secretaries, cooks and servants. The entourage intrigued the French, but not so much as Mehmet himself, who became a favourite of the great ladies of Versailles and entertained a flow of visitors. He was rewarded with the plans of the *plaisance* of Marley-le-Roi and a part of the palace at Versailles. On his return to Istanbul, he was responsible for an enchanted retreat being created at the head of the Golden Horn. There, like Marley, a grand basin was lined with kiosks built by ministers, and western baroque was born afresh in Turkey. Saadabad ('Palace of Joy') was destroyed in the popular uprising of 1730 and, indeed, during a period of military defeats and troubled economics it was a provocative extravagance with its tiles and musical fountain. The poet Nadim wrote a famous love song about this paradise:

There'll be only you, myself and one musician skilled in song
　　And if you are agreeable, poor Nadim will come along.
　　All our other friends forsaking, let this day to us belong.
　　　Let us visit Saadabad, my swaying cypress, let us go!

In those fateful days Nadim vanished, never to be heard of again.

Ibrahim Pasha encouraged his sovereign's creative ideas and, among many innovations, established the first printing press in Istanbul. Beside the Gate of Majesty, Ahmet III also built the grandest baroque fountain from which sherbet and water were dispensed through grilles at each corner while anyone could fill their pitchers from the taps between. Not without reason, this fountain is one of the best-known monuments of Istanbul. The movement of the canopy, the curving of the corners, the elaborate floral carvings that were once painted, the poetic inscription under the eaves and the divine gift of water all add up to the arrival of baroque from France, to be translated into a new language. It was a style

which could be disastrous when applied to a major mosque but which was ideal for pavilions and water. Seyit Vehbi's poem in honour of Ahmet III, and somewhat bumptiously of himself, compares the fountain to the waters of paradise.

Ahmet III was as devoted to his park and gardens as Murat III had been; and the founder, Mehmet II, would have been well pleased. The lavish expenditure on the *saray* gardens under the Ottomans was astonishing. Mehmet II had once ordered half a million narcissus bulbs from the Crimea, while a lonely promontory in Greece had been conquered in the sixteenth century simply to harvest its double violets, as yet unheard-of in France and Italy. Fifty thousand white rose bushes were matched by an order for the same number of blue roses – whatever they might be – from Maraş while 20,000 red roses came from the royal market gardens (also founded by Mehmet II) in Edirne. Later, above the palace at Manisa, the hillside was to become a veritable cascade of bulbs. Something of the order of magnitude of the caravans is indicated by Mehmet's request for 16 tonnes of white roses, also from Edirne. The wildly improbable number nevertheless reflects the toll taken by journeys that lasted many weeks on the backs of camels and mules. The roads must have been strewn with dead bulbs, which were doubtless only modest fertilizers. Trees were equally important and a janissary detachment was constantly at work transporting them from the forest round and above the Gulf of Izmit. Five thousand were delivered in 1745 and they included arbutus, elm, hornbeam, lime, various oaks, plane, terebinth and wild pear. The Ottomans had exported the incomparable wild tulip with its pointed petals to the Netherlands, where the bulbs were cultivated and developed until the Ottomans were reimporting their descendants.

The terraces below the *saray* must have been wonderful. Taking advantage of this, Ahmet and Ibrahim instituted the Flower Festival, which took place on the day and evening of the first full moon in May. The first day was devoted to the officers of palace and government, after which the women of the harem could visit it in seclusion. For them there was a treasure hunt for trinkets while all guests enjoyed music, song, poetry and dancing boys on both days. The Turkish word for these youths is *köçek*, which also means the foal of a camel.

The whole area was converted into a conservatory, which is likely to have been erected in the Sofa Garden. Plants were stacked in pots one above the other on a grandstand of shelves. These must certainly have invaded and overcome the royal terrace of Ibrahim and flowed in and out of the kiosks and colonnades until visitors did not know whether they were inside or out: it could not have been more Turkish. If a flower withered, Ottoman artists were adept at creating the most delicate paper flowers to take its place. Tortoises ambled round with lanterns on their shells, and lamps of coloured glass and globes filled with tinted liquids hung everywhere. Canaries and other songbirds added delight to delight. It may be that all the lower gardens, including those of the Baghdad Kiosk, were brought to life. There are handsome stairs beside the Sofa Kiosk leading down to these gardens, although simply to survey them from the terraces might seem enough.

On a lesser scale, similar festivals were held along the shores of the Bosphorus at one or other of the royal pavilions and palaces. Rightly famous under the cloak of Tulipomania, such a title ignores the variety of bulbs in bloom, with each of them having its own place. Daffodils, crocus, honeysuckle, jasmine, geranium and, above all, narcissus were loved and prized. A language of flowers grew up with which the amorous could communicate silently in the same way that courtiers used the deaf-and-dumb language of the *saray*. Naturally, there was the special post of Master of the Flowers. It was no sinecure.

There was also a long tradition of artificial gardens, to which we shall return. Men would shoulder trays of sugar planted with dwarf fruit trees and miniature flowers, and also model kiosks with their pools and baby fountains. One account tells of a model where water trickled from hand-high hilltops and some models were enriched with turquoise and mother-of-pearl. Others were carried on floats of six or eight wheels and were accompanied by musicians. The dockyard slaves who pulled or bore these imperial toys were liberated at the end of a festival.

The Flower Festivals overshadowed other occasions. Such pleasures included horse racing, with young boys for jockeys equipped with reins and whips but with neither saddles nor

A late sixteenth-century tile panel in Iznik's grandest manner

stirrups. Turkish thoroughbreds were the ancestors of the bloodstock of Europe. Indeed, early in the nineteenth century, Lord Derby exclaimed that the Turks used racehorses to pull their ploughs. Ahmet III's reign was a brief interlude of delight for a few, but of harsh reality for many. The Ottoman court would never regain pleasure in pleasure itself. It was not simply that the mob was knocking at the gate even after the corpse of Ibrahim Pasha had been flung to them – later to be honourably buried in his fine foundation at the Şehzade. Victorious, the illiterate strutted about the Second Court and appropriated grand offices, whose function they could not imagine except to get rich. But 18 months later, after he had bided his time, Ahmet's cool successor, Mahmut I, invited leaders and lesser lights alike to a great feast and slaughtered all 400 of them there and then. His 24-year reign was tranquil after that, although he was sufficiently hostile to the Orthodox Church to send Patriarch and bishops to the galleys. Leaving government to his ministers, he lived a life of pleasure. He was educated, however, and a bibliophile who made the Revan Kiosk his personal library. Riding back to the *saray* from noon prayer one Friday in 1754, he suddenly died in the saddle at the age of 58, of apoplexy.

The Park

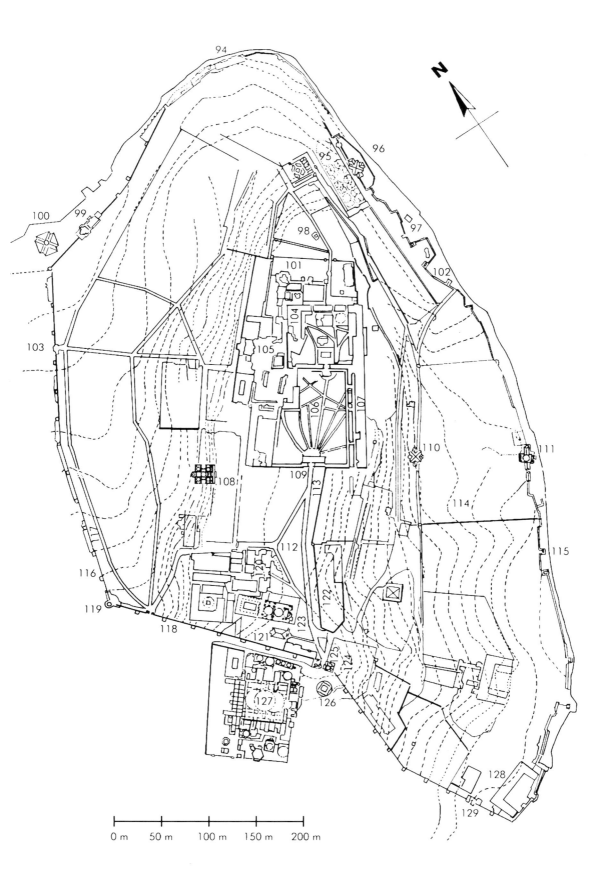

A rococo drinking fountain, marked 'Safe', at the gates of the Park of the Rose

The Park of the Rose

(Gülhane)

Gone the time when nature's verdure
languished listlessly in bed,
When the garden's heart was stricken
just by hearing 'rosebud' said.
Now the time has come when tulips
turn the hills and valleys red,
Taste their pleasures while you're able;
pass they must these days of spring.
(Mesihi, d. 1512; trans. Nermin Menemencioğlu)

There are many parts of the grounds of the *saray*, not all of which may be visited. At least nowadays no eunuchs will be crying '*Halvet!*', or 'Privacy!', which meant that all men, whoever they were, had to escape by the nearest gate until the harem women left. Not even a muezzin might mount to the balcony of his mosque if it overlooked any part of the *saray* grounds whatsoever. And to hide, let alone peek, meant immediate death. To walk in Gülhane Park is to be overwhelmed by a medieval fair. There are also many fine trees to admire.

First, however, we must pass through the turnstile, down the hill from the great gate of the First Court. Here we can admire a small rococo drinking fountain in the Ottoman style at its best. The lively leaves in marble make a definite visual statement which is so complete that one more curl would have been disturbing.

On the other side of the avenue is the Kiosk of Processions (Alay Köşkü), where we have already encountered

The belvedere of the
Alay Köşkü (Kiosk
of Processions)

Murat IV shooting. From the reign of Murat III, it was used
as an obvious viewpoint when it was merely an old Byzantine
tower. The core of the tower is still there, but because the
Ottomans were not concerned with conservation, the pavil-
ion (rather than kiosk) was rebuilt rather than just redeco-
rated by Mahmut II in the first quarter of the nineteenth
century, with rooms for women to enjoy the pageants, not to
mention royal children. It was not only used as a vantage
point for the guild processions but as a place for ministerial
discussions. Mahmut II's pavilion has a splendid central room
crowned by the finest onion dome in Ottoman architectural
history: it has twenty-four ribs and tilted eaves over the large
grille windows, seven in all – making one for each facet. On

the garden side are frail retiring-rooms, lightheartedly painted. This extension is of brick, supported and ribbed by twenty-six posts over the Byzantine basement. The pavilion is approached by a spacious and gentle slope rather than a stairway. Since it is only rarely open, it is best seen from the street. Mahmut II lived until 1839 – just long enough to see his transformation completed.

The tower had considerable political importance. The public who came to enjoy the guild processions (and many of whom had members of their family on parade) used the occasion to pay homage to their monarch. Safe in his tower, the sultan would appear at his window and address the city mob or mutinous janissaries. Once, the corpses of the Chief Black and the Chief White Eunuchs were thrown out as a sacrifice. But by the nineteenth century, the room was

Cross-section of the
Alay Köşkü

Still hidden by
bushes, the secret
gate of Sokollu
Mehmet Pasha

convenient for the entourage and sultan to meet before setting
out to attend Friday noon prayers at the chosen mosque.

The guild processions (which lasted three days) were led
by the great officers of state, the mufti of Istanbul and the
leading judges of the *ulema*, their beards shampooed and
scented. The three days were symbolic of the balance of power
between the state which spent wealth, the merchants who made
it and the army which, at least in theory, defended it. Digni-
taries might don headgear that was symbolic of fabulous days.
The chamberlains, for example, wore seven feathers on their
heads to evoke the Simurgh, the bird of paradise. Bands came

one after the other, echoing distance apart, because their art was said to polish the soul. Bakers baked, bottle-makers stoked even hotter ovens and barbers shaved intrepid customers however much the floats might lurch. Each guild had its patron. Plato was considered to belong to the mustard sellers because he had been prone to wind and took mustard for his digestion. The costly clothes of the apprentices reflected the wealth of grander trades such as goldsmiths or coffee merchants. It was all much more exciting than Harrods, Bloomingdales or Galeries Lafayette. We have encountered some of the less noble guilds already although why fruit sellers fought each other even when they sold flowers we can only guess. Tanners frightened the crowd and were known as 'man dragons'. Beggars horrified: the great ones — the gangsters of their time — rode mules while the worst were naked except for their sores. Butter-makers threw grease in people's faces but the tar-makers did far worse damage. Firework-makers tied their wares to the tails of bears, wolves, swine and dogs — which were the secret population of the city. These tormented animals rushed wildly among the spectators to the delight of Murat IV. The last great guild procession was held in 1720 in honour of Ahmet III. After he was deposed, the heart seems to have gone out of the event until in 1769 it was abandoned for ever after one given for Mustafa II.

Just a little way downhill from the tower on the right is a small postern gate: it is opposite the tired but lavish entrance to the Grand Vezir's offices known as the Sublime Porte, rebuilt in the taste of the late nineteenth century after one of several fires. Half-hidden as it is, the gate (which was created for the all-powerful Grand Vezir Sokollu Mehmet Pasha) is worth a smile. History records that two Turkish girls, on their way to pay a family visit to Egypt, had been captured by the French. The French admiral broke a truce with his act of piracy, but such misdeeds were common enough on both sides. The girls were not only beautiful but winsome and they were sent to Catherine de Medici as a gift. The queen was delighted to make them ladies-in-waiting and eventually they married noblemen. Unfortunately, their mother at last found out what had happened at the very time that a treaty was

being negotiated between the Ottomans and the French. She had a good clerk with a clear script and a piercing voice and proceeded, as she had the right, to petition Süleyman's stirrup and also the Grand Vezir (quite apart from an exasperated French ambassador), interrupting his work day after day. The Ottoman government begged the girls to return but it was clear that they were happy and thankful to be out of earshot of their mother, whom Sokollu Mehmet Pasha avoided by escaping by this secret gate. Selim II had succeeded his father before the woman ran short of money and she was bought off, but the door remains as her memorial and as a tribute to the tolerance of the Ottoman government.

The walk in the park has yet to begin and includes an escape from the hullabaloo of the fair, but the famous cypress avenues and the orchestra of fountains are gone. It is worth ascending the slope among the fine trees to inspect the back of the Tile Kiosk with its projecting bay (which visitors rarely see) if only because of its scattering of glazed bricks. The kiosk itself will complete the visit. When we finally climb to the end of the stalls and sheds, we come to the Goths' Column (a reference to their defeat by the Romans in AD 268), which is 12 metres high and supports a Corinthian capital.

A barracks for the gardeners was built above the nearby gate. Beyond are modern teahouses which do not compare with the lost pavilions of the sultans. If we persevere to the end, there is a view of the back of the *saray*. This includes the delivery door of the present restaurant far above. It gives some idea of the quantity of waste produced by the *saray* kitchens and the effort needed to carry it down to a sump near the Stable Gate, there to be shovelled into the swift current of the Sea of Marmara and feed the fish. But enough metal objects sank, including gems and gold from the *Hamam* of the Pages in particular, for diving sessions to take place three times a year: clearly with some success. It is also possible to

A rear view of the
Tile Kiosk

catch a glimpse of the massive retaining wall that Bayezit II
had built to protect the *hamam*.

Abandoning this area of the park, it is time to consider
the domain of the pasha of the parks and gardens, the
bostancıbaşı, who was also Chamberlain of the Household.
Certainly the equal of the Chief Eunuch, his power was aug-
mented by his terrifying subsidiary office as Chief Execu-
tioner, although he never wielded the axe himself. It was his
duty to summon any notable who was in trouble to his kiosk
in the fish market, which came under his jurisdiction due to
his control of the royal fisheries. When the vezir or other
unfortunate miscreant arrived, he knew well why he had been
summoned but he had to bite his lip through the courtesies
of hospitality before, at long last, being handed a cup of sher-
bet. If it were white, he sighed with relief, but if it were red he
was in despair because red was the colour of death. The sen-
tence was carried out immediately by five stalwart janissary
cadets unless a plea to be sent into exile were granted. As we
have seen, the same lusty teenagers would usually ride after
him and catch up with the wretch after two or three days and
dispatch him on the road. Later, however, the system was

relaxed and exiles were let go. A few even managed to return.

The chamberlain was also responsible for the local police and the inspectors of woods and waterways and he was in charge of law and order along the seashore. Murder and theft were not frequent in Istanbul and the streets were remarkably safe. Serious crime was usually the work of soldiers. At one time, the illustrious officer had the use of the Yalı Kiosk near Seraglio Point besides other less splendid coastal residences and lands which rewarded him with enviable revenues; he also made an income out of renting new janissary recruits to landowners. These kept the lads hard at work on the farms and their pittance went to the chamberlain and not the recruits. He also ran a prison in the park for convict labour; and labour they did. Above all, he was the Head Gardener who knew his pinks from his elderberries, his eggplant from his sage. His responsibilities were unremitting, for flowers cannot cheat or the flavour of tired lettuces be restored. Every spring, he had the honour of giving a great feast at the Sweet Waters of Europe at the top of the Golden Horn. It was the only official banquet that the sultan invariably attended along with his vezirs and leading officers.

Such a post was bound to enliven jealousies and develop quirks. There was a separate establishment at Edirne since a gardener could not spend weeks away from his jonquils or his orchards. When the head gardener died at Edirne, he could only be replaced by a local man and never from Topkapısaray: and vice versa.

There were 3,000 men and boys divided into 9 different ranks in the pasha's establishment. Most were janissary recruits who had failed to become the pages of a pasha and certainly not of the sultan. Most were aged between 12 and 25, but some remained until the end of their careers. All were trained as combat troops although between 300 and 400 were left behind when the sultan went to war. A skilled company was trained as oarsmen to row skiffs and barges. Others guarded the barracks at the *saray* and were the sentinels at the dozen gates and, later, at Dolmabahçe and the Bosphorus palaces. Some 300 or 400 of them went on campaign or accompanied the sultan to Edirne as tent-pitchers. They had

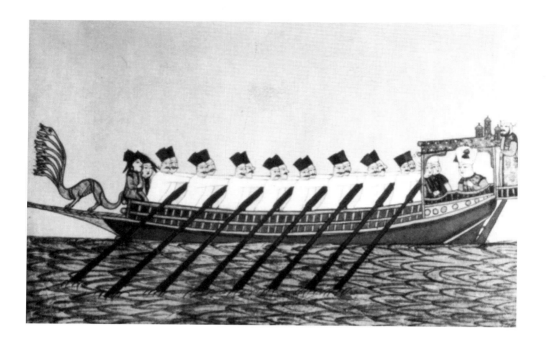

The Royal Barge

always to be a day ahead in a game of leapfrog so that all was perfect when the sultan arrived from his previous camp. Only the chests and baskets travelled with him.

With the departure of the sultan from Topkapısaray in the middle of the nineteenth century, the staff was cut drastically. The account books of 1879 show that some departments were still working, however, including the profitable market gardens. Like the janissary guards, 200 gardeners and workmen were lodged in the Byzantine towers. In all our perambulations at the *saray*, we have met with very few people who enjoyed privacy of any kind. Vezirs and high-ranking officers certainly did: one thinks of what is now the Museum of Turkish and Islamic Art, which was probably the grandest of the Grand Veziral residences. Lady Mary Wortley-Montagu makes clear how different home and office were. When in Edirne at the beginning of the seventeenth century, she was invited to dinner by the wife of the then Grand Vezir. A coach was sent for her and her lady in attendance, and on arrival she proceeded through several rooms with 'she-slaves' [sic] fully dressed and standing on either side. The great lady was robed

Pages using *jerids*

in sables and they proceeded to feast on 50 dishes served one at a time: a great number of ragouts in particular. The soup was served last. Meanwhile, perfumed girls played guitars and others danced. Two black eunuchs then escorted the great ladies through the wooded garden to a pavilion overlooking a pool with gilded sashes to the windows, under trees covered with jasmine and honeysuckle. There a 12-year-old sister was discovered covered in jewels. This was an ideal Ottoman life of which a Valide might be jealous.

Lady Mary was also the guest of another great lady who wore a gold brocade kaftan, a silver shift of finest gauze, a jewelled belt and bracelets. Then a princess arrived with jewels hanging to her feet. An exotic dance was performed by harem girls while censers perfumed the air. One is touched that Lady Mary appreciated the gossamer towels so much that she was ashamed to soil them.

We must now descend to the Stable Gate and peep before taking the Marmara highway to Seraglio Point because the whole south-eastern area is closed to visitors. In the middle, a barracks protects a neglected area where there were exercise grounds, archery butts and *jerid* fields which were the sportsgrounds of the pages. The immense stables for the Inner Service and the *sipahis* are gone. Most of the horses, however, were kept outside the city in order to protect the meadows from overgrazing. Breeding was reserved for Bursa and Edirne. There were also prize nags from Wallachia for junior officers and 5,000 mules were kept in Thrace. Thus the dignified gate is a symbol of times past. The area for hunting was in the woods that we have already seen but the deer, goats, bears and lions were kept in a Byzantine church against the wall. It appears in early eighteenth-century engravings but has since vanished. In 1681 another church over by Seraglio Point, with a monastery attached, was that of St Demetrius. Complete with mosaics, it served as a dormitory for the gardeners.

Outside the walls near the Stable Gate were rough landing stages for the royal fishermen, who also had a wooden fishing tower floating at some distance from the shore. Other vanished works included kilns which were important for repairs and maintenance besides supporting the building programme which never quite came to an end. There were also sawmills, windmills and boatyards, with each group of artisans housed in the nearest tower. Reference has already been made to the wells and cisterns of Sinan. Into the 1960s, before this area was out of bounds, it was possible to find a particularly large font used as a trough and which probably came from the church of St George of the Manganese. At least the modern highway was built largely over the rocks, but the coming of the railway in 1859 did untold damage to the park. The greatest loss was that of the Summer Palace and its large gardens towards Seraglio Point. Although Melling's project may not have been carried out, an early nineteenth-century engraving by him shows a lightly built, three-storey summer-house with ample rooms and broad galleries.

The Pearl Kiosk (Incili Köşkü), in the middle of the Marmara Wall between the stables and Seraglio Point, was the gift of Sinan Pasha to Murat III and is said to have taken its name from the unusual number of pearl tassels hung from the ceilings. It was built by the architect Davut Agha between 1590 and 1591 near the Mill Gate – for many years, the *saray* had ground its own corn. Its foundations are still striking, emerging from the rocks in the form of vaults against the wall and incorporating a Byzantine tower. At the foot of the tower was a spring called Tu Sotiros which was particularly venerated by followers of Greek Orthodox beliefs. The central chamber was some 10 metres long and slightly projecting: it looked straight out over the sea. But on holy days, Murat III was amused to look down on the devout on the beach making their pilgrimage to the well in the basement where there are now the remains of an Ottoman fountain. Later, wharves stretched all the way to Seraglio Point from which royal salutes were fired, but cannon also fired on any ship that sailed too close to the shore. When the wind dropped or was contrary, however, boats would haul the ships round

the point, much to the enjoyment of the Valide and other harem ladies who had come to watch.

The kiosk had large lateral rooms and fireplaces with chimney stacks so slender that western travellers mistook them for minarets like the one surviving in the Pavilion of the Holy Mantle. Not a trace remains of this considerable structure nor of its famous panels of Iznik tiles. These may have been moved when Mahmut II restored the building early in the nineteenth century.

The pavilion was completed in time for the first Islamic millennium, to which people looked forward with misgivings and even dread. Murat III believed that it presaged his death. All of this gloom proved to be misplaced: the year was unremarkable and no worse than any other at the time. But Murat suffered increasingly from melancholia as if he had never been a sultan who was famous for his festivals. He was ill from stomach ulcers and a deep depression, possibly at the fate of his family and the coming decimation of his sons. He had to abandon his skills as a horseman and with a sword, but he may have continued to make arrows with the prized

An eighteenth-century view of the Pearl Kiosk; only traces now remain

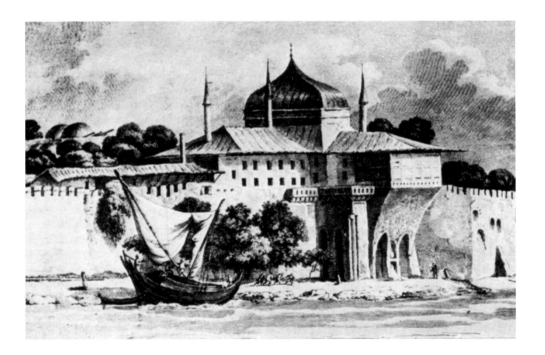

quills of the wild geese nurtured at the *saray*. His courtiers
had nightmares in which great trees fell and Haghia Sophia
was destroyed. Finally, the famous seer Saatçi ('Clock-Maker')
Hasan Pasha feared the worst and wrote to the sultan, who
promptly went into a decline and died three days later. One
may note that the clock-maker's prophecy was somewhat be-
lated. In the Islamic heaven, God has a tree of mankind where
each leaf bears the name of every living person. When an
angel shakes it and a person's leaf falls, their soul has forty
days to live – which was thirty-seven more than Hasan Pasha
could allow. There is also the question whether forty signi-
fies infinity: the leaf, after all, is already in heaven.

Let us remember Murat III for his Venetian lust for festi-
vals, pageants and mock battles, and equestrian sports. At his
time, processions included architects carrying models of great
buildings or working windmills, galleons and galleys, sugar
gardens made of wax, and children dancing. The *nahils* (date
palms) could be 23 metres high: these were multifoliate trel-
lises which were symbols of fertility and were carried at wed-
dings in honour of both bride and groom. They were so big
that the sultan had to pay to have balconies and eaves re-
moved (and subsequently replaced) in order to let them pass
But there were also marionettes, recitations by poets, and at
night breathtaking firework displays with backdrops of tin-
sel to reflect the dazzling blaze. To celebrate the birth of Kaya
Sultan to Murat IV (whose wives were unrecorded), Evliya
Çelebi filled a boat with seven huge rockets. Each exploded
with a loud bang, launching another large rocket which spewed
and frothed. Then it shot off forty smaller rockets which
scattered and fell into the crowd of spectators.

More than a century later, Ahmet III also enjoyed guild
processions. The celebration of the circumcision of his 4 sons
when the youngest, Bayezit, was only 2 years old took place
on the archery ground on the far shore of the Golden Horn.
The 10,000 wooden plates and as many pitchers were exceeded
in number by the 15,000 lamps. All had to be organized in
less than a fortnight, including the roasting of 7,900 chick-
ens and 1,400 turkeys. Three hundred surgeons were kept hard
at work on 5,000 sons of the humble.

Before continuing with the festivals of Ahmet III, however, one should lament the vanished Marble Kiosk at Seraglio Point itself. It was indeed built of marble for Abdülselam Efendi ('Gentleman'), who was treasurer between 1514 and 1516 or even as late as 1518. It was intended as a luxurious lookout post and one wonders how the minister acquired the gold to build himself what must have been one of the most expensive sentry boxes in history. However, it was presented to the sultan just as Hampton Court was presented to Henry VIII. Grand Vezirs and pashas were in the habit of making noble gifts to the sultan. If one of them was given a jewel or valuable by the sultan, the lucky ones knew that they had to make a present of greater worth in return. It could be seen as a form of taxation. Koca ('Venerable') Sinan Pasha not only gave Murat III the Pearl Kiosk but also the Yalı Kiosk, which must have been nearly as costly to build and furnish. The pasha was a Grand Vezir of little prestige whose fame rested on his conquest of Yemen. Masked by gossip, no doubt, there seems to have been some truth in reports of his lumbering manners and his temper which was as coarse as it was beyond his control. As for corruption, the two finest kiosks in the *saray* can only have been paid for by the use of other people's backs. The sultan was, however, placated.

The highway and the railway cut the last of the pleasure pavilions off from an already shorn park and the Basket-Makers' or Net-Makers' Kiosk (Serpetciler Köşkü) is the only one that still exists. This a tribute to the formidable piers and vaults added to the Byzantine wall, which here is almost 2 metres thick. It ends in a tower of the same period. On such foundations the gutted remains of the actual pavilion perched, 8 metres above the road, seemingly doomed but eventually rebuilt as Istanbul's press centre. Inscriptions and stonework have been preserved. The pavilion was first built for Ibrahim in 1643 but it was extensively renovated by Mahmut I and again early in the nineteenth century in particular. It consisted of a splendid open summer hall with a fountain. The wide arches, with their blinds to ward off the wind, must have been enchanting. A modest door led past service rooms to a grand salon with traditional projecting windows and

sofas. It was a perfect viewpoint from which to watch the shipping of the Golden Horn and the mouth of the Bosphorus. Although the room has lost its hooded fireplace, its shallow dome has been restored. The walls were of brick girded with wooden struts while the window frames were of marble and the roof was an elaborate wooden structure of trusses and cross-beams covered in lead. The sea came within a few metres of the garden, where there is now a veritable bulwark protecting an open-air bar for journalists. Before railway and goods yards (not to mention tired barracks) cut them off, the densely wooded slopes flowed up to the *saray* itself to be topped by the domes of Haghia Irene and Haghia Sophia. It was a royal backdrop and, happily, the harem were invited when waterside events took place: at least by the eighteenth century.

In the shadow of this fortress of a pavilion, the now totally destroyed and forgotten Yalı Kiosk was built in 1592. It may have replaced an earlier kiosk built by Bayezit II at the beginning of the sixteenth century and then permitted to decay, but this is merely a guess. Once again, the architect was Davut Agha. After a period of neglect, the kiosk was completely renovated by Ahmet III and it was here that his Water Festivals, with all kinds of marvels, took place just to prove that extravagant fun is a good way to be remembered. The kiosk was built in the form of a Greek cross. One arm formed the visitors' entrance, a prayer room, a coffee pantry and the lavatory. The other three arms formed the traditional throne room but without the usual sofas. The entrance door was beside the hooded fireplace and the wing was decorated with a wall fountain, while the long south wall opened onto the terrace surrounding the kiosk. The throne was in the centre of this colonnade. In front of it stood a fountain which fed a charming cascade where the water gently flowed from cusped shallow saucer to saucer and then into the sea. The salon dome was a fine hemisphere with pendentives and a lantern at its crown. Marble window frames were ornamented with little fountains. Fortunately, an Antoine de Beaumont engraving is evidence of what has been lost. When first built, the room was richly tiled and the ceiling lavishly painted.

Other engravings show how crowded the terraces could be and here again blinds were skilfully drawn against the wind. Ships moored beside the kiosk and at hand were the boat-houses for the royal skiffs and barges.

This was the perfect setting for Ahmet III's Water Festivals to which he invited the ladies of the harem as well as European ambassadors. They were entertained all night. There was a limitless store of fireworks, the unbroken beating of a great drum, floating orchestras and even wine. Dancing boys, whom the janissaries pursued all over the city, were safer here because they disported on floats and barges. One miniature shows eight starlets dancing to a band of nine instruments, their skirts flouncing in time with the choreography. One float carried a towering puppet, only to be outdone by the next. The most astonishing feat of all was to drive carriages on two tightropes, kept taut between the spars of two galleons, over a long stretch of water. Amazing acrobats, among whom the Egyptians were the star performers, could not outdo the coachman and his horses in the sky.

A lane leads back up from the gates of Gülhane (Rose) Park to the three museums and then on to the Middle Gate of the *saray*. The Museum of Archaeology is of the first importance and is beautifully arranged. The much smaller Museum of Oriental Art is also of interest. They occupy the last fore-court to the Tile Kiosk (Çinili Köşkü), which is itself a museum of Iznik ceramics. It is a fitting final curtain to lower before the drama of Topkapısaray. The ground before it was laid over vaults to be truly flat as befitted the stadium of a king. Here were held fights between lions and other beasts, polo matches and the very Turkish sport of wrestling. For this reason, it was covered in sand, hence its name of Kum Meydanı ('Sand Field'). When the sultan pleased, posts were erected for him to practise throwing javelins through hoops – *jerid* – at the gallop or it could serve as an archery ground.

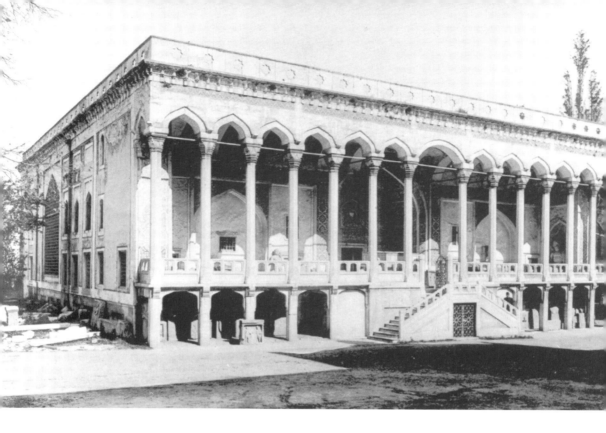

Once upon a time, a large basin reached almost to the steps of the pavilion. The roof was also flat and could make a fine grandstand but the climate dictated the addition of a lead roof. It would have been safer than the terrace in a bitter winter when there were great snow fights between the pages of the Palace School. They must have been among the grandest of such displays in history and ended in broken bones as well as black eyes.

The Tile Kiosk is a small palace which could serve as a hunting lodge. We have seen several examples of the concept of a pavilion in a garden as an ideal space in which to escape the straitjacket of palace formality. At this kiosk as well, the concept of a pavilion turned to stone was the first of its kind in Istanbul. The tiles remain but all the ornamental fabrics have gone. The ceramic decoration of the terrace is in the long tradition of glazed brick and it could well be that kilns were set up in the vicinity and that the potters came from Tabriz, or elsewhere, as had happened with the Green Mosque at Bursa. The geometric patterns dictated by the size of the bricks are sweeping as is the large but rigid calligraphy. The

interior walls, however, are covered in conventional Ottoman tiles, much smaller and therefore less theatrical. They could create green shadows or, as one western traveller described them, walls of the sea. If there is a coarseness in some of the ceramics, such as the thick and murky webbing in which some hexagonal tiles are set, the show cases are full of fine earthenware. In the sixteenth century, the Iznik kilns could produce 5,887 tiles in 90 days, quite apart from dishes, lamps and jugs.

The kiosk was completed for Mehmet II in 1473, only shortly after the first main courts of the *saray* in 1469. It was a haven, and the rooms set apart for the sultan, modest as they are, signify this. It was a haven that was also enjoyed by Mehmet II's son Bayezit. During his time, it was popularly known as the Sırça, or Glass Palace, because of the terrace's brilliant tiles which made such a fine backdrop for a sultan seated in state. One hundred years later, Murat III added a remarkable fountain, echoing the open tails of peacocks, in the bedchamber. These rooms opened onto the inner hall. This was lit by the bay window which we have seen from the park. It faced the central hall under its large dome from which hung a gilded ball, a larger than usual symbol of the universe. Here meetings could be held with the Divan or a whole assembly of notables. The other rooms on this floor were also grand, partly because of their height and the elaborate ribbed plasterwork of their ceilings. The floor below is reached by a staircase hidden under a broad trapdoor; it echoes the apartments above, until it digs into the hillside and becomes a semi-basement.

Halfway down the broad stairs under their huge trapdoor, there is a window with steps cut into the stone of a wide sill: this was so that kitchen supplies could be delivered out of sight. The steps descend to the basement and kitchens. One floor deeper is the cellar where ice was packed for summer use. The ornate decoration introduced by Abdülhamit I has gone and we are left with the unsullied original forms. But not quite. The deep cubic loggias in the centre of either flank have been glassed in, thus masking the play of light and shadow. This stifles the original sense of drama, quite apart

from the damage done to the contrast of projection and recession which are such important elements in the composition of any building.

With the façade, one regrets the fire of 1737 when the original columns were destroyed. They were of dark wood in contrast to stone and tile. Moreover, the span of the arches was contracted to make room for thirteen in place of the original nine, while the width of the terrace was modestly cut back. Sadly, one cannot be sure of the architect of this masterpiece although the name of Alaüttin of Tabriz occurs beside one Kemalettin. We know nothing about either of these men except that they were trained in Tabriz to become major craftsmen.

Inevitably much has been left out, including the hospital for the gardeners near Seraglio Point which was a curious triangular shape to prevent inmates looking over the wall into the gardens of the summer Harem; and the rose-water distillery. But neither can be seen. The attempt has been to show the *saray* in use, remembering always that the functions of spaces constantly changed. Topkapısaray was a great symbol, and to a small degree it still is. It was the great Renaissance architect Alberti who wrote that a symbol is the reverse of a sphinx: it is more alive when its riddle is answered. Or, in this instance, partly answered. The visitor has seen how ingeniously space and function were organized, how no centimetre of space was wasted and how, by doing this, architectural drama was created – not showmanship, with which so much building of this and the last century has been equated.

Questions could go on for weeks but the book does not. The hope is that there is enough of it for visitors to smell the right smells, hear the fabrics rustle, taste the best pilaf and, finally, be able to answer their questions for themselves. There is no longer any divine right and there are no more sultans but they and thousands of people were here for many reasons

which varied from period to period. It would be a pity to wander round and meet nobody and nobody meet you. If you can hear Kösem's murderers panting in the Court of the Black Eunuchs, sense the silence, or hear the splash of a teased mute pushed into Murat III's now parched basin, then you have visited Topkapısaray.

Arriving by horse, the sultan sits outside his kiosk contemplating the sea with members of his household. In the loneliness of silence he epitomizes the sadness of Topkapısaray

Select Bibliography

Atasoy, Nurhan, and Çağman, Filiz, *Turkish Miniature Painting*, Istanbul 1974.

Ayverdi, E. H., *Fatih devri mimarisi* [Architects of the Fatih Period], Istanbul 1953.

Bon, Ottaviano, *The Sultan's Seraglio. An Intimate Portrait of Life at the Ottoman Court*, introduced and annotated by G. Goodwin, London 1996.

Bouhdiba, Abdelwahab, *Sexuality in Islam*, tr. Alan Sheridan, London 1998.

Dallam, Thomas, *The Diary of Master Thomas Dallam, 1559–1600*, in J. T. Dent, *Early Voyages and Travel in the Levant*, London 1893.

Davis, F., *The Palace of Topkapı in Istanbul*, New York 1970.

Eldem, Sedad Hakkı, *Köşkler ve kasırlar* [Kiosks and Summerhouses], vol. 1 Istanbul 1969.

——and Akozan, Feridun, *Topkapısarayı, bir mimari araştırma* [Research into the Architecture of Topkapısaray], Istanbul 1982 (valuable plans and elevations).

Evliya Çelebi, *Seyahat-name* [Travels], vol. 1, Istanbul 1314/1896–7.

Gibb, H. A. R., and Bowen, H., *Islamic Society and the West*, vol. 1, Oxford 1950.

Goodwin, G., *A History of Ottoman Architecture*, London 1971, pp. 131–8.

——*Sinan: Ottoman Architecture and its Values Today*, London 1993.

——*The Janissaries*, London 1994.

——*The Private World of Ottoman Women*, London 1997.

Grelot, Guillaume-Joseph, *Relation nouvelle d'un voyage de Constantinople* [New Account of a Journey to Constantinople], Paris 1680.

Hierosilitano, Domenico, *Relatione della Gran Città di Constantinopli* [Account of the Great City of Constantinople], ms B.L. Harley 3408, fols. 83–141.

Koçu Bey, *Risala* [Influential Advice for Sovereigns], ed. Ali Kemalı Aksut, Istanbul, 1925.

Kritovolous of Imbros, *History of Mehmed the Conqueror by Kritovoulos (1451–1467)*, tr. C. T. Riggs, Princeton 1954.

Menavino, Giovantonio, *Le cinque libri delle legge, religione e vite de'Turchi et della corte, e d'alcune guerre del Gran Turco* [The Five Books of the Laws, Religion and Lives of the Turks and of the Court, and of Several Wars of the Great Turk], Florence 1548.

Necipoğlu, Gülru, *Architecture, Ceremonial and Power. The Topkapi Palace in the Fifteenth and Sixteenth Centuries*, New York 1991.

De Nicolay, Nicolas, *Navigations and Voyages*, London 1586.

Rogers, J. M., *An Ottoman Palace Inventory of the Reign of Bayazid II*, in J. L. Bacqué-Grammont and E. van Donzel (eds), *Procs. CIEPO*, Istanbul 1987.

——*The Topkapi Saray Museum, Architecture, the Harem and Other Buildings*, ed. and tr. from Turkish texts by K. Çiğ, S. Batur and C. Köseoğlu, Boston 1988.

Sarella, Francesco, *Dissegni della città di Constantinopoli, delle sette torre Serraglio, et delle otto sue reale moschèe (dec. 1686)* [Drawings of the City of Constantinople, of the Seven Towers of the Seraglio, and of the Eight Royal Mosques (Dec. 1686)], ms Vienna, Nationalbibliothek, cod. 8627.

Schneider, M., and Evin, Alpay, *Le Harem impérial de Topkapı* [The Imperial Harem of Topkapı], Paris 1997.

Uzunçarşılı, I. H., *Osmanlı devletinin saray teşkilâtı* [The Palace Organization of the Ottoman State], Ankara 1948.

Illustrations

Colour Plates

Index